MAKING A

SPEC

TAC

LE

MAKING A
SPEC

T A C L E

A Fashionable History of Glasses

JESSICA GLASSCOCK

BLACK DOG
& LEVENTHAL
PUBLISHERS
NEW YORK

Black Dog & Leventhal Publishers
Hachette Book Group
1290 Avenue of the Americas
New York, NY 10104

www.hachettebookgroup.com
www.blackdogandleventhal.com

First Edition: October 2021

Black Dog & Leventhal Publishers is an imprint of Perseus Books, LLC, a subsidiary of Hachette Book Group, Inc. The Black Dog & Leventhal Publishers name and logo are trademarks of Hachette Book Group, Inc.

The publisher is not responsible for websites (or their content) that are not owned by the publisher.

The Hachette Speakers Bureau provides a wide range of authors for speaking events. To find out more, go to www.HachetteSpeakersBureau.com or call (866) 376-6591.

Additional copyright/credits information is on page 243.

Print book interior design by Alex Camlin

Library of Congress Cataloging-in-Publication Data

Names: Glasscock, Jessica, author.
Title: Making a spectacle : a fashionable history of glasses / Jessica Glasscock.
Description: First edition. | New York, NY : Black Dog & Leventhal
 Publishers, [2021] | Summary: "Making a Spectacle covers the history of
 eyeglasses, from their origins as a useful, if unsightly, tool to their
 current status as an essential part of the fashion narrative" —Provided
 by publisher.
Identifiers: LCCN 2020042997 (print) | LCCN 2020042998 (ebook) | ISBN
 9780762473441 (hardcover) | ISBN 9780762473434 (ebook)
Subjects: LCSH: Eyeglasses —History. | Eyeglass frames—History. |
 Fashion—History.
Classification: LCC GT2370.G57 2021 (print) | LCC GT2370 (ebook) | DDC
 391.4/409—dc23
LC record available at https://lccn.loc.gov/2020042997
LC ebook record available at https://lccn.loc.gov/2020042998

ISBNs: 978-0-7624-7344-1 (hardcover), 978-0-7624-7343-4 (ebook)

Printed in China

APS

10 9 8 7 6 5 4 3 2 1

I would like to dedicate this book to my mother, Terry Rodriguez.
I am sorry I kept losing my glasses in second grade. In retrospect,
I like to think I was just angling for multiple pairs.

CONTENTS

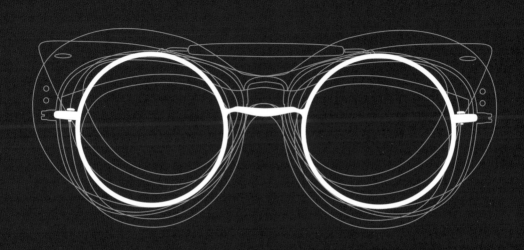

INTRODUCTION
The Better to See You With

Mark of distinction? Medical miracle? Social suicide? Eyeglasses are unquestionably a technological miracle, but their history as a fashionable accessory has been strangely occluded, to say the least. For about seven hundred years, fashion seemed to be at war with eyewear. Rather than a window to a brighter world, eyewear was a disfigurement, and its transformation from object of necessity into object of desire was slow and ambivalent. This is all the more nonsensical when one considers that eyewear started with a jewel. Before the frames of horn, wood, metal, leather, before men seldom made passes, the very first lens for the first piece of eyewear was made of a beryl crystal. When beryl is blue, it's an aquamarine, and when it's green, it's an emerald. When it is crystal clear, it is the origin story of what is now a billion-dollar accessory business nestled neatly between want and need, necessity and luxury.

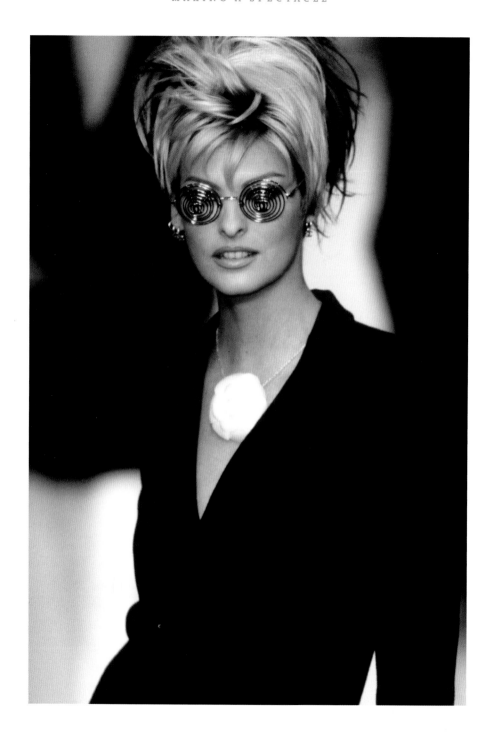

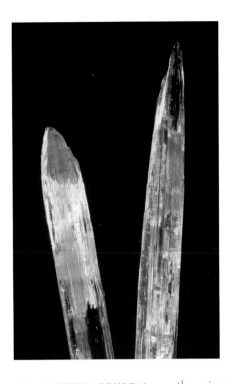

< **FROM THEIR MOMENT OF INVENTION,** eyeglasses were as much a vehicle for social status as for improved vision. First fashioned by medieval guildsmen specializing in rock crystal and glass work or the manipulation of carved or finely drawn precious metals, eyewear was a mark of achievement even before its privileged possessor got any reading done. Refined over the course of eight centuries, eyeglasses have become a fashion spectacle with couture designers unapologetically exploiting its sculptural and cosmetic potentials, sometimes over and above the ideal of eyeglasses as a prosthetic device for actual seeing. The earliest eyeglasses in the thirteenth century had a beveled edge, which made for clarity of vision as well as resistance to damage for the early beryl-crystal lenses. Wire framing for eyeglasses was introduced at the very beginning of the seventeenth century, which kicked off mass production of eyewear. For the runway in 1996, the House of Chanel created a pair of glasses that use wire to create a beveled effect, finishing playfully with the brand's interlocking C logo at the center of the "lens." [House of Chanel runway. Photograph by Guy Marineau, 1996.]

∧ **CLEAR BERYL CRYSTAL** was the primary material used to create eyeglass lenses in the thirteenth century, as it would be many years before glass could be manufactured to the quality required for corrective spectacles. This is what made the earliest eyeglasses such a high-status object. The crystal was in use for vision even before it was placed in the frame of early spectacles. The use of a "reading stone" is recorded around the year 1000. An even-earlier reference that is related in many of the histories of eyeglasses and sunglasses is the historian Pliny's claim that the Roman emperor Nero used a green beryl crystal, better known as an emerald, to view gladiatorial games. [Beryl crystal, 2020.]

EARLY

EYEG LAS SES

· I ·

Beginning to See the Light

I n 1267, philosopher, scientist, and
Franciscan friar Roger Bacon made the first recorded note of the potential for
magnifying lenses to correct sight. It was a concept of particular interest to the
emerging literate community in western Europe. In the Middle Ages, clerics were
more likely than most to live past the age of forty and were therefore more likely to see
their eyes fail due to age-related presbyopia, or farsightedness. Losing the ability to
read and write was often the end of the work that had defined the clerics' lives.

The invention of eyeglasses followed Bacon's comment within twenty years,
though the identity of the inventor is unclear. The title has been assigned to a
couple of figures; a monk named Alessandro della Spina and a Florentine named
Salvino d'Armati appear in earlier histories. The only certainty is that corrective
eyeglasses were of Italian origin, likely the work of Venetian makers from the

guild of glass and rock-crystal workers. Eyeglasses were quickly recognized as an invaluable tool for medieval media makers and tech nerds: monks, bookbinders, transcribers, clerks, professors, watchmakers, accountants, and arms makers. Johannes Gutenberg's invention of the printing press around 1440 further increased the desirability of eyeglasses, and through the fifteenth and sixteenth centuries a simple design of the earliest eyeglasses took form: a pair of lenses fixed into a riveted or solid bridge frame of bone, horn, wood, or leather.

While the earliest eyeglasses aren't known to have survived, their design and styling can be sussed out through portraiture. The earliest portrait that includes eyewear dates to 1352, though it is anachronistic. The portrait depicts French Dominican friar Hugh of Saint-Cher, who had died a good decade before the invention of eyeglasses. Nevertheless, artist Tommaso da Modena portrayed the friar with eyeglasses on his nose and hard at work on a book. This inaugurated a consistent portrayal of spectacles in art, where they appear, either held in hand or worn, as a marker of the intelligentsia. Spectacles were props in portraits of artists, religious leaders, and scientists that said: "Here is a man of substance [and it was almost always a man in the earliest years]; what he sees and what he thinks of it matters."

Spectacles were already a luxe accessory at the dawn of the Renaissance. In the fifteenth century, spectacles were made with gold frames and worn in the Spanish court as badges of rank. In the sixteenth century, the eyewear guild in Nuremberg required members to make a "masterwork" pair of eyeglasses for confirmation to the guild. These high-style glasses, however, were not universally approved. In his 1967 book *Fashions in Eyeglasses*, fashion history scholar Richard Corson discussed the enthusiasm for spectacles in Spain, but he also noted that

in other parts of Europe, eyeglasses were indicative of age and infirmity. Medical practitioners weren't very enthusiastic for the corrective lenses, either. In 1583, according to Corson's account, Dr. Georg Bartisch of Dresden wrote, "It is much better and more useful that one leaves spectacles alone. For naturally a person sees and recognizes something better when he has nothing in front of his eyes than when he has something there. It is much better that one should preserve his two eyes than that he should have four."

Largely absent from the tradition of hagiographic portraiture of early eyeglass adopters are their lady wearers, though there was almost certainly a substantial female market for eyeglasses. The fine work of lacemaking and other textile manufacturing would have called for spectacles as much as accounting or illuminating manuscripts would have. But it does seem that at least through the sixteenth century, there was not much in the way of fashionable eyewear for women. It was left to male wearers to be fashionable, which they indisputably were. Fashion didn't become a feminized sphere in Western culture until the nineteenth century; in the sixteenth and seventeenth centuries, fashionable prerogatives were as much, if not more, male than female. This is affirmed by the luxe forms of eyewear available through the Renaissance as well as the prominence of spectacles in men's portraiture. There was a performative attitude surrounding spectacles worn with panache and paired with other expensive accessories and ensembles. It would take, however, an elaboration of options for eyeglasses to be embraced by the bright young things of the eighteenth century. More expressive and impressive versions of eyewear than two round lenses in a gold bowed frame were needed. The story fashionable eyewear told couldn't just be one of vision corrected; it needed to be Enlightened.

∨ **EYEGLASSES HAVE ALWAYS** been needful things, whether in their original form as precision-ground crystals of beryl or rendered in luxury materials by Cartier. The pair detailed in the hand of Benedictine monk Benedictus van Haeften were likely to assist with the scholar's farsightedness. This is the reason the spectacles could be held in hand rather than worn. Convex lenses for presbyopia were invented in the thirteenth century, whereas concave lenses did not come into use for myopia until the fifteenth century. The nearsighted needed to wear their glasses, but the farsighted could secrete them away, producing them only as needed. Van Haeften would have perched the eyeglasses on his nose while reading. The simple construction of these bow glasses was accepted for hundreds of years, despite the seeming inconvenience of such precarity. [Detail of *Portrait of Benedictus van Haeften*. Cornelis Martinus Vermeulen, 1654–1709.]

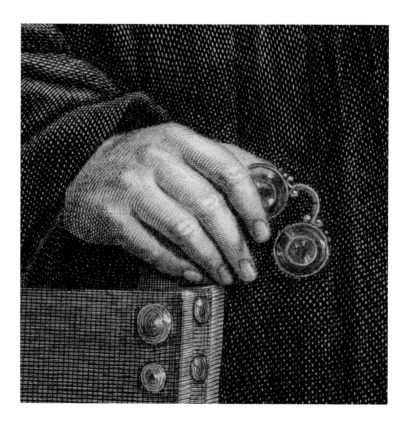

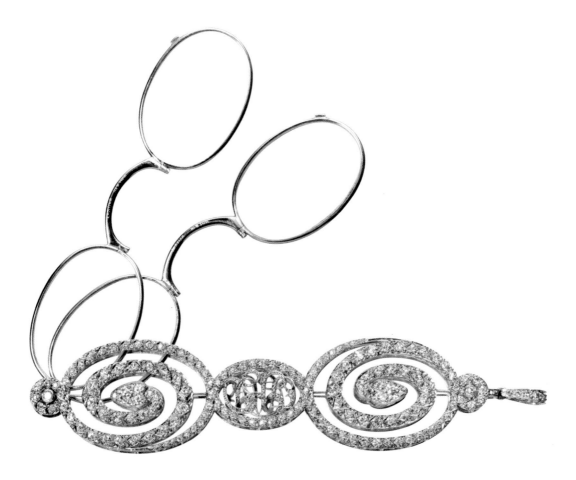

∧ **THOUGH MADE FROM COSTLY** crystals (they are diamonds set in platinum), the lorgnettes from the personal collection of the heiress and noted bibliophile Jeannette Dwight Bliss were also handheld. With two sets of spectacles apparent, it seems likely that Ms. Bliss needed to correct both nearsightedness and farsightedness. Lorgnettes were a style of spectacle used mainly by women in the nineteenth and twentieth centuries. Though more-efficient wearable frames were widely available, they were considered inelegant. Fashion journalists especially forbade glasses for evening wear. If Ms. Bliss wanted to read a menu and see a play in the same evening, the lorgnettes would have been the fashionable solution. [Lorgnettes. Cartier, ca. 1905.]

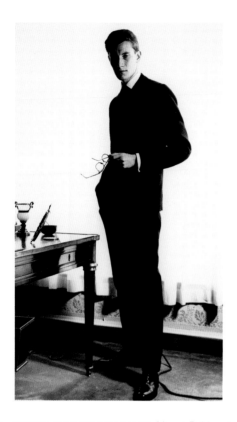

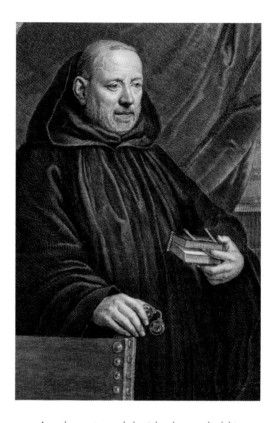

∧ **WHEN PHOTOGRAPHER** Horst P. Horst photographed designer Yves Saint Laurent in 1958, the fashion prodigy who had just taken over the House of Dior, he was well aware of the history of eyeglasses in portraiture. Though Saint Laurent cuts a more slender line, his delicate grasp of his spectacles echoes that of Benedictus van Haeften in the engraving by Cornelis Martinus Vermeulen. Both are portrayed in their professional guise, Van Haeften the scholar and Saint Laurent the fashion designer, with the glasses signifying sight as a crucial component of their work — a tool of the trade.

An elegant model with glasses held in hand, rather than worn on the face, was a common conceit in the fashion photograph. It was unusual, however, for a photo of Yves Saint Laurent. He was typically photographed wearing his eyeglasses and wore a range of fashionable frames over the course of his public life, even wearing his glasses when photographed nude by Jeanloup Sieff in 1971. [(Left) French fashion designer and couturier Yves Saint Laurent at Dior, Paris. Horst P. Horst, 1958. (Right) *Portrait of Benedictus van Haeften*. Cornelis Martinus Vermeulen, 1654–1709.]

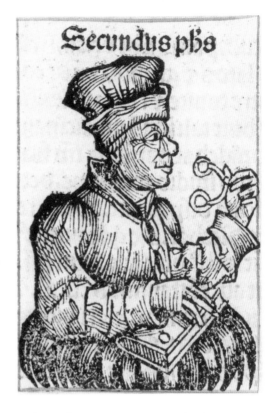

> **THIS WOODCUT PRINT** shows a gentleman holding a pair of rivet spectacles, which were the earliest form of eyeglasses. Rivet spectacles were two magnifying lenses on the ends of metal handles riveted together. Like the more solid bow spectacles that followed, they were meant to be held or balanced on the nose for short-term use. This image of Secundus the Silent and his pair of rivet spectacles was published as an illustration in the book *Nuremberg Chronicle*. Venice was the earliest center of eyewear production in Europe, as glassmaking was already a well-established industry there, but as the demand for a learned and literate workforce rose, other centers became established in the major European capitals. Nuremberg had a rising publishing trade, as well as some of the bureaucratic offices of the Holy Roman Empire, and there is documentation of eyewear made there as early as 1478. Though the rivet spectacles depicted in the woodcut are extremely rustic, some of the most ornate and expensive early eyewear was made in Nuremberg in the seventeenth and eighteenth centuries, masterworks that were required by the guild of spectacle makers and used by apprentices to show off their gold working and optical talents. At the same time, the German eyewear makers developed mass-production techniques that made eyewear more widely available, introducing a wire-rimmed frame shaped from one continuous length of copper. The democratized access to spectacles made possible by the Nuremberg guild likely reduced the status of spectacles as a part of the lifestyle of the rich and learned. [*Secundus de Stille* (Secondus the Silent). Michel Wolgemut (workshop of), 1493.]

> **ROUGHLY THREE HUNDRED YEARS** into the evolution of eyewear, this portrait is particularly notable in terms of the solution devised to keep the spectacles fixed on the face of Cardinal Fernando Niño de Guevara. A looped cord anchors the eyeglasses behind his ears. It's a seemingly obvious solution, but one that would only slowly and iteratively be devised by successive makers of eyewear over the next century or so. As with other men of the cloth (and the glass), we already have some sense of the personal narrative meant to be implied by featuring glasses so prominently in a portrait. As cardinal, Spanish inquisitor general, and later archbishop, what Niño de Guevara saw was central to his profession and his power. His eyeglasses convey that status. They were also quite fashionable, as was the cardinal himself, resplendent in his vestments of biretta, mozzetta, and lace-trimmed rochet. The cord-spectacles he wears were mainly seen in Spain (and in China, whose eyewear industry developed concurrently with that of western Europe). That Niño de Guevara was known to wear eyeglasses has helped to confirm the identity of this portrait, since scholars at the Metropolitan Museum of Art noted that no one would have worn glasses in a formal portrait unless they were distinctive in their actual appearance. [*Cardinal Fernando Niño de Guevara*. El Greco (Domenikos Theotokopoulos), ca. 1600.]

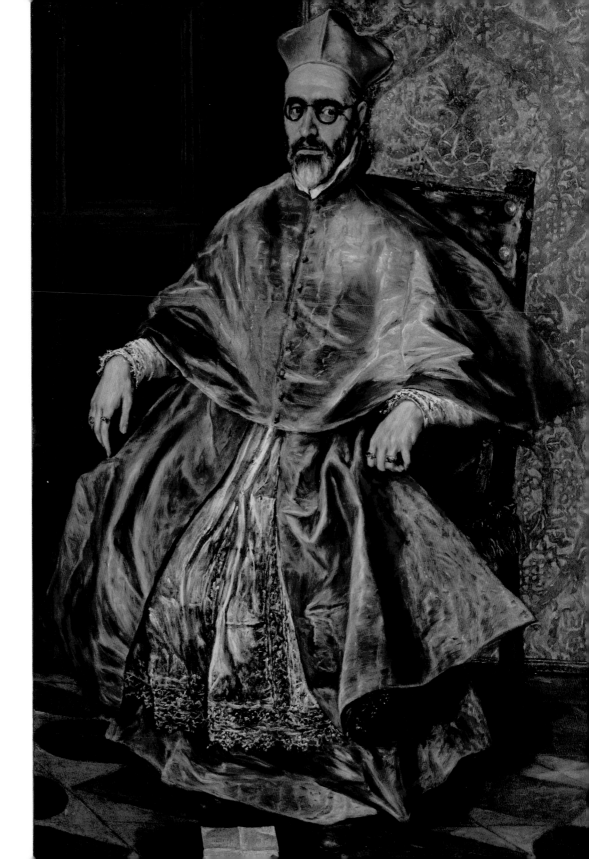

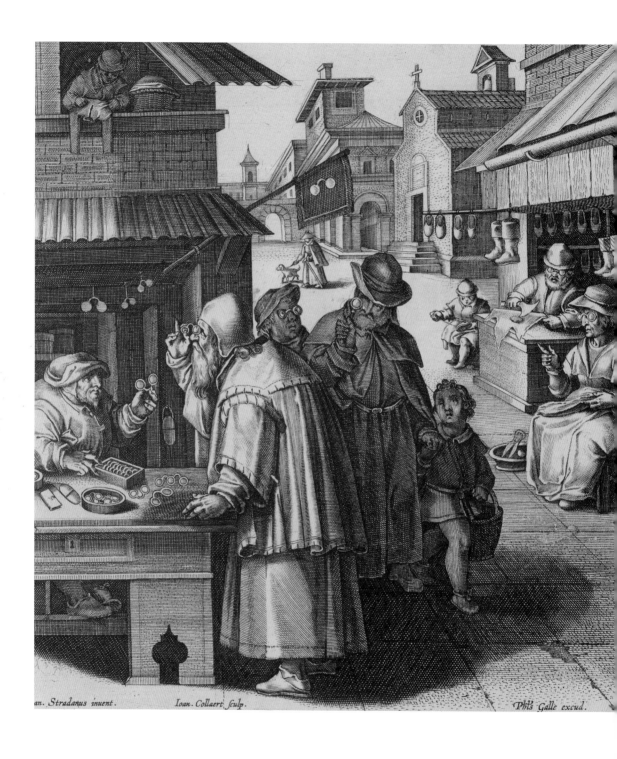

an. Stradanus inuent. Ioan. Collaert sculp. Phls Galle excud.

< **THIS DUTCH PRINT,** one of a series from the early seventeenth century, documents the pivotal moment of the democratization of spectacles. Central European makers developed innovative construction techniques that made the first mass production of eyewear possible, and the revelation of eyewear in the hands of the middle and working class is apparent. In *The Invention of Eyeglasses,* the fifteenth plate from a print series entitled *New Inventions of Modern Times,* the literal market for spectacles is illustrated as a man tries on a pair of eyeglasses. The banner above advertises spectacles with a simple graphic image, which would be used as signage by opticians into the twentieth century. The uses of eyeglasses are illustrated as well: one man takes in the street scene, another walks with a child and what was known as a perspective glass to look around the corner, one man reads a book, and someone else reads a document. In the background, a shoemaker wearing spectacles as he cuts a piece of hide for his work is particularly notable, since it shows the use of spectacles in fashion trades. [*New Inventions of Modern Times, The Invention of Eyeglasses* (plate 15). Jan Collaert I, ca. 1600.]

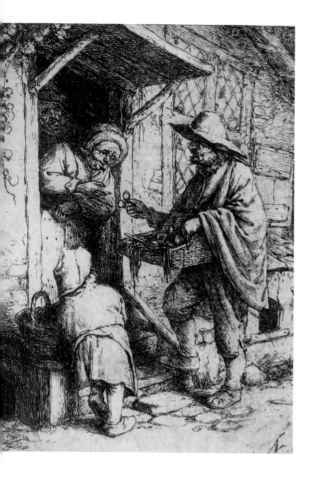

< **IN** *THE SPECTACLE SELLER,* we see another mode of distribution for inexpensive eyeglasses in the seventeenth century. The peddler with a basket of spectacles was a common figure in the period, much to the chagrin of the more refined optical practices that were finding foothold in urban areas. The peddler had lenses of various strengths and offered them up based on the age and gender of the customer. These were the first iteration of "readers," a style of glasses that provided only magnification and could be used without any eye exam. Optical-trade opposition to readers was sustained from the seventeenth century to the present, as they are now typically peddled at chain drugstores. The commercial success of cheap glasses would lead to a fashionable failure of spectacles generally. As spectacles became widely available, their association with the elite waned. [*The Spectacle Seller.* Adriaen van Ostade, 1610–85.]

> **SPECTACLES** and spectacle peddlers were also drafted into service in seventeenth-century allegorical prints. This is not a genre scene but rather the illustration of a proverb that everything is deception. The meaning and value of sight with eyeglasses as its symbol would be a topic for satirical prints for hundreds of years to come. [*Brillenverkoper* (Eyewear seller). Clock (Nicolaes Jansz), 1602.]

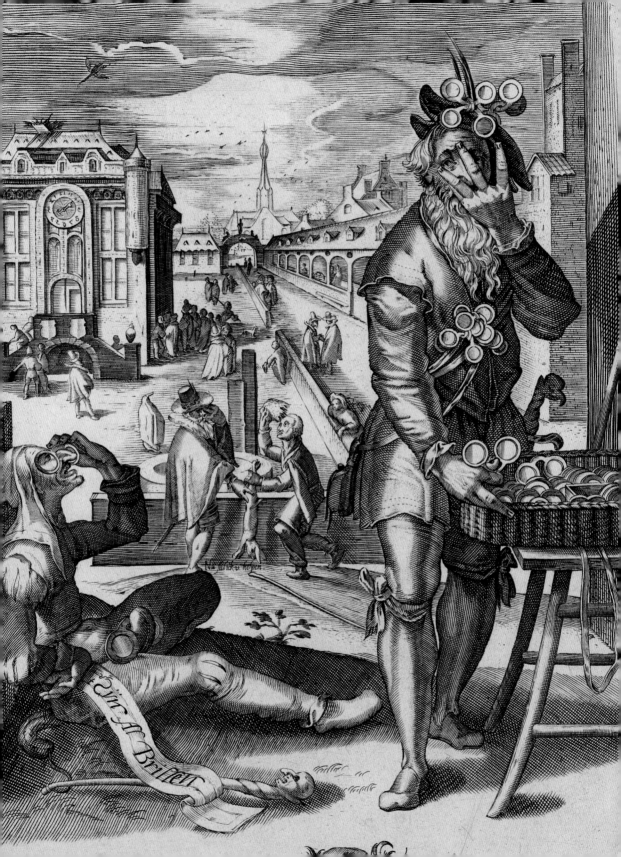

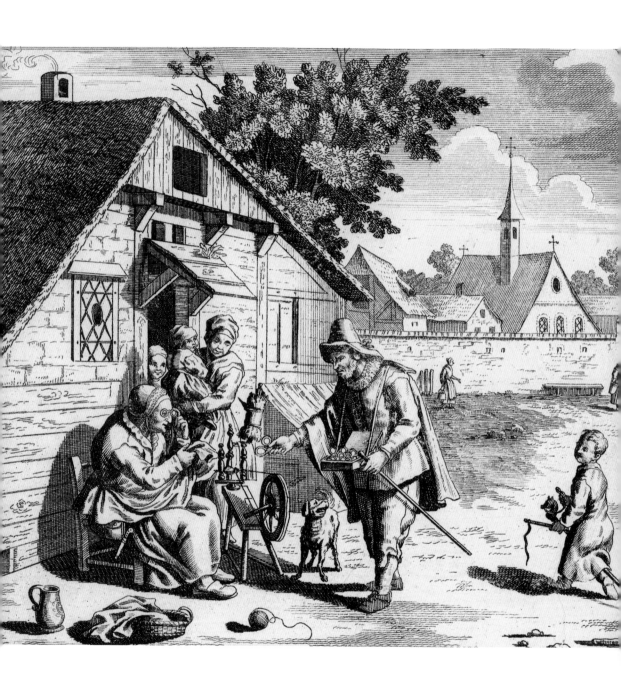

< **HERE THE USE OF SPECTACLES** in textile work is illustrated. The association of spectacles with the aged is on full display as well. [*Brillenverkoper verkoopt een bril aan een oude vrouw met een spinnewiel* (Glasses seller sells glasses to an old woman with a spinning wheel). Elias Baeck, 1694-1744.]

< ∨ **THE IDEA** that glasses did not constantly need to be worn led to a number of practical solutions from loops and hooks built into accessories to the simple solution of tucking spectacles over the ear. [(Left) *Gezicht* (Face). Conrad Lauwers, after Joos van Craesbeeck, 1700–1799. (Below) *Portrait of Sebastiano Resta*. Arthur Pond after Pier Leone Ghezzi, 1738.]

< **THE INVENTION** of temples or side pieces to secure spectacles would not come until the late 1720s, when they were first advertised by London optician Edward Scarlett. In the meantime, frames of natural horn such as these had to be balanced on the nose. [Bow spectacles, ca. 1675.]

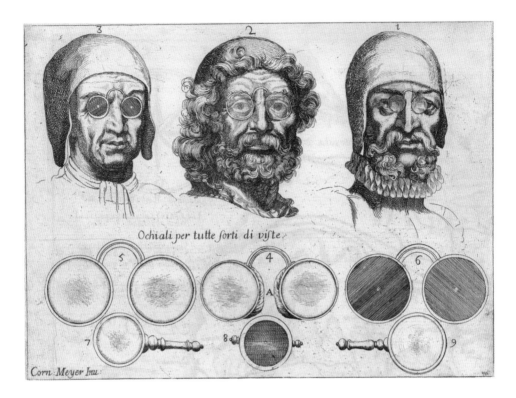

Ochiali per tutte forti di viste

Corn: Meyer Inu:

∧ **THIS PRINT** intended for an Italian-speaking audience shows the stylishness of spectacles even before spectacles were dramatically styled. The variation among these "glasses for everyone with strong views" (a translation of the original caption) is small and driven by differing functionalities. Though glasses had been in mass production for nearly a century, only the simplest forms are illustrated in the print. The darkened pinhole glasses worn by the gentleman on the left would have been intended to reduce eyestrain and possibly help with astigmatism. The other gentlemen wear differing glasses, each made to more aptly fit over their respective noses. The glasses at lower center show the option of padding for better fit as well. But all are of a similar functional design, which is expressive of the role of eyeglasses as technological implements first and foremost. It is not the eyewear but rather the illustrated gentlemen themselves who are stylish, most tellingly confirmed by the clean and elegantly curled facial hair and the crisp high ruff worn by the gentleman at the far right. Though not particularly ornate, eyewear is an accessory component for the well-dressed man just before the eighteenth century. [*Verschillende brillen* (Different glasses). Cornelis Meijer, 1696.]

ENLIGHTENED

IMPLE MEN ts

·2·

Enlightened Implements

The first iterations of eyeglasses as a fashionable accessory for women were wielded in the artful hands of French and British society ladies and gentlemen. The eighteenth-century eyeglass fit into a pose, rather than on the nose, in a variety of forms. The prospect glass was a small layman's telescope, and the spyglass was a more elegantly shagreen-bound version of the same. The quizzing glass was a single eyeglass that could be set into a frame of a base metal or could be a vehicle for the most ornate jewel work. Scissors glasses featured a pair of lenses set into an elaborately decorated handle meant to be held directly in front of the face of the user. The miniature lorgnette was a tiny telescope that could be secreted at the end of a painted fan, in the head of a walking cane, or at the core of a jeweled vial of perfume worn as a pendant charm. A variant of the miniature lorgnette called a jealousy glass held

a magnified mirror positioned at an angle for the surreptitious viewing of those behind the user. In theory, the miniature lorgnette devices were intended to assist a nearsighted theatergoer, but what all the eighteenth-century eyeglasses really signified was wealth and privilege. The fashion was for being seen seeing.

The eyeglasses of the eighteenth century melded luxe jewelry production with state-of-the-art technology of augmented vision. They were an emblem of participation in the Enlightenment era. The novelty appeal and the unapologetic positioning as a fashion accessory were crucial to the success of these eyeglasses, which made them an ideal vehicle for rapidly improving lens-making technology. They allayed the anxiety about infirmity (or the commonly used term disfigurement) inherent in spectacles and replaced it with more powerful vision. It was eyewear that enhanced the wearer by staking a position in the realms of jewelry. Whether or not they were needed, the eighteenth-century eyeglasses were wanted. They were the first wave of eyeglasses as fashionable accessories.

In the eighteenth century, luxe, fashionable eyewear was most visible, but the optical trade also strongly pursued technical innovations for workaday spectacles. This was the era when temples, or side pieces on eyeglasses, were patented, marketed, and refined. First advertised by the optician Edward Scarlett

in the 1720s, temples were just one of the design issues refined over the course of the eighteenth century. Bifocal lenses were being perfected by the last quarter of the eighteenth century, as both opticians and individual wearers attempted to solve the problems of nearsightedness and farsightedness in a single instrument. All sorts of functional solutions were developed and patented: for ease of stowing, dual folding lenses; for the hunting enthusiast, pinholed shooting glasses; for the mechanical trades, protective eyewear with side panels of beveled pebble crystal. The outcome was the foundation of what could aptly be called an eyewear wardrobe, primarily for men, which became entrenched in the nineteenth century.

The fashionable positioning of these functional forms of eyewear in the eighteenth century was evidenced and heightened via their use by artists of the era. Clear vision was a necessity of the artist's trade, so eyewear figured prominently in self-portraiture and in print portrayals of notable artists. The eighteenth-century visual culture of artists in eyewear lent the minimalist wire-rimmed bifocal frames a certain bohemian appeal that went beyond their association with the merely learned.

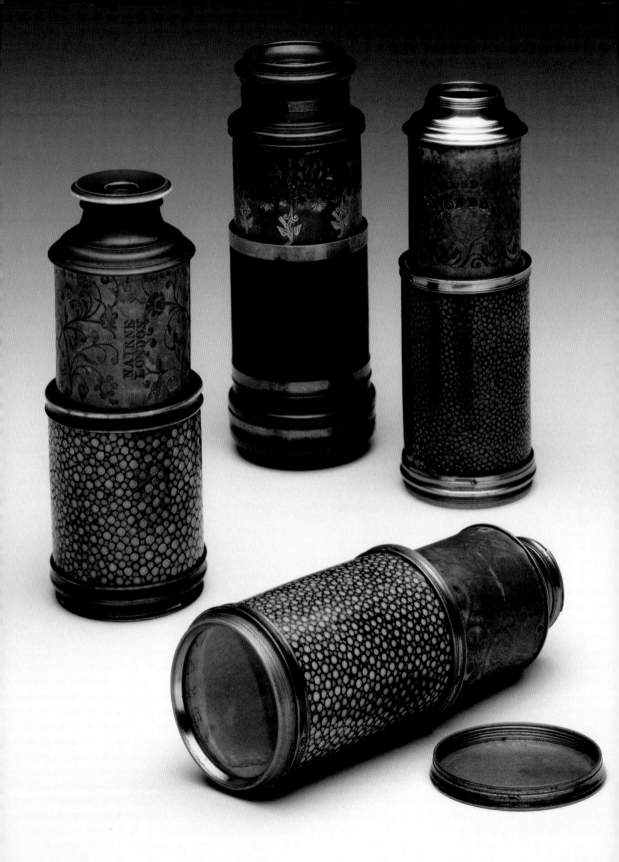

< **IN 1608, GLASS MAKERS** and inventors in the Netherlands were making the first telescopes. Within ten years, the layman's adaptation of the telescope appeared and began its evolution from emblem of the emerging Enlightenment to ideal apparatus for the Rococo eye. The prospect glass, the spyglass, and the miniature lorgnette were all based on the technology for the telescope. These accessories were captured in genre scenes, portraits, and satirical images of the range of society ladies and gentlemen in the eighteenth century. As expensive and technologically advanced implements, they were high-status eyeglasses. Their embrace in fashionable courts and urban entertainment venues contributed enormously to the recuperation of eyewear's glam status after its diffusion in the form of cheap wire-rimmed readers in the early seventeenth century. [Prospect glasses, 1749–73.]

< **THIS PIECE** from the Science Museum in London was also known in academic circles of the Enlightenment era as a polemoscope. One of the earliest examples was owned by Stephen Demainbray, who was a natural scientist and astronomer to England's King George III. In society circles, it would have been better known as a jealousy glass. Disguised as a miniature lorgnette of the type that would have been used at the theater, the opera, or other large event, it was actually a configuration of two lenses and an angled mirror that would allow the user to observe one's fellow partygoers surreptitiously. That these devices went from Stephen Demainbray's lectures on natural philosophy to the accessory collections of the likes of Madame de Pompadour and Madame du Barry is a perfect example of the overlap between science and fashion in the Enlightenment social milieu. The jealousy glass could be camouflaged as a prospect glass or it could go further incognito into a pillbox or other casing for a miniature lorgnette. [Ivory jealousy glass, ca. 1750.]

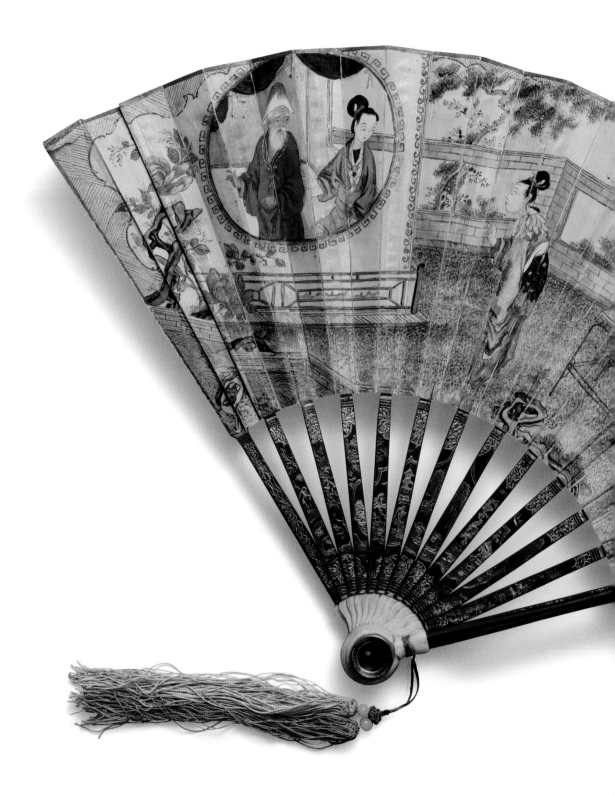

< ∧ **THE FOLDING FAN** was the most iconic accessory of the eighteenth century, with an entire language of attitude and nuance attached to its use. The lorgnette or opera-glass fan had some vogue in the seventeenth century and then again in the latter half of the eighteenth century. Around 1782, Queen Marie-Antoinette was gifted with a diamond-studded fan that contained a tiny prospect-glass lens in its handle. Not all lorgnette fans had the lens in the handle. Some had a lens at the end of one blade of the fan and could be used when the fan was collapsed, creating a tube for viewing through a hole in the blades of the rest of the fan. [Lorgnette fan, mid-eighteenth century.]

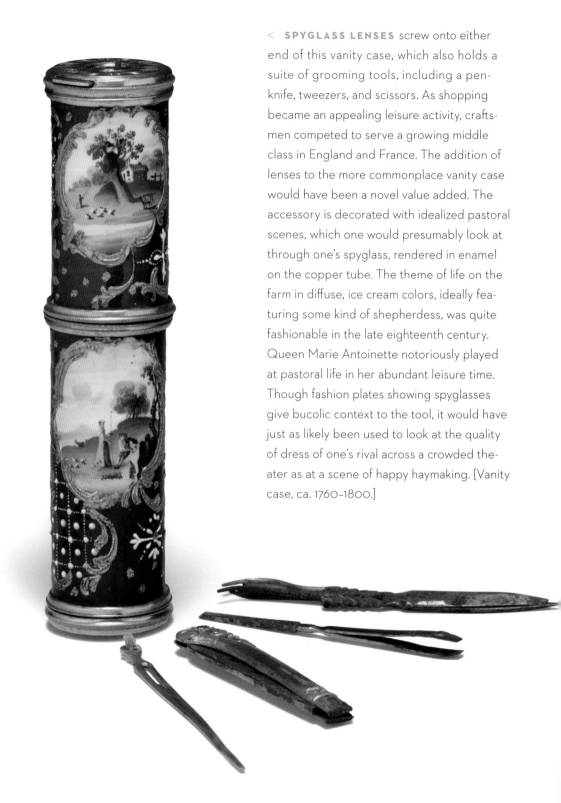

< **SPYGLASS LENSES** screw onto either end of this vanity case, which also holds a suite of grooming tools, including a pen-knife, tweezers, and scissors. As shopping became an appealing leisure activity, crafts-men competed to serve a growing middle class in England and France. The addition of lenses to the more commonplace vanity case would have been a novel value added. The accessory is decorated with idealized pastoral scenes, which one would presumably look at through one's spyglass, rendered in enamel on the copper tube. The theme of life on the farm in diffuse, ice cream colors, ideally fea-turing some kind of shepherdess, was quite fashionable in the late eighteenth century. Queen Marie Antoinette notoriously played at pastoral life in her abundant leisure time. Though fashion plates showing spyglasses give bucolic context to the tool, it would have just as likely been used to look at the quality of dress of one's rival across a crowded the-ater as at a scene of happy haymaking. [Vanity case, ca. 1760–1800.]

∨ **THIS BRITISH SPYGLASS** is rendered in the very on-trend (for the late eighteenth century) material of jasperware. A product of Josiah Wedgwood's studios, jasperware was meant to imitate ancient Roman cameo glass, which was then in the process of being literally unearthed in Italy. Such artifacts were collected voraciously by young British aristocrats while on their Grand Tour of the Continent, which they undertook to complete their education. The neoclassical design on this spyglass was the work of sculptor and draughtsman John Flaxman, who was employed by Wedgwood expressly to create designs in the style of ancient Rome, such as this "Triumph of Cupid" design from 1782. While Wedgwood's jasperware work was intended to capture the market for ancient Roman collectibles, its manufacture was also recognized as an expression of efficiency in rapidly industrializing England. It is likely for that reason that it could be used to decorate a spyglass — also a supermodern tool and one that was not likely to be mistaken for a product of the Caesars. [Spy or opera glass. Josiah Wedgwood, late eighteenth century.]

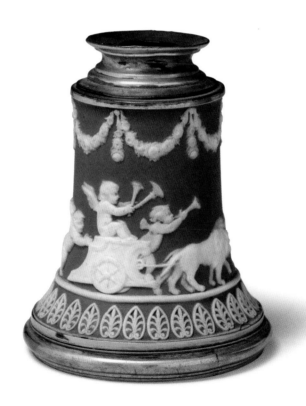

∧ **SOMETIMES IDENTIFIED** as a monocle, the eyeglass worn by artist Anna Dorothea Therbusch-Lisiewska in her self-portrait is actually drawn from the long history of spectacles and eyeglasses secured in coiffure. Part of the reason that temples were so long incubated as the ideal method to secure spectacles is that a number of mechanisms for keeping eyewear on the face were hidden in the wigs of seventeenth-century men. [Self-portrait. Anna Dorothea Therbusch-Lisiewska, ca. 1782.]

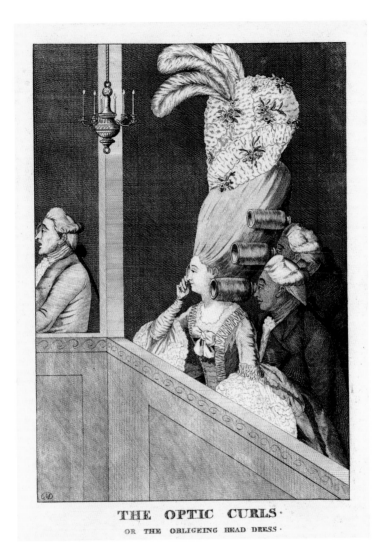

THE OPTIC CURLS·
OR THE OBLIGEING HEAD DRESS·

∧ **IN A MATTHEW DARLY PRINT** with a lot of eyewear ideas to unpack, the vogue for eyeglasses is ridiculed alongside the extreme hair of the 1770s. The gentleman at left as well as the lady are using the single-lensed quizzing glass to observe the stage while two other gentlemen use spyglasses secured in the lady's hair. Mary and Matthew Darly were a husband-and-wife team of caricaturists, who had begun their career with political satire but drifted over to fashionable foibles by the 1770s. [*The Optic Curls, or The Obligeing Head-Dress* (print). Matthew Darly, 1777.]

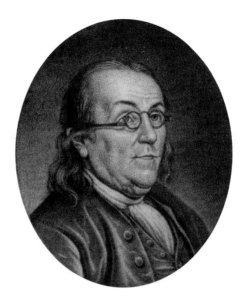

∧ **WHILE BIFOCALS** lack the ostentation of many Enlightenment-era eyeglasses, they are an equally crucial part of the fashionable history of eyewear, especially as popularized by Benjamin Franklin. As was the case with a number of technical innovations of the late eighteenth century, bifocals were likely invented independently by several persons roughly between 1760 and 1784. It was the nature of the Enlightenment project that laymen as well as proper opticians would be interested in finding a way to resolve the complex problem of presbyopia combined with any additional deficiency of vision. There are competing accounts of earlier inventors, but Benjamin Franklin documented his invention of bifocals in a letter to a Philadelphia optician in 1784.

Though Franklin's glasses look exceedingly simple, that does not necessarily reflect a lack of fashionableness. Ben Franklin was, like many eighteenth-century American men, deeply engaged with fashion as a part of his general appreciation for French culture. While he was ambassador to France, from 1776 to 1785, that appreciation was reciprocated by the French, who were charmed by what they perceived as Franklin's rustic manner and style. The simplicity of the glasses in this Charles Willson Peale image was in keeping with the emerging American fashion system, which favored functionality over excessive decoration as a matter of democratic principle. Franklin's bifocals and the vogue for simple, functional eyewear for men took firm hold by the nineteenth century, due in no small part to Franklin's fame as a Founding Father of the United States of America. [*Benjamin Franklin.* Charles Willson Peale, 1787.]

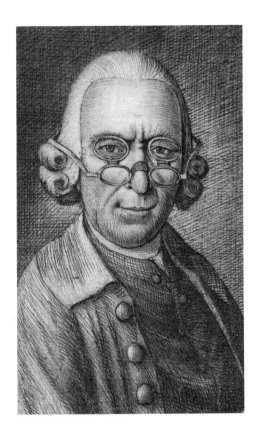

< ∨ **THOUGH** bifocals were invented by 1784, their perfection would be a moving target over the course of the nineteenth century. This left room for other solutions for seeing near and far in one implement. Hinged and reversible double spectacles were among the other solutions. Portrait painter Rienk Jelgerhuis had a pair of glasses that he adjusted up or down the bridge of his nose as required for his work. Other solutions included additional lenses hinged at the sides or the tops of the frames of the wearer's regular glasses, an idea that would stay in circulation into the late twentieth and twenty-first centuries, though more for protective lenses than bifocals. In the 1980s, the fashion designer Kenzo Takada used side-flip hinges to add sunglass lenses to prescription glasses. [(Left) Self-portrait. Rienk Jelgerhuis, 1791. (Below) Kenzo hinged silver sunglasses, 1980s.]

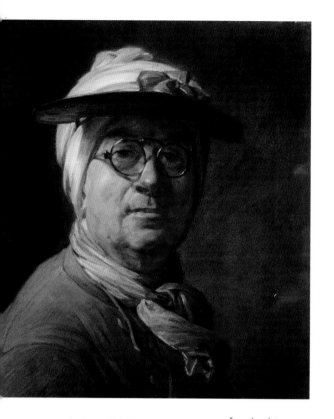

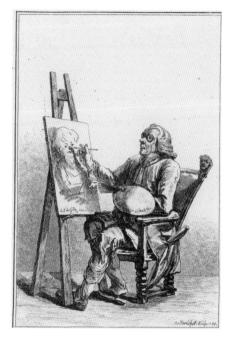

∧ > **ANOTHER RESOURCE** for the history of the most functional eyewear in the eighteenth century is in the portraits of artists. Jean-Siméon Chardin, who had issues with his eyesight from using lead-based paints, rather audaciously made his wire-rimmed spectacles the focal point of a self-portrait. The painting captures the reflective silver metal of the frames and the rounded tops of the screws that secure the temples. The temples disappear into the artist's headdress, which helped to secure the spectacles. These glasses in combination with a visor to reduce eyestrain allowed Chardin to sustain his work as he evolved from a genre painter into a portraitist in eighteenth-century France.

The association of artist with eyeglasses was so strong that in Joseph Franz Freiherr von Goez's series titled *Exercises d'imagination de differens caractères et formes humaines inventés peints et dessinés par JF de Goez, Suite 1* (Imagination exercises of different characters and human forms invented painted and drawn by JF de Goez, Suite 1), the artist portrayed his painter in thick-framed spectacles. Von Goez's spectacles are exaggerated bow spectacles, seemingly without

temples, which suggests they may be more about portraying the cliché of eyeglasses than accurately documenting any specific artist's practice.

Franz Jakob Joseft Ignatz von Predl portrayed what one must assume to be the quite visually demanding profession of miniature painter with eyewear in place as well. The miniaturist's eyeglasses are in the shape of bow spectacles, but they are finely drawn, with a lightness of both spectacle frames and temples ending in a ring, which reflects the increasing delicacy of metal frames by the end of the eighteenth century.

By 1823, Abraham Girardet's self-portrait in eyeglasses is able to show the improvements in fit over the face of the artist, with the connection of frame to temple crisply rendered. [(Left) *Self-Portrait with a Visor*. Jean-Siméon Chardin, ca. 1776. (Center Left) *Schilder zittend op een stoel achter zijn ezel* (Painter sitting on a chair behind his easel). Robert Brichet after Joseph Franz Freiherr von Goez, 1784. (Center Right) *Portrait of an Artist Sketching a Portrait Miniature*. Franz Jakob Josef Ignatz von Predl, 1799. (Right) *Portrait of Abraham Girardet*. Pierre Michel Adam after Abraham Girardet, ca. 1823.]

THE

LAM

POONED

LENS

·3·

Satirists Examine Eyewear and Eyeglass Wearers

At the end of the eighteenth century, the abundance of options for seeing meant that the science and the art of eyewear jostled for supremacy. The affectations of people of fashion for handheld eyeglasses, especially when wielded with a flourish by those who might not need improvement to their vision, drew the gimlet eye of satirists. By the early nineteenth century, those satirists offered an additional historical record of fashionable eyeglass design. In it, spyglasses, scissors glasses, and the quizzing glass were treated with derision, particularly when used by men. Those ornate glasses were the province of doughy old letches and dubiously qualified lawyers. While the science of optometry proposed an unimpeachably functional, steely clean aesthetic for spectacles, satirists poked holes in the pretension of luxe-eyeglass enthusiasts.

> **THIS CARICATURE** showing the earl of Derby and his then mistress, Elizabeth Farren, walking together inspecting pictures at James Christie's aptly illustrates the use of the spyglass or prospect glass. That these were the height of fashion is illustrated by featuring the glass in the hands of Elizabeth Farren. Farren was one of the leading actresses of her generation and had played numerous starring roles in the London theater. The need for the spyglass is also illustrated by the mode of art display at the end of the eighteenth century.

The paintings were typically hung all the way up to the ceiling, and some of the higher ones could potentially be out of sight without the assistance of a spyglass. Caricaturist James Gillray's reduction of Farren to the earl's "Nimeny-pimeney" (a reference to a role she had played some years earlier) notwithstanding, the earl married her the following year. [*A Peep at Christies;-or-Tally-ho & His Nimeny-pimeney taking the Morning Lounge*. James Gillray, September 24, 1796.]

Within the first few decades of the nineteenth century, eyewear for women and men came to occupy separate spheres. Spectacles were for the serious; handheld eyeglasses were frivolous and feminine. This split was the origin of the myth that women, and by extension fashion, were opposed to eyewear in all forms. That it wasn't true is immediately clear from women's fashion plates throughout the nineteenth century. They consistently depict handheld eyeglasses for women as a part of the elegant ensemble for day or evening. Handheld eyeglasses persist as a continuation of eighteenth-century luxury eyewear accessories, such as spyglasses and scissors glasses. Only spectacles were excluded from the fashion plate — and emphatically so.

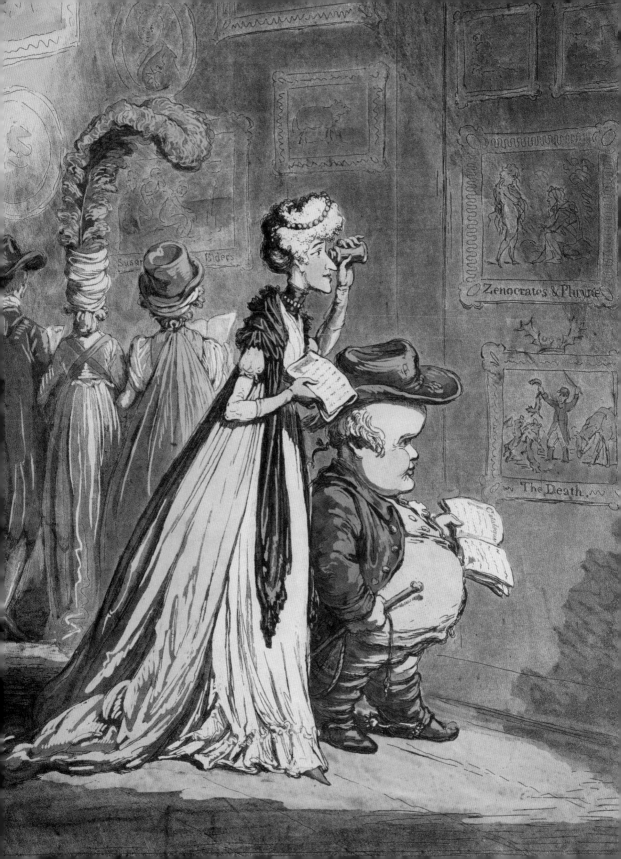

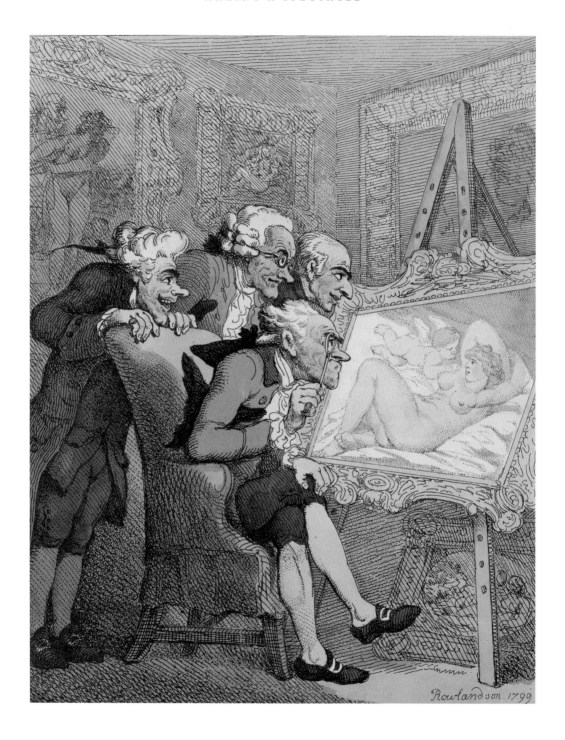

< ∨ **THOUGH BOTH** regarded fashionable society, the contrast between the satirical print and the fashion plate at the end of the eighteenth century was quite marked. In his satirical print of 1799, Thomas Rowlandson took a jaundiced view of society "connoisseurs" and their leering through eyeglasses at a rounded, nude Venus. The lipless gentleman at the center of the composition is particularly unappealing with his doughy skin and receding hairline, and he ogles through a quizzing glass. This was not a coincidence. The expensively appointed but old-fashioned powdered hair, the wig bags, the chapeau bras, were all indicators that these men were out of fashion. They were aging macaronis, who had been men of fashion in the 1770s, but now were just old. Men's use of the quizzing glass and other handheld eyeglasses was being made the hallmark of old age as well as unearned artistic pretentiousness.

At very nearly the same moment, a pair of scissors glasses were a highlighted accessory in a fashion plate from the *Journal des Dames et des Modes*. The illustrations, called Costumes Parisiens, were a form of reportage observed in ballrooms and other fashionable sites for publication. This particular ensemble was documented at the Théâtre Italien in Paris. The scissors glasses, held partly closed in an impossibly tiny hand, are part of a suite of fashionable accessories, including a turban atop aggressively cropped hair, a spencer decorated after Algerian motives, and a

reticule with a pair of cherubs. Observed by the artist from behind, the fashion plate is deferential and dispassionate. It also marks the moment when the kind of fashionable pose or attitude that was so effectively evoked with a pair of scissors glasses or the quizzing glass was cast as a decidedly feminine mode. [(Left) *Connoisseurs*. Thomas Rowlandson, June 20, 1799. (Below) Fashion plate from the *Journal des Dames et des Modes*. Costumes Parisiens, November 1, 1798.]

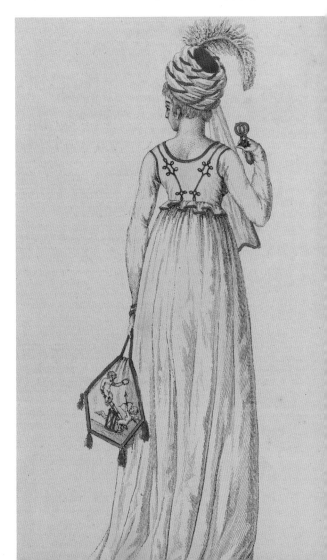

< > **A PAIR OF WIRE "GLASSES"** made solely for the Chanel runway in 1996 show the fashionable prerogative for the purely decorative in eyewear, but the origins of this ideal date back to the eighteenth-century phenomenon of scissors glasses. The general form, which appeared around 1750, was two framed eyeglass lenses held by a handle that had to be positioned directly in front of the mouth. Scissors glasses were the subject of immediate derision and often used in the face of accusation that they were embraced for fashion's sake rather than for visual assistance, but that did not impede their popularity. They could be relatively simple, as in the pair shown in Rowlandson's satirical print of aspiring Egyptologists, or they could be jeweled and ornate. The fashion for scissors glasses peaked in Paris in the late 1790s, and they were particularly associated with the Incroyables, a resurgent group of aristocrats who dressed in resistance to the values of the French Revolution with overtly luxurious style and unapologetic pretentiousness. By 1805, the fad for scissors glasses was fading, especially since the wearers might have trouble seeing and making themselves heard at the same time. A few years later, scissors glasses would become a clear marker of someone hopelessly out of fashion. [(Left) House of Chanel runway. Photograph by Guy Marineau, 1996. (Right) *Antiquarians à la Greque*. Thomas Rowlandson, July 14, 1805.]

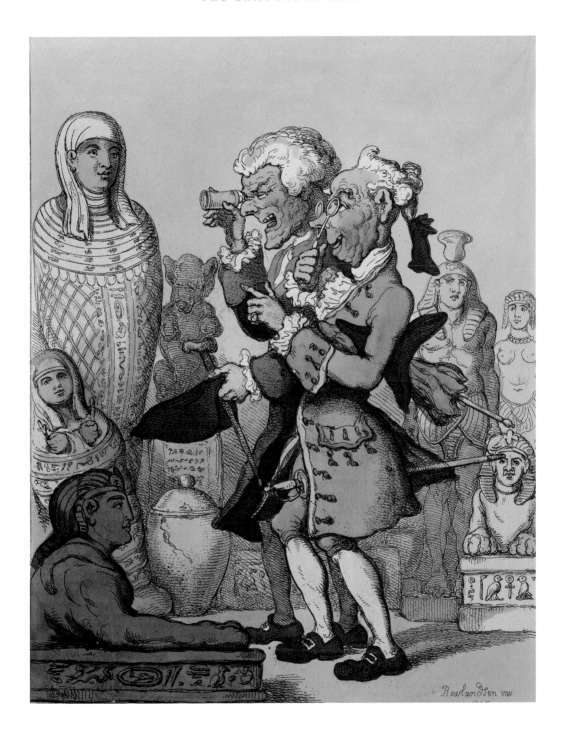

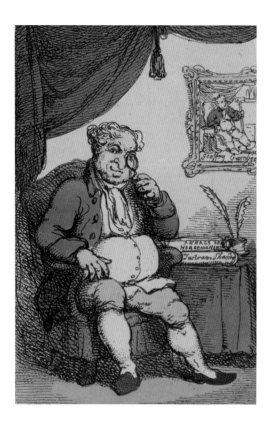

∧ > THE QUIZZING GLASS was the eighteenth- and early nineteenth-century name for a handled single eyeglass. The form had been in use since the thirteenth century, which is confirmed in its appearance in a sculpture of Hippocrates from that period. In the seventeenth century, the quizzing glass had traveled in aristocratic circles under the name *perspective glass*. Though it was not a technologically innovative instrument like the various multilensed miniature lorgnettes of the eighteenth century, the quizzing glass was significantly popular in society settings and in their observance by satirists. Its appeal was

likely the same as that of scissors glasses: it could be used with an attitude.

Typically worn on a long black silk cord or ribbon, the quizzing glass was a masculine style associated with the early nineteenth-century figure of the dandy. Depending on the source consulted, the dandy was either a man of highly refined fashionable taste or a man whose cultivation of his own physical appearance could safely be deemed perverse. Either way, the presumption of the right to observe and judge the world around was in the dandy's purview, as those who made the most social success of the pose, such as Beau Brummell, were also acknowledged tastemakers in the early nineteenth century. In his *Portrait of Caleb Quizem, Esq.*, the satirist Thomas Rowlandson looks back at the wielder of the quizzing glass, who is probably his friend and fellow satirical print artist George Moutard Woodward. Though no dandy, Woodward does embody the judgmental eye behind the quizzing glass. A fashion plate of a few years earlier offers a more dandified and perhaps more benign hand on the glass. In the fashion plate, the quizzing glass is a clear component of the fashionable attitude, an elegant exclamation point atop well-polished boots, closely cut trousers, a mildly menacing riding crop, a tight-waisted coat, a raffishly looped cravat, and aggressively groomed sideburns. [(Left) *Portrait of Caleb Quizem, Esq.* Thomas Rowlandson, 1809. (Right) Fashion plate, 1806.]

∧ **THIS CRISPLY SEERSUCKERED** groundskeeper from Thom Browne's spring/summer 2015 menswear presentation clears the field for the models to come in a mask-like pair of shades that obscure his evaluation of the proceedings with the appropriate dispassion of a dandy. These frames were inspired by a July 1967 *Vogue* cover featuring Twiggy with a flower body-painted over her eye. The flowers of the 1960s were wrought for Browne's runway as metallic cut-out flower silhouettes strung on thin gold-colored wire. [Thom Browne runway, 2015.]

∨ > **FIRST PATENTED** and promoted in the 1720s, temple glasses introduced temples (also called side pieces or arms) to secure spectacles. The optician Edward Scarlett of London is generally credited with the earliest advertisement for what were called temple spectacles. Scarlett's spectacles had spiraling curls at their ends to grip the head, but a temple concluding in a ring became more common in the eighteenth century. Riding temples were developed in the 1720s as well, and they featured an arm that curled around the ears for more definite security during any exertion. Early temple spectacles were made of steel and reflected the optician's concern for improved vision over the jeweler's expressions of wealth and style that dominated

fashionable eyewear in the eighteenth century.

Thomas Rowlandson provides a picture of temple spectacles in society in his 1802 print *How to Pluck a Goose*. A fashionably dressed, though distinctly unappetizing, trio of women are portrayed on the cusp of gaming a young military officer out of some coin. The women wear high-style clothing and accessories but are simultaneously showing the frayed edges of their age. The woman at left wears a modish, dark coiffure, but spiky tufts of gray hair peak out underneath the wig. The woman at the center sports a massive feathered turban but has only a single, lonely tooth in her mouth. The woman at right wears a dress with a fashionable décolleté that reveals a

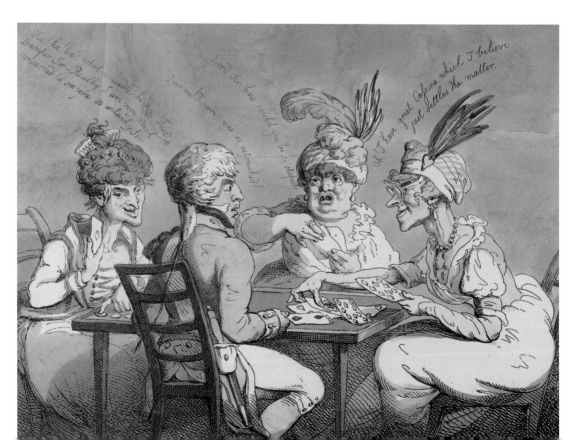

soggy, fallen bosom. In short, the women are old. And the spectacles worn by the woman at right could be interpreted as just another expression of age and its depredations. It is to be noted, however, that the woman in spectacles is just about to fleece the soldier. The eyeglasses reveal her age but reflect her cunning. That cunning was frowned upon in women at the beginnings of (and, honestly, for most of) the nineteenth century. Women weren't even allowed to profit by gambling in public in the nineteenth century, and Rowlandson's uglification of these lady hustlers confirms his opprobrium. At the same time, spectacles are secure in their smartness. [*How to Pluck a Goose*. Thomas Rowlandson, June 10, 1802.]

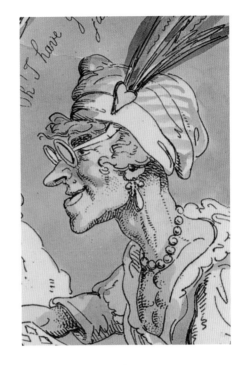

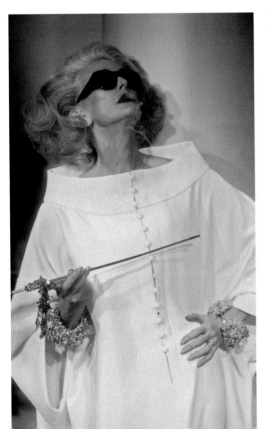

< ∧ **CARMEN DELL'OREFICE** was a successful model in the 1940s and 1950s who relaunched her career in 1978 and sustained it into the 2010s. Walking the catwalk for Thierry Mugler's spring/summer 1996 collection, Dell'Orefice swanned down the runway in several ensembles, but none so redolent of the wealth and privilege of a woman of a certain age as this voluminous white dress with oversized costume bracelets, a bedazzled cigarette holder, and an opaque mask of dark-framed sunglasses. Dell'Orefice realizes what Rowlandson's lady gambler only implies, which is eyewear as an armor capable of obscuring intentions as much as age. [(Left) Thierry Mugler runway. Photograph by Guy Marineau, 1996. (Right) Detail of *How to Pluck a Goose*. Thomas Rowlandson, June 10, 1802.]

∨ **THE GAME-CHANGING** fashionable iteration of sunglasses didn't emerge until the twentieth century, but other versions of the same tool predated that starting point considerably. Inuit and Yupik peoples were using slit eyewear to block the glare of their snowy landscape at least two thousand years ago. There is documentation of the use of a smoky, "tea stone" quartz for eyeglasses in China around the same time. Colored protective lenses emerged much later in Europe, around the seventeenth century, and they began to be promoted by opticians in the middle of the eighteenth century. Green lenses were the first to become popular, though blue lenses were also an option, and they gained a foothold in part because of an association with a life outdoors rather than the circumscription of spectacles for book-bound presbyopics. By the end of the eighteenth century, J. R. Richardson had invented a hinged colored-lens attachment for corrective lenses. This pair of glasses, probably Dutch from the 1830s or 1840s, were forged in silver and feature a modified, scalloped ring at the terminus of the temples. [Glasses with silver frame and round, green lenses, ca. 1835.]

∨ **THIS MINIATURE** portrait of Sir Joshua Reynolds by Thomas Peat illustrates the use of upturned temples, such as those also seen on Rowlandson's lady cardplayer, as opposed to spiral or ring temples. The miniature was based on Sir Joshua Reynolds's self-portrait of 1788, one year before he lost sight in his left eye. [*Sir Joshua Reynolds*. Thomas Peat, 1792.]

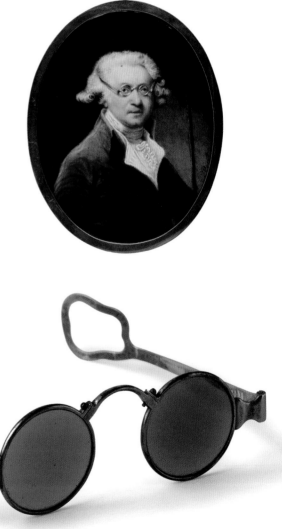

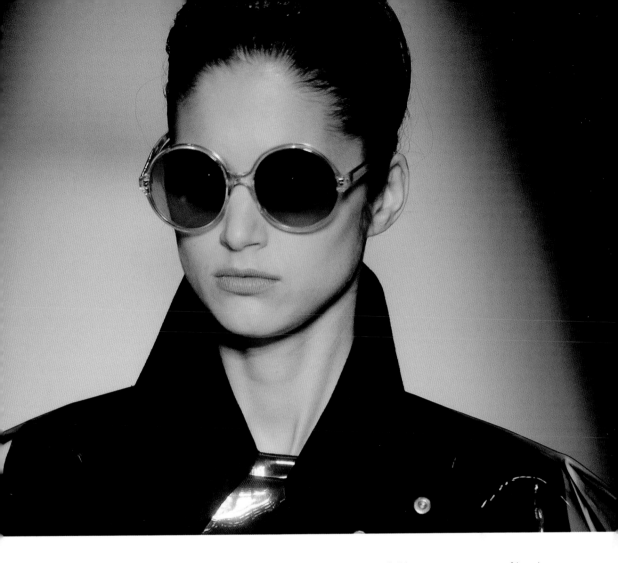

∧ **IN STEPHANO PILATI'S** collection for Yves Saint Laurent in fall/winter 2010, a pair of bottle-green-lens glasses evoking the nineteenth century were featured in a runway presentation that was heavy on the color black and transparent mozzetta capes, among other ecclesiastical motives. The designer's report to *Vogue* that it was "about protection" makes the choice of green lenses logical. Before the invention of polarized lenses in the twentieth century, tinted glass was primarily intended to calm the eye. Through a larger frame, the runway sunglasses echo the simplicity of nineteenth-century spectacles with straight temples that bisect the frame sides at the midpoint. These construction elements were improved and then nearly refined out of existence through the mid-twentieth century, until fashion designers revived them for purely aesthetic purposes. [Yves Saint Laurent runway, 2010.]

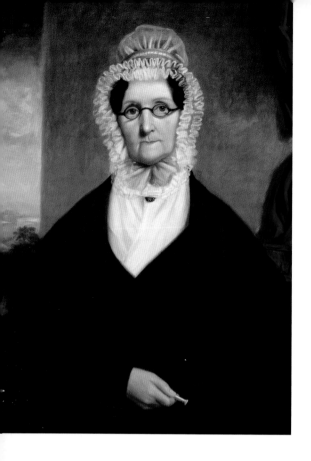

∧ > **THE** consistently written truism of fashionable spectacles for women in the nineteenth century is that there was no such thing. A survey of American and European portraiture tends to bear this out. When spectacles are seen, they tend to be worn by older women, as in this portrait of Catherine Brooks Hall by Shepard Alonzo Mount. She is not a fashionable figure, but rather dressed in black with jet jewelry, which indicates a widow in a state of mourning. A flashy pair of gold scissors glasses would be no more appropriate with such an ensemble than would an emerald tiara. Instead, she wears what look to be horn-rimmed glasses with small oval lenses. She

also holds in her hand a stylus. This device would have been easily recognizable in 1830 as the tool of an accomplished needleworker. Though Hall was not a professional artist, her portrayal with glasses and the tool of her favored work continues the fine art tradition of the portrait of the artist in spectacles. With that acknowledged, the idea of eyeglasses as the purview of only socially disregarded older women, then, is too reductive. Spectacles continue to evoke fine hand skills and creative ability, even on ladies.

A fashion plate from around the same moment as Ms. Hall's portrait further gives the lie to the idea that women went without glasses in the nineteenth century. In a review of fashion plates from the period, handheld eyeglasses pop up again and again as part of the ensembles in the Costumes Parisiens. While spectacles are never seen, eyewear such as the small pair of scissors glasses seen in the plate are a fashionable accessory as crucial as the Italian straw hat, the jewelry on the ears and wrists, the oval-buckled belt, the pristine white gloves, and the square-toed shoes. Though handheld eyeglasses were almost entirely eliminated for men in 1829, women continued to consume them as an amalgamation of fine jewelry and medical necessity. [(Above) *Catherine Brooks Hall*. Shepard Alonzo Mount, ca. 1830. (Right) Fashion plate, *Journal des Dames et des Modes*, Costumes Parisiens (2714): Chapeau de paille (…) (Straw hat…). Anonymous, July 31, 1829.]

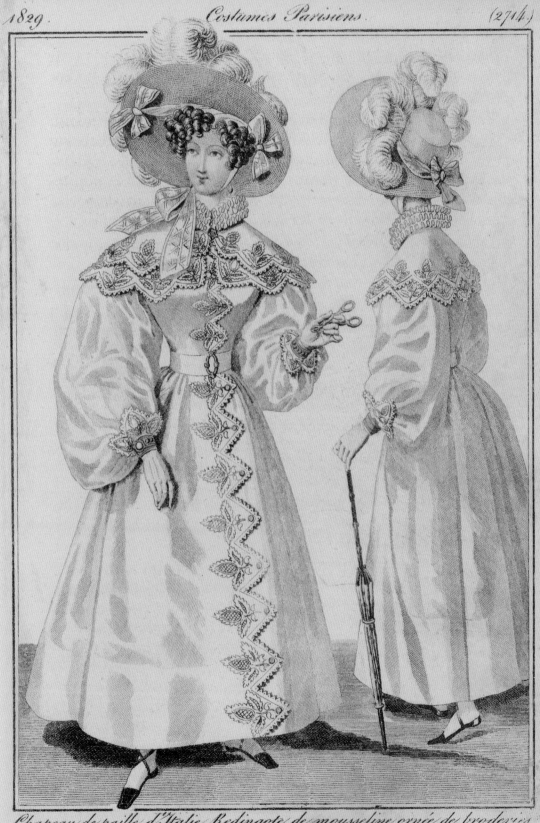

Chapeau de paille d'Italie. Redingote de mousseline, ornée de broderies bordée d'une petite dentelle et fermée par des boutons d'or.

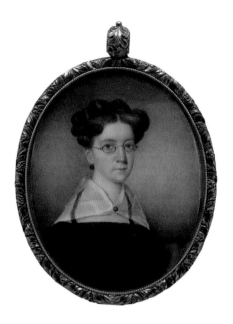

∧ **THIS LOVING** miniature, *Portrait of a Lady*, from the Metropolitan Museum of Art's American Wing captures a young woman in watercolor on ivory. A miniature was carried as a memento of a loved one and might portray the living or the dead. Before there were photographic portraits, miniatures were the dominant form of commemorative image. This lady is also one of the rare young women in spectacles in the museum's portrait collection. Her eyeglasses, crisply rendered despite the small size of the image, shows the ongoing technical refinements to spectacles in the nineteenth century. These wire-rimmed glasses are lighter and clearer as innovations in metal and glass work allow, with hinges and careful fitting around the bridge of the nose apparent. [*Portrait of a Lady*, ca. 1835.]

> **DESPITE ONGOING** technical innovation, the fashionable eyewear stays in the hand, as recorded in 1830s fashion plates. The figure at left holds the most popular form of eyeglass for women through the nineteenth century, the lorgnette. The lorgnette was not to be confused with the miniature lorgnettes of the eighteenth century, which were essentially tiny spyglasses. Rather, the lorgnette was an evolution of the eighteenth-century macaroni's scissors glasses that had the handle moved off to the side of the frames. It was a rare nod to practicality for women's eyewear that the handle did not need to be held directly over the lips when in use. [Fashion plate, *La Mode*, Chapeau de crêpe doublé — Robes (…) (Hat of lined crepe—Dresses…). Jean Denis Nargeot, after Louis Marie Lanté, April 5, 1834, plate 366.]

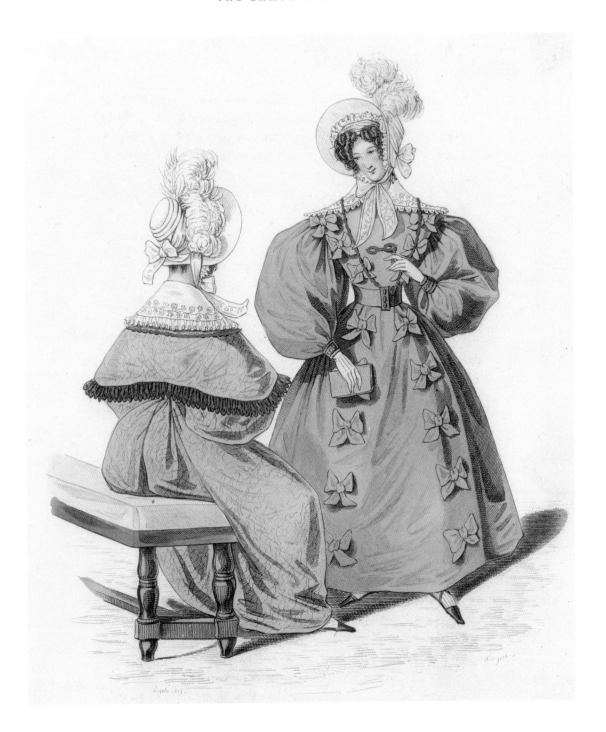

THE

SPOR

TING

LENS

·4·

Men's Nineteenth-Century Eyewear

Of course, the idea that men (and by extension their spectacles) were not a part of the fashion system in the nineteenth century is fundamentally false. The subtle but expansive set of metal frame styles evident in men's portraiture from the era confirms fashion was in play when men visited the optician. In the nineteenth century, distinction in menswear was finely drawn but carefully cultivated. In particular, elegant, purpose-built eyewear was integral to the sporting life, which already had a full set of wardrobe requirements. A review of spending habits of the nineteenth-century upper crust shows that society men and women had equally substantial budgets for clothing. The difference was in the vendors (men went to tailors instead of dressmakers). Men's evening wear was fairly uniform, but there also had to be bespoke ensembles for all manner of aristocratic enthusiasms — hunting, shooting, riding. Every

endeavor had its own specific outfit and specific glasses. Men's sporting life also made room for niche protective eyewear, which was repurposed from lower-class men's industrial work to suit gentlemen's adventures, such as arctic exploration. And through these evolving functional styles, men embraced and encouraged the march of technical innovation in spectacles in the nineteenth century.

Specific refinements in the construction of eyeglasses can be traced through paintings, drawings, photographs, and extant examples of nineteenth-century eyewear, a substantial amount of which survive. As early as the 1830s, the temples of glasses became adjustable, extendable, padded, or curled, all in an effort to perfect wearability. Bridges, screws, pads, lenses, and rims were similarly adjusted and reinvented. These granular technical refinements made eyewear's functionality and emerging fashionableness one and the same. Invisibility, the ideal in eyewear at the beginning of the nineteenth century, was no longer the goal with men's spectacles by the mid- to late nineteenth century. This is increasingly apparent in photographic portraits from the period, in which spectacles reassert themselves as props. Along with a book and a sober suit, glasses were integral to the stories nineteenth-century men chose to tell about themselves in their photographic portraits. As the perfected function of eyeglasses was in sight, so to speak, their styling had begun to reassert itself as a crucial selling point.

> **WHILE SOCIETY WOMEN** were limited to lorgnettes, Victorian men could style a range of spectacles and still evince an appetizingly modest form of handsome. This carte de visite captures British watercolorist William Collingwood Smith in his pair of small oval wire-rimmed glasses. His checked trousers, crisp frock coat, and dotted necktie all suggest fashionable engagement while his tousled curls give a hint of bohemian insouciance. And his eyewear detracts from none of it. Smith was a highly successful artist, especially through publication of his work in the *Illustrated London News*, the first illustrated weekly news magazine and therefore a new media phenomenon of the Victorian era. Wire-rimmed spectacles such as Smith's were increasingly available as industrial production methods, such as steam-powered machines to cast and polish lenses and mechanically drawn wire to construct frames, became widely used. [*Collingwood Smith*. John and Charles Watkins, 1860s.]

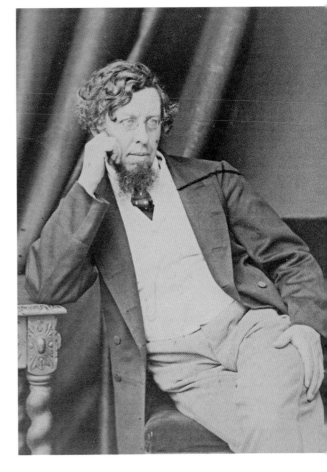

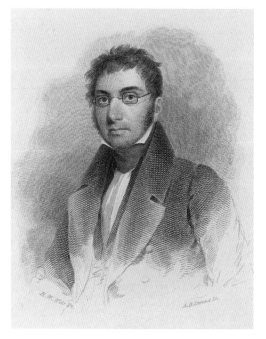 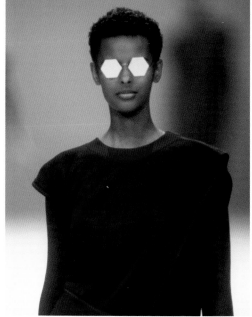

∧ **ONE OF THE HALLMARKS** of industrialization as an aesthetic was crisp edges, and this applied to eyewear as much as anything else. Oval and rectangular glasses were patented by Dudley Adams in 1797, and he patented octagonal frames a bit later. The octagonal frames seen in this portrait of Knickerbocker school writer and editor Robert C. Sands were meant to offer superior fit as well as the best possible corrective ability. Some eyeglass history suggests that octagonal frames were the most invisible, though that is certainly not the case in this engraving, where the frames are assertively rendered.

In his spring/summer 1992 runway presentation, Issey Miyake sent a series of models down the runway in sharp, hexagonal-lensed eyeglasses that were mirrored and multihued. As a designer, Miyake self-consciously aligned with technological innovation over the course of his career. It follows that, in a collection that featured a knapsack that unfolded into a jacket as well as the designer's signature permanent pleats, which were part of the runway presentation and would be formally patented by Miyake in 1993, the eyewear would lean toward the "techspressive." Wire, micro-thin glass, and crisp geometry became shorthand terms for the supermodern in eyewear at the beginning of the nineteenth century and remained so through the twentieth. [(Left) *Robert C. Sands.* Asher Brown Durand, ca. 1829. (Right) Issey Miyake runway. Photograph by Guy Marineau, 1992.]

∨ **THE NINETEENTH** century was an era of separate spheres for men and women. While women were limited to handheld eyeglasses in public life, spectacles were an essential and evocative part of the menswear wardrobe, multiplying in form and function as they took on varying roles for varying men. A joke of the optical trade in the eighteenth century was that a banker, lawyer, judge, or other man of letters could add five dollars an hour to his wages with the purchase of a pair of spectacles.

As much as the morays of nineteenth-century tastemakers sanctified the ideal of

separate spheres for men and women in their wardrobes and every other aspect of their lives in the Victorian era, French fashion designer Jean Paul Gaultier upended and destroyed those separations in his decades-long fashion career. Among the first fashion designers to put men and women together on the runway, Gaultier freely mixed elements of menswear and womenswear in his work. His playfully perverse businesswoman sports a big cigar, a cliché of the financially successful gentleman, along with a pair of oval sunglasses that hybridize several eyewear elements in an interplay of (continued on next page…)

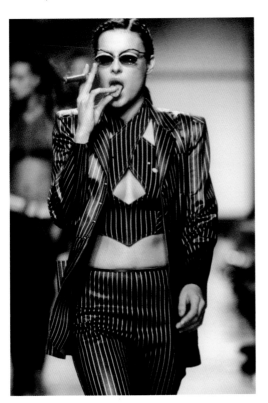

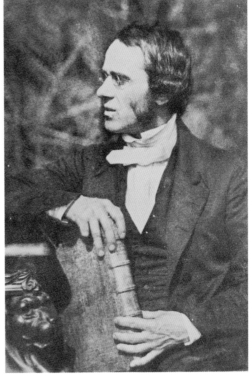

masculine and feminine topping a fetish-slick pinstriped suit. Meanwhile, a man in brown pinstripes and carrying a purse followed on her heels on the runway.

Gaultier's eyewear accessorizing plays on the connection between the professional man and his glasses that was illustrated photographically at the very birth of that medium. This salted-paper print of the Reverend Dr. Andrew Sutherland is both a fine example of the beginnings of photographic portraiture as well as a fine example of its early clichés. The dark suit, the heavy book, the wire-rimmed glasses, and the contemplative gaze are all typical features of early photographic portraits of men with Reverend or Dr. or both in their title. [(Previous page, Left) Jean Paul Gaultier runway. Photograph by Guy Marineau, 1996. (Previous page, Right) *The Reverend Dr. Andrew Sutherland.* Photograph by Hill and Adamson Photography Studio, 1843–47.]

∨ **LORD LEIGHTON'S** portrait of author William Makepeace Thackeray captures in brief the lightness that eighteenth-century warhorse-temple spectacle frames could now have, thanks to the introduction of steel wire and thinner, lighter lenses. [William Makepeace Thackeray, in *Sketch Book with Drawings on Twenty-Six Leaves.* Frederic, Lord Leighton, ca. 1850.]

> **THE IMMENSE** technological innovation in eyewear manufacture in the nineteenth century made the ideal of invisible glasses almost possible. As early as 1825, rimless lenses were perfected in Vienna using small drilled holes to attach bridge and temples to lenses that were otherwise unframed by wire. The lightness of drawn wire made near invisibility possible, especially as less glossy or shiny metals were used in the creation of spectacle frames. In Charles Loring Elliot's portrait of the photographer Mathew B. Brady, we see an example of the lightest and most nearly invisible spectacles that were possible in the mid-nineteenth century. Wire-rimmed spectacles also feature in a photograph taken by Brady in the same year as the Elliot portrait was painted. The photo shows an unknown man wearing lenses of a heavier metal frame. With this ink-retouched salted-paper print, as with the print of the Reverend Dr. Andrew Sutherland, we see a portrait where spectacles are used, not only because they are likely needed by and associated with the person in the portrait, but also because they have a style element that adds to the overall impression of the man. It is likely that it was not lost on either the photographer Brady or the gentleman in the photograph that the heavier-framed spectacles bisect the sitter's face between the high forelock and the low beard quite perfectly, expressing as much stylish intent on the subject's part as the asymmetrically sloped cravat. [(Top) *Mathew B. Brady.* Charles Loring Elliott, 1857. (Bottom) *Portrait of a Man.* Photograph by Mathew B. Brady, ca. 1857.]

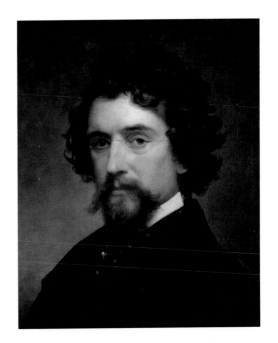

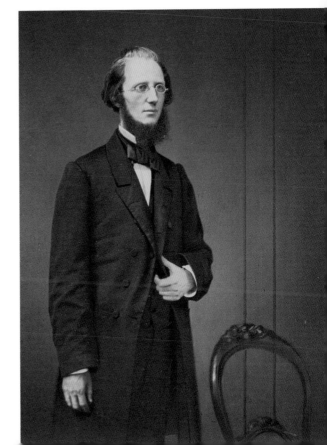

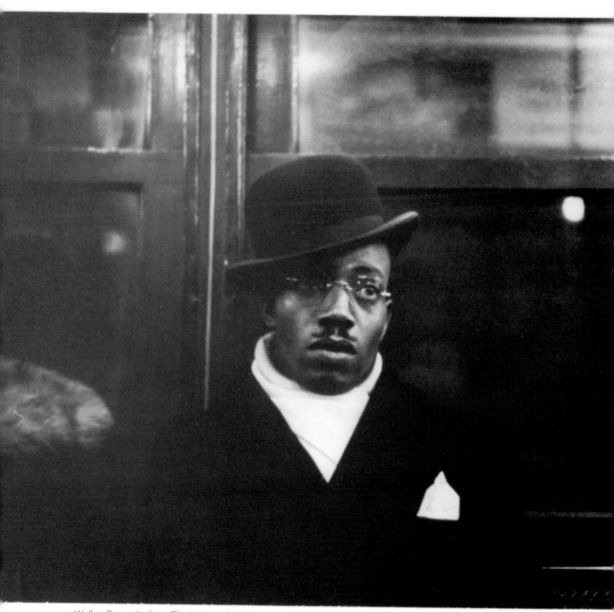

< **THE IDEAL** of eyeglasses as the elegant-gentleman's prerogative persists from the nineteenth century onward. In a 1941 subway photograph taken by Walker Evans, a rimless pair of glasses with crisp, rectilinear hardware at the temples and bridge completes a highly composed ensemble where the curves of the mustache are copied in the brim of the canted bowler hat, and the pocket square and neck scarf seem to point to one another. Though Evans took his photographs in secret with a camera hidden inside his coat, this unknowing sitter still evinced the dandiacal sangfroid to which fashion models aspire. [*Subway Portrait.* Photograph by Walker Evans, 1941.]

I'LL SEE YOU

AT

THE

OPERA

·5·

Opera Glasses and Jeweled Eyeglasses
in the Nineteenth Century

Handheld eyeglasses continued to be a component of the fashionable woman's wardrobe, as is evident in fashion plates of the nineteenth century. Early in the century, scissors glasses appeared with ball gowns and day dresses alike. By the 1820s, the handle of the scissors glasses moved to one side, and they became the lorgnette, a pair of lenses mounted to a handle. In 1825, Robert Brettell Bate patented a pair of frames that folded into their handle, and the dominant high-style eyewear for women's evening dress was cemented for the remainder of the nineteenth century. At the same time, the eighteenth-century miniature lorgnette for the opera was replaced by "double-spyglasses," or binoculars. These ever more luxe handhelds found a venue at the opera, with sales of opera glasses boosting the optical-glass industry during the first half of the nineteenth century.

In women's evening wear, the ideal of eyewear as jewelry was refined as women's eyeglasses took the form of pendant jewelry quizzing glasses and lorgnette worn on a chain folded into a handle of gold filigree or other precious materials. Jewelers competed or collaborated with opticians to develop more elegant eyeglasses that could be worn as jewelry when not in use for vision. Some optical manufacturers started as jewelers, as was the case with one of the founders of American Optical, one of the dominating eyewear concerns over much of the twentieth century. The precision metal work and technical expertise that eyewear required befit the skills of jewelers.

By the late nineteenth century, eyewear in all its forms was secure in the retail firmament of the urban centers of Europe and the United States. Indeed, as fashion's audience expanded and democratized, so did the market for fashionable eyewear. The success was twofold. The increasing improvement of eyewear design and its undeniable usefulness were one part of the story. Spectacles were no longer an unwieldy mask strapped rigid and flat onto the curves of the face. And they were no longer randomly matched to eyes that might not be well served by the lenses' particular power or lack thereof. These problems had been resolved. The other element of the success of eyeglasses was the instant character they offered. Each particular type of eyewear had taken on meaning over decades of learned associations. There were glasses that meant hunting, that meant driving, that meant exploration, that meant cultivation, that meant erudition, that meant elegance, that meant introversion, that meant flirtation, that meant penetration. There was a storytelling potential to eyeglasses by the beginning of the twentieth century. Identity (as much as fabric and silhouette) is the medium of fashion. And eyeglasses offered an immediate shorthand to the modern identity.

AUJOURD'HUI

31 X^bre 1839

JOURNAL DES MODES RIDICULES

2^me ANNÉE

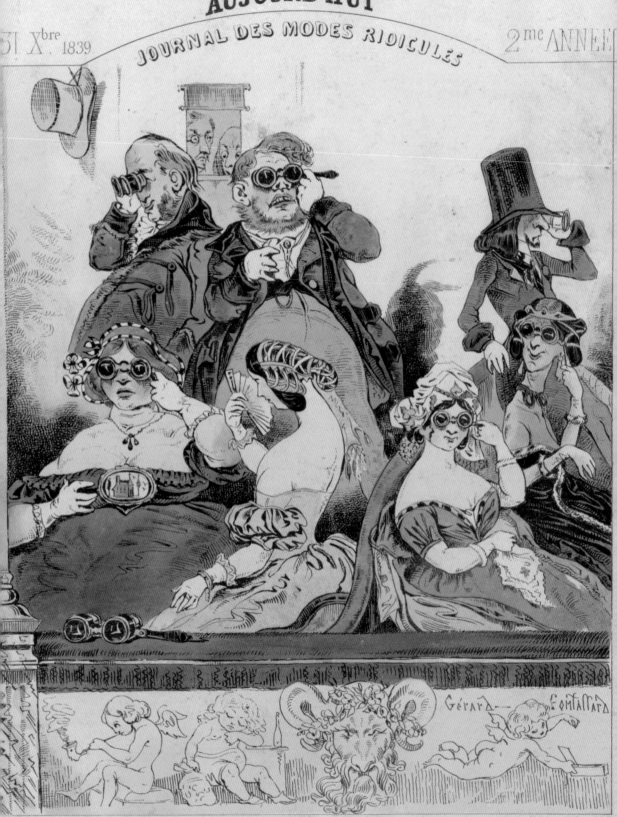

Gérard Fontallard

Im. de Lemercier Benard et C^ie

< **PRINT MAKER** and caricaturist Henri-Gérard Fontallard captures the unisex nature and unbridled pretension of opera glasses in the mid-nineteenth century. Opera glasses were elegantly appointed binoculars that replaced the miniature lorgnette of the eighteenth century. An optically effective design for opera glasses was established by 1823, and their sales helped lift the trade in optical glass as a whole. Fontallard's satirical take on the matter was that opera glasses were the second coming of the morally dubious jealousy glass. With an emphasis on its function as much as its fashionability, the caption for this image refers to the opera glasses as instruments of slander and backbiting, mainly intended for the wielders to see the mote in their neighbor's eye without examining the beam in their own. The image shows two rather substantial older gentlemen looking anywhere but the stage with their opera glasses, while a slender dandy uses the spyglass (though it would have been considered outdated by 1839). Three of the four ladies are equally distracted by their amplified vision, while the young beauty in blue has set her opera glasses aside, perhaps the better to be observed. The opera glasses are only the first among many fashion trends observed in the biting satirical print, including the fads for impressively cultivated facial hair, complicated turbans, bare shoulders, and ample bosoms. [(Previous page) *L'artillerie du binocle, Aujourd'hui: Journal des Modes Ridicules.* Henri-Gérard Fontallard, 1839.]

> **THESE NINETEENTH-CENTURY** opera glasses are highlighted by a decorative exterior of tortoiseshell, a material that would come to feature heavily in the production of eyeglasses in the coming century. Though the use of tortoiseshell dates back to ancient Greece, it was popularized as an inlay for luxury objects by the cabinetmakers of the court of Louis XIV, whose work was seen as the gold standard in the aspirational taste of the industrialist arrivistes in the late nineteenth century. Tortoiseshell was a natural material to use on opera glasses. It suggested luxury and refinement but was easily appended to the various accessories of bourgeois theatergoers, transforming a mere implement into a middle-class luxury object.

Though best known for his interest in the world of the ballet, Edgar Degas engaged with the opera as well. In his painting *The Ballet from "Robert le Diable,"* Degas depicts the late nineteenth-century phenomenon of the opera as popular culture with a man looking not at the stage but at the audience. As a well-known painter of contemporary life, especially scenes from the theater and the ballet, Degas surely made extensive use of opera glasses in his observations, especially considering that his eyesight had been found to be defective during his time in the National Guard during the Franco-Prussian War. [(Top Right) Opera glasses, mid- to late nineteenth century. (Bottom Right) *The Ballet from "Robert le Diable."* Edgar Degas, 1871.]

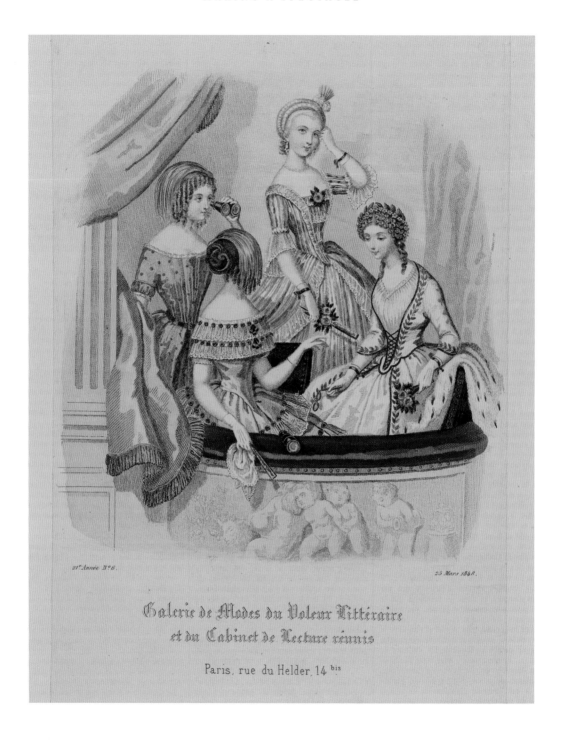

21ᵉ Année N°6.

25 Mars 1848.

Galerie de Modes du Voleur Littéraire
et du Cabinet de Lecture réunis

Paris, rue du Helder, 14 bis

< ∨ **THE VOGUE** for ornate opera glasses has a certain logic in the nineteenth century. The consumer culture of the era was driven, to some degree, by the fantasy of acquiring an aristocratic, eighteenth-century lifestyle, which was newly within reach to the middle class. Industrialization and mass production made Rococo accessories accessible beyond the courts of Europe.. Echoes of eighteenth-century styles are seen in an 1848 fashion plate set in the opera's exclusive box. The figure at the center sports powder-pale hair over a whitened complexion with the barest flash of rose in her cheeks, note for note copies of the facial ideal from about one hundred years earlier. Her dress follows the silhouette of the eighteenth-century *robe à*

l'anglaise. All the figures are clad in the chalky, candy colors of eighteenth-century Rococo. And while the woman at left holds a modern pair of opera glasses, even the antiquated spyglass makes an appearance, lying casually on the velvet-upholstered edge of the theater box alcove. An early twentieth-century pair of opera glasses by Cartier, which belonged to the American Mary Scott Townsend, were offered by the company in a full Rococo palate. Enamel colors ranged from light blue, lilac, reseda green, sea green, mauve, pink, gray green, to the blue gray seen here. [(Left) Fashion plate from *Galerie de Modes du Voleur Littéraire et du Cabinet de Lecture réunis*, fashion plate, 1848. (Below) Pair of opera glasses. Cartier Paris, 1911 (Cartier Collection)]

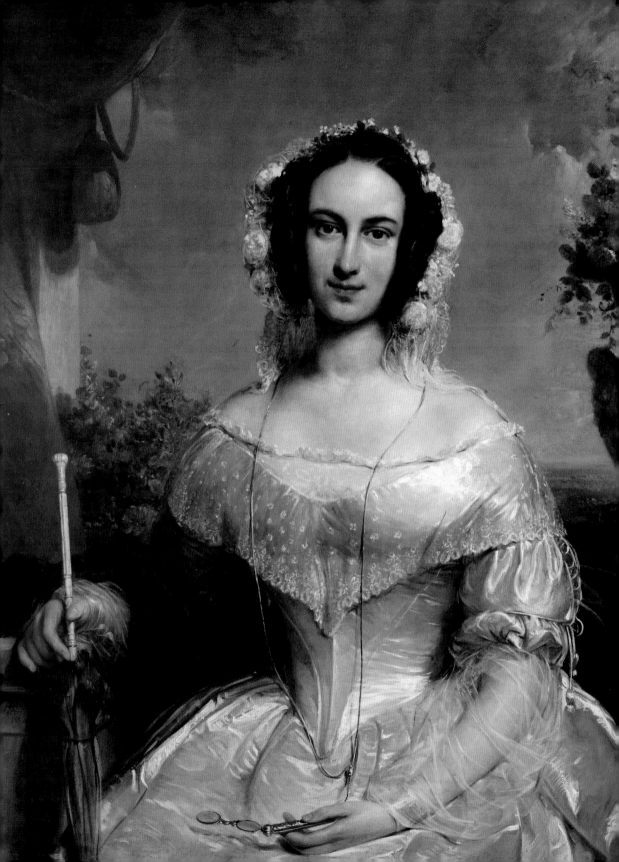

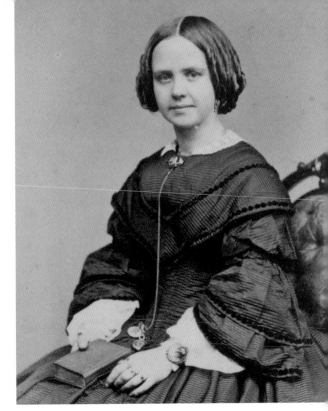

< > **WHILE OPTICIANS** sought to assert themselves in the eyewear trade as much as possible in the nineteenth century, the jewelry store was also a prime location for the purchase of eyewear. Around 1833, the jewelry-store owner William Beecher began successfully offering glasses in his shop and would go on to found American Optical, one of the giants of American eyewear manufacture. By 1887, the jeweler Cartier made its first lorgnette. In the portrait of Agatha Petronella Hartsen, we see an example of the high-style lorgnette as jewelry. Cradled in the hand of the sitter and complementing the gown's silk satin with its luster, the lorgnette's provenance as a fashionable accessory can be assumed from the context: this was Hartsen's wedding portrait on the eve of her marriage to Jan van der Hoop. The lorgnette is suspended from a finely wrought gold chain, which was the recommendation of fashion magazines in the nineteenth century. The hinge and opening groove of the gold case show that it is a folding lorgnette, a mechanism that was patented by Robert Brettell Bate in 1825. The sitter has chosen to open the lorgnette to reveal the spectacles, which would suggest that she wanted to be known as a wearer of eyeglasses.

A few decades later we see another young woman who has chosen to wear her glasses as a pendant charm in her portrait. Her eyeglasses are decidedly less ornate and more utilitarian than Hartsen's. They are close to

the book in her hand and secured with a cord attached to a brooch. Brooches, gold, and silver chains, silk cords, small reels, gold pencils, small timepieces, and lenses of varying magnifications could all be combined in the various eyeglasses that women wore as part of their dresses in the nineteenth century. Fashion magazines, especially in the late nineteenth century, devoted a considerable amount of text to the comings and goings of trends in these accessories to eyeglasses. They were a key part of the fashionable bodice, if not the fashionable face. [(Left) *Agatha Petronella Hartsen (1814–78)*. Jan Willem Pieneman, 1841. (Above) *Portrait of a seated young woman with a book on her lap*. Photograph by Peter Carstensen, ca. 1862.]

∧ **IN A TURN** from portraits to a genre painting, we can confirm the establishment of eyeglasses in the urban fashion firmament by the end of the nineteenth century. Giovanni Boldini was one of the most celebrated portrait painters in Paris in the late nineteenth century, and he remains one of the fashion historians' primary articulators of the period's grand style. In his scene of daily life, *The Dispatch-Bearer*, it is surely no accident that he has made the optician's shop the backdrop for his dramatic scene of a messenger's delivery. Though half a century later, Dorothy Parker would observe, "Men seldom make passes at girls who wear glasses," this image of Boldini's makes clear that the high style of eyewear is not particularly in question.

Above the optician's storefront in the painting are a pair of glasses of the style that would have been secured by a silk cord or gold chain offering one red lens and one blue one. Below the colored lenses, a second pair of oversized frames hang directly in the store's doorway. They are a simple pair of bow spectacles with rigid bridge and owlishly round frames. This simplified prototype of eyeglasses that dates back to 1600 is still the graphic icon of the eyewear trade centuries after its invention. [*The Dispatch-Bearer*. Giovanni Boldini, ca. 1879.]

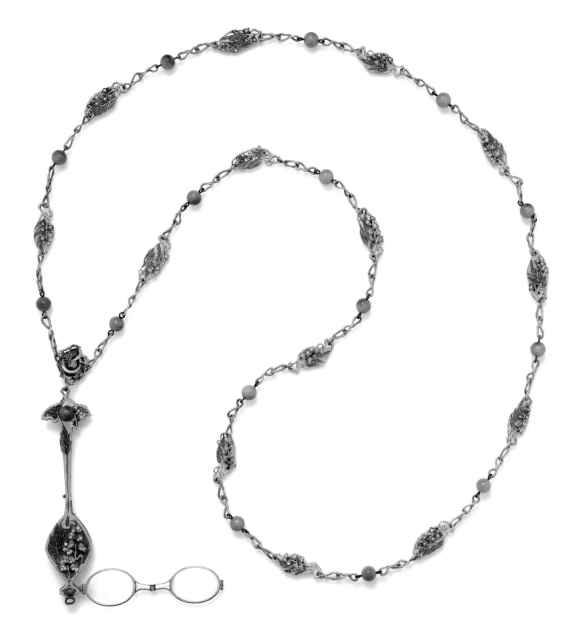

∧ **THIS PRISTINE** example of eyewear as jewelry was made of gold, enamel, diamonds, jade, and glass by René-Jules Lalique. The frames first folded in half before discreetly folding inside the protective and decorative pendant at the end of the chain. [Lorgnette and chain. René-Jules Lalique, ca. 1900.]

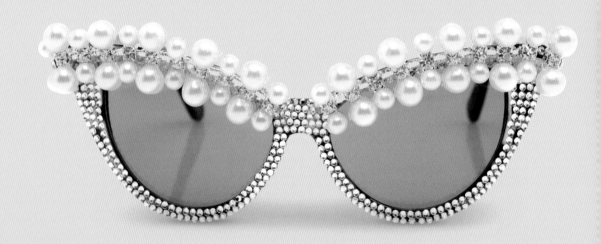

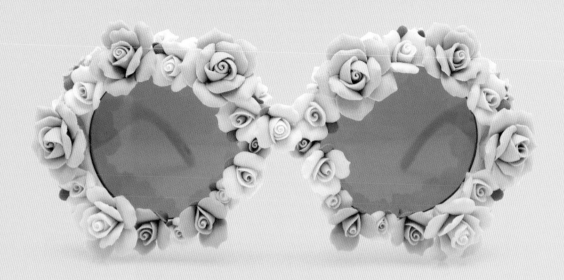

THE MAKER

KERIN ROSE GOLD

Kerin Rose Gold founded the eyewear line A-Morir in 2009. After designing a pair of sunglasses for herself with adhesive and an inordinate amount of crystals, Gold was "discovered" by the buyers at Patricia Field, where she had a part-time job. She soon realized that she could make a business of her bedazzling, and abandoned graduate-school plans to pursue it. Along with her regular eyewear collections, Gold has worked on countless custom projects for fashion editorials and music videos where luminaries, including Beyoncé, Katy Perry, Lady Gaga, and Rihanna, have worn her iconic eyewear. She took time out to talk a little about how she makes her famous frames.

JESSICA GLASSCOCK: So, what got me thinking about your work as I was researching this book was the realization that there was this moment when glasses became not so much a corrective tool but rather jewelry or even this mask that you could take on and off. They became instant character. I thought of your work because you've been creating these over-the-top and bejeweled and bedazzled eyewear ideas, and because I knew you did all this work with sort of stylists and celebrities, helping them find this "instant character mode." So I'm kind of trying to draw that story out. But first and foremost, could you just talk a little bit about how you started in your career? Tell me the origin story.

KERIN ROSE GOLD: Sure. So I very much started on accident. I did not study eyewear. I did not come from an eyewear background. I had never needed glasses aside from using them as an accessory, which I always did. My aesthetic has always been big and over the top and sunglasses are part of that as well. I went to NYU — I went to Gallatin — and got a degree where my concentration was fashion as a spectacle, as in the French existentialist Guy Debord concept of a spectacle. And it was about sort of looking at pop culture and subculture and fashions as spectacles. And I was very interested in the identical storylines between punk rock and hip-hop.

While I was in college, I worked at record labels doing college marketing. I worked at Sony and then at Universal. Throughout all of this I had ulcerative colitis, so I was very sick all the time, and I needed a job where I sat at a desk, and so I sort of fell into alternative marketing and worked on and off until I subsequently got fired because I just wasn't capable of really working at the time. I finally went into remission when I was twenty-five, in 2008. I took one last marketing job and had a post-traumatic-stress breakdown while working there. I got fired from that job the day I went in to quit and then went straight from that job to the NYU campus, where I got the application for the master's program at NYU for costuming history, because I wanted to work at the Costume Institute at the Met. This was the summer of 2008, so I had a year to kill before that program started, so I collected unemployment and walked everywhere because I was like, "A subway ride, that's too expensive." I needed to make extra money, so I helped someone I know start a vintage business, and did the flea market racket for a few months. And then while shopping at Patricia Field, which I'd been doing for forever, I saw that they had a Help Wanted sign and I was like, "I don't have a job. I can do this until school starts next fall."

JG: So music style and personal style were already your thing. How did you get to eyewear?

KRG: You're either a maker or you're not a maker and I've always been a maker. I've always been creating. I've always been refurbishing my clothing. I've been big on embellishments. I've always loved glitter. I've always loved crystals.

I've been embellishing forever. And one of the things that I used to crystallize were my cellular phones. To really date this, let's say I was ready for my upgrade from my Motorola flip to a BlackBerry. I was getting back into crystal artwork and crafting during this gap year and spending time with an artist friend of mine who I've lived down the hall from for thirteen years, and he said, "Hey, I know you love working with crystals. I know you're bored right now, come over and we can make some stuff." And he showed me a different way that I could apply the crystals.

And I started working with teeny tiny crystals and I thought, "Oh, this is cool. I'm going to get these tiny crystals for my BlackBerry." And like I spent my last few dollars on ten gross of crystals. And then, turns out I read something wrong and didn't get an upgrade. I had just lost or broken my last pair of Canal Street sunglasses and it was summer; I needed a new pair. Everything available was *so* boring, so I thought, "I've got these crystals." I felt like the inventor of the peanut butter and jelly sandwich, just mushing these two elements together and creating the best new thing.

It was also the first time I had made anything that people asked me about. It was also the first time I'd *worn* anything that people even asked me about, to the point where I would walk from my apartment down Third Avenue to Patricia Field on Bowery, and people would cross the street to ask me, "Where did you get your sunglasses?" "Oh, I made them." "Are you selling them?" And I would always reply, "No, just made…" I didn't even think that that was the thing that I could do. I've never been on trend and have always been pragmatic about my creativity in regards to commerce. It never occurred to me that I could make money this way.

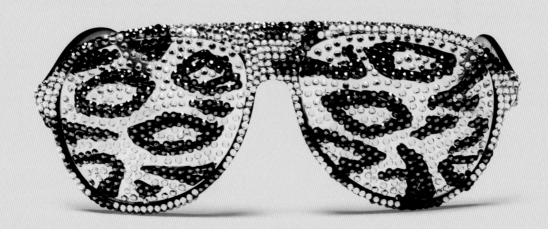

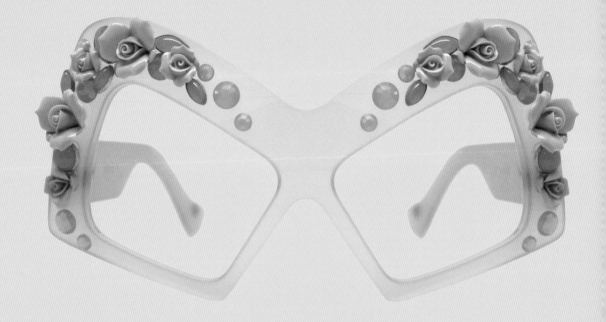

JG: But then, a star is born?

KRG: Well, one day, the buyers of Pat Field were upstairs when I was coming in and they were like, "What the fuck are those?" "Yeah, just some shit I made." "Cool, make more, we'll sell them." "Oh, okay." It was so organic…This was 2008, so eyewear was boring. Nobody was doing runway eyewear right then — the super over-the-top runway stuff. Nobody was doing that shit.

JG: It wasn't part of your master marketing plan to break into eyewear?

KRG: Definitely no. I mean, obviously, because of my magpie attraction to glitter, I was very aware of the Cher, Elton John, Liberace extravaganza that was in the seventies and knew about all of Elton's over-the-top glasses. But, if you had been like, "Do you know about Oliver Goldsmith?" I'd likely have replied, "Did we go to Hebrew school together?" I didn't know anything; it wasn't something that I had even thought of to do any research on. And so, I was coming at it with fresh, organic eyes, and it was a means to an end. "Hey, no one's making anything I want to buy. I'm just going to make it myself."

That's how it started, and then it took off very quickly. I think I started selling my glasses in the fall of 2008, and I set up my ecommerce then, too. After a few months, Mariah Carey had worn a pair in a music video, and Katy Perry had gotten a pair and worn them to perform at

a party for *Paper* Magazine. And all of a sudden I had these beautiful photos of a huge pop star singing into a microphone wearing my sunglasses.

The first few designs were pretty basic: shapes I loved covered in crystals. Then, I had sort of seen a version of the Chanel leather-strap-chain glasses. And I understood that I needed to level up. I thought, "I can do a chain necklace. That would be cool." And a friend of mine bought a pair and was approached by personal shoppers who worked for Rihanna, so she gave them my information. Next thing I knew Rihanna came to the Pat Field store on a day that I was off, and asked for me. I spent $2 and whatever on the bus so that I could get down there really quick. And she ordered a handful of pieces from me and asked me to do

a custom version of the Love/Hate, my brown-and-gold-chain glasses in black-on-black for her and wore them out the day she got them and immediately became an aggressive supporter of my work.

JG: So no more NYU grad school?

KRG: That was sort of the moment where I was like, "Oh, I can do this for a living." Because I was working at Pat Field's for $8 an hour for three days a week and one pair of sunglasses that I sold on my website was $250. I could do a few in a day at that point. I'm quicker now, but at the time I could do probably like two or three in a day. And I quickly began making more money than I had at my previous office jobs and thought, "Mathematically, this is something I

can do." And then the NYU master's program started and I dropped out…I knew I couldn't half-ass either of the things that I was trying to do. The program will be there forever, but this, I do now or I never get to do it again.

JG: That's an excellent origin story. I love that the music connection is threaded through. Would you be able to walk me through how you make a pair of your frames? Do you buy wholesale a standardized base, or are you thinking about prescription lenses? Are they always sunglasses? Walk me through how you make something.

KRG: I mean, when I first started, I was literally going down to Canal Street and purchasing individual pairs of sunglasses (the internet has made things so much easier). There were a few wholesale shops around here in the high twenties off Broadway. Now, I have relationships with reputable wholesalers that I've been purchasing from for a long time. I inherently know what

kind of frame shapes and surface area I can tell a story with. That's the way that I tend to do most of my things because with standard eyewear, there's a lot of lead time. If you're producing eyewear through a factory, it costs a lot of money and takes a lot of time. I love having an idea and actualizing it immediately, not waiting six months to sell it. When you develop frames with a factory, your MOQs, which are the quantities that you need to purchase, are super high. If I was making boring eyewear, I could make a killing, but not by

designing what I want to design. I'm not going to sell three hundred pair of giant crystallized, seven-inch-tall cat eyes. It's not happening.

JG: Sadly, the market is not there.

KRG: If only, one day. My most popular pairs, I've probably sold two hundred of. I'm not doing those big numbers. I've produced demi-couture pieces from scratch before, and it's all more fashion-forward. I'll lean towards

shapes that are a little bit edgier, but I'll also do some classic shapes because I know that the edginess comes from the embellishment itself. The way that I prefer to do it is, "Oh, hey, I really like this shape. How can I flip it? Or I found this material or I found this thing, how can I recontextualize it?"

JG: Do you do extensive prototyping or experimentation?

KRG: The best way to describe it is, if I was a master chef and I was going into a fridge and being like, "Okay, what ingredients are we working with today?" There is a little bit of an element of that, but it's honestly something that's so innate. I would see a frame, and I would see a material, and I would pick out the crystal colors that I want to use, and I would go, "Okay, I'm going to do this." And then I would make it, and it would come out perfectly. I've never done a second sample, or ideations of designs, or tested things out. Every item on my website is the first version of the design ever created. I'm sure a lot of that has to do with the fact that I'm using prefabricated frames, so the frames them- selves look good.

JG: The optician's work is already done at the factory then?

KRG: The concept of designing eyewear where you're discerning between millimeters of space between the nose bridge? That's not what I do.

I'm not an architect, I'm an interior designer, if you want to use that analogy. There are rules you have to follow when you build a house, but not when you decorate. My talent is in rethinking and recontextualizing what you think eyewear can be. And yeah, sometimes it's getting excited over a material, sometimes about finding a really cool frame. But you start with one ingredient and then you build a whole meal around it. It would be a failure on my part not to talk about adhesives. I know a lot about adhesives. People tend to thumb their noses at adhesives because they think that everything is done with either Elmer's glue or hot glue (both of which serve their purposes). Adhesives come in dozens of categories, can be scientifically complex, and take a lot of time and practice to use skillfully. And so, if you're using the correct chemical bond on the correct materials, you'll create something of quality. I have at least a dozen adhesives in my repertoire that serve specific purposes. Also, I dare you to find an object in your house or a pair of shoes or a bag that doesn't have adhe- sive in it, you're not going to.

JG: Have you ever designed a frame?

KRG: I've worked with two different facto- ries (one factory and one bespoke workshop) to make frames from scratch. The workshop that I work with now is called Fellow Earthlings on Prince Edward Island. The work I do there is full soup-to-nuts, sketching out a design, creat- ing a linear render. I'll cut it out and hold it to my

face and say, "Oh, you know what? This needs to move in a little, this needs..." They're brilliant with frame "architecture," and I trust them with that. But I create the design; they engineer the shape; I okay it. I pick out the acetate, I design the temples. They can do far more than what I use them for. But my goal is to create a beautiful base because I'm going to be putting so much on top. I actually do my bespoke pieces in four-millimeter thicknesses instead of five to make them lighter, so that when I embellish on top of them, it doesn't add to the weight.

JG: Do you ever do prescription frames?

KRG: I mean, I started with sunglasses because that's what I personally needed. Very shortly thereafter, I would include a few nonprescription eyewear frames because I wanted to be able to wear my work indoors or at night, and not be an asshole walking around in a club in sunglasses, because that's the worst kind of person I think you can be. I mean, there are many. Stylistically speaking, that is one of the worst.

JG: There're greater crimes against fashion, but —

KRG: That's a big one, for me, that ranks pretty high. And I do actually work with a lens lab. I can do prescriptions for nearly every piece and I do a lot of Rx's. But then, I also have a series that I call half frames or lensless. Those were a bit of a "fuck you," because I was getting a lot of

criticism from people, internet trolls, saying, "Your pieces are ridiculous, they are really impractical." And I was like, "You want to see impractical? What if I cut glasses in half and take out the lens?" And so, I designed frames by quite literally cutting them in half horizontally and sanding them down and re-lacquering them and embellishing them.

JG: Inspired by internet trolls! Any notable fashion history inspirations? You have some floral embellished frames that are so totally 1950s Schiaparelli.

KRG: I love that piece, and I had no idea about them until I made my floral piece. I actually don't do a lot of eyewear research because I'm worried about something imprinting on my brain, because I'm a very good visual person. I will forget someone's name. If you introduce me to someone, I will not remember their name, but I will remember every detail about what they looked like. I will not remember the name of a restaurant I went to, but I can re-create it on paper. I can recall ten-year-old press editorials from memory.

Knowing this early on, I never did eyewear research, because I was worried that it would stifle my own creativity or I'd copy somebody and not realize it. I still rarely do eyewear research, and I never make mood boards. Copying, reinterpreting, homage work, is a big no-no for me. I'm not into that. But yeah, the pastel floral pieces that I did are one of my more

well-known pieces. I debuted them in Milan for *Vogue Italia*, New Talents, in 2011, and the Dolce & Gabbana ones came out a year or a year and a half later using the exact same ceramic pastel flowers, which, like, "Okay." Over the last few years when I was still trying to build retail relationships, buyers would scoff, "Well, these are just Dolce & Gabbana knockoffs." In a pre–Diet Prada world there was no way to correct someone without sounding like an asshole.

JG: That is such a tremendous issue, but looking at the big picture, it's also a tremendous advantage for the market as a whole. The gradations of price in the sunglasses market have made it so successful. And it sucks when somebody is punching down and taking from someone who's a smaller maker, but the success of sunglasses can be measured by the fact that you could go to St. Mark's or Canal Street and get the $10 version of this thing.

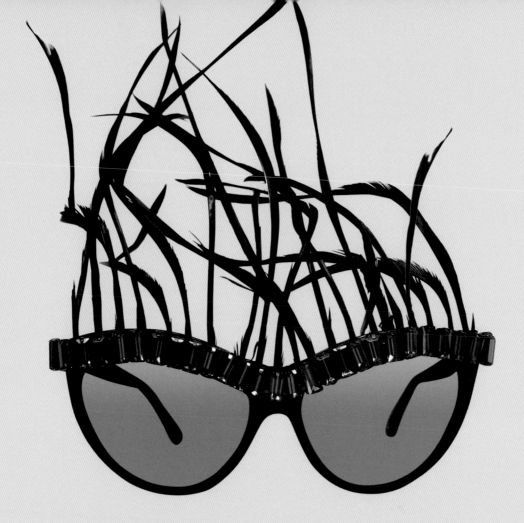

For high-fashion labels, the sunglasses are the access point. Eyewear is an entry-level object. If you want to be part of the label, you get the glasses, and that's what you're getting because the dress is $1,200.

KRG: You can buy the lipstick. You can buy a wallet. You can buy the glasses. You can do all of that.

JG: But with the glasses you wear the logo.

KRG: Absolutely. By the way, I have had three or four of my designs make it to St. Mark's, so it felt very full circle.

JG: What is inspiring you currently? What's driving you?

KRG: I feel like my entire career is a decade-plus-long creative attempt to push it forward. I would make something and then I would go, "Okay, how can I top this? What can I do that hasn't been done? I'm going to cut eyewear in half. I've never seen anybody put a veil on a pair of glasses, I'm going to put a veil on a pair of glasses. I've never seen tassels; I've never seen things hanging." It just really became about trying to move the needle. And I feel like I achieved that, and I got a little burnt out.

Of course, there's always more to do. I did a frame that came out at the beginning of the year that has seventy-five feet of crystal chain hanging off of it. Because I was just sort of like, "Fuck it. I haven't done anything really crazy in a while. I'll just make this one for myself." And then I was inundated with messages asking, "Is this for sale?" And I was like, "I guess it's for sale now." I priced it at $1,350 and released it with a collection containing a dozen pieces of very beautiful, wearable, affordable pieces. The seventy-five feet of crystal chain sold the most. It reassured me that my job isn't to make pieces that are safe and pretty, my job is to make something "Fuck it." The more authentic I stay to my design process the better my people respond.

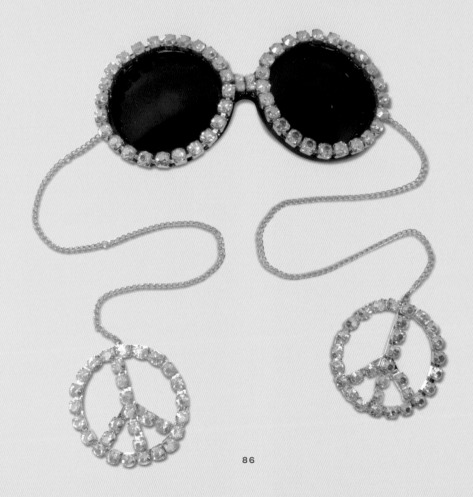

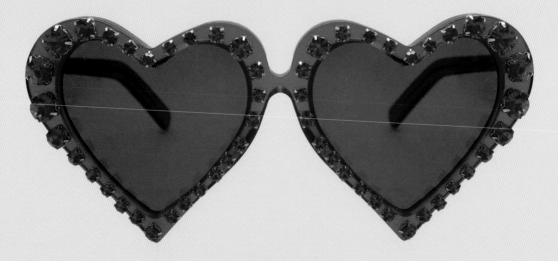

It's always been a creative exercise and a creative challenge. The way that I design and the way that I create anything has always been about making something that makes me happy. And I'm assuming if it makes me happy, it'll make other people happy.

JG: So it's a happy ending!

KRG: Oh, yeah, and covering the lenses, I did a lot of covering the lenses, a lot, oh my God. I had two big Rihanna moments early on. One was when she wore the Love/Hate black-chain glasses, and then another was when I made this piece for the music video with Jay-Z and Kanye West called "Run This Town." I made her these shield glasses fully covered in a trim that's made of matte pyramid studs. Because Rihanna said, "Hey, make me something I've never seen before and make it black." And I was like, "That's a brief. Okay. Let's go."

JG: That is — it's a great brief.

KRG: Right? And I had made her a few spike-heavy pieces that she previously purchased, so I based these new pieces off of those, and at the very end, I made what I felt was the simplest one, but I wanted to send her something a bit different. And she wore it for the music video and there were all these great close-up shots. And then she wore them for the inaugural Fashion's Night Out, may it rest. And there were all of these write-ups. Then that was the first time where I was recognized as a designer and was called a genius by a number of publications. The glasses in question are the Barracuda. But then, Page Six wrote about how Rihanna was wearing glasses she couldn't see out of, and they became a gossip item. You can see out of them, by the way. And then, I'd wear them out, and I would get stopped on the street by people who were like, "I heard Rihanna can't see out of those."

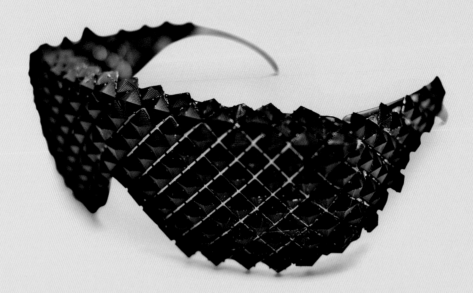

And I'm like, "I'm not walking with echolocation. I can see." So I did a lot of lens covering and I still do a lot of that just to be subversive and just sort of poke the bear a little bit.

JG: What is the process of working with stylists and the teams of people like Rihanna and other performers?

KRG: I have probably five hundred or so eyewear samples at my studio. A lot of the time, it is as simple as an email or a text: "Hey, what do you have that's pink?" "Here's all my pink." "Great, we'll take these seven." And then, other times it's, "Hey, we're doing this performance" or "shooting this music video." "Can you make something?" Usually, my lead time is twenty-four to thirty-six hours. So I'll either be actualizing something

very specific or I'll interpret a more vague direction like "covered in fruit."

Then there are fuller collaborations, like where I did an eyewear-lens mobile piece for Lady Gaga for her ARTPOP Tour promo photos. Her stylist said, "I want to do this thing with lots of lenses coming off of it, like a mobile, can you do that?" And I didn't know if I could, but I said, "Yes." And then, I made a sketch, and he was like, "Oh, can you change this and change this?" I was like, "Sure." And I said, "I have these old-school metal measuring frames" where it's like you have…

JG: Just the numbers on an empty frame?

KRG: Yeah, exactly. And I said "I could create the mobile off of this. This would look cool."

I want to say there were probably like fifteen lenses coming off of it? In order to create it, I had to source wire with the correct thinness and stiffness, wrap the frame in wire, drill a hole through each lens, put a small screw through the hole, wrap the wire around the screw. So I'll have moments like that where it's like creating an art piece or a sculpture.

JG: But an art piece where you have to really tune in to the performer. Or their stylist.

KRG: I'm super lucky that I've had relationships with some stylists for a really long time. They trust me and they know that I get it. A lot of the time I'm lucky that I'll get free reign. And there are tons of occasions, still, where I'll create something for someone and they say, "We love it but we're not going to use it." For every one press piece, or performance piece you've seen, there are probably eight or nine occasions where something I've made has never seen the light of day.

For Katy Perry, a number of years ago, her stylist wanted me to make glasses that had movie-theater food on it. And so, I made one pair, one cat eye that the top was aligned with popcorn that I spray-painted gold, with Lucite mirror and red chains. And then, another cat in red crystals with Mike and Ikes all over the corners. And she wore the Mike and Ike pair and the other pair got returned.

JG: You know you are going to have to give me a picture of those for this book.

KRG: I would, but, unfortunately, popcorn is not forever.

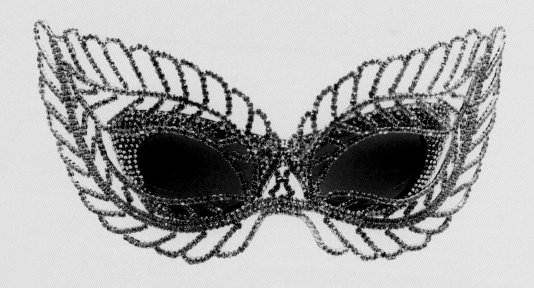

EYEWEAR

EN
FRAN
CHISED

·6·

Democratizing the Pince-Nez
in the 1890s and 1900s

The total shift in the perception of
eyewear from disfigurement to character enhancement was exemplified by the
vogue for the monocle alongside the surging ubiquity of the pince-nez. These
styles also marked the end of the strict gendering of eyewear. Men wore spectacles
and women carried lorgnettes and nere the twain would meet through most of
the 19th century, but that was changing at century's end.

The pince-nez represented a triumph of technology and sheer practicality.
Though the overall idea of eyeglasses without temples connected by a metal
wire that perched and balanced on the bridge of the nose was unchanged from
the original spectacles of the thirteenth century, nineteenth-century technical
refinements transformed the idea into a device that would fit securely. The pince-
nez became a universal style and could be a vehicle for any number of iterations

of eyeglasses that had come before it. Pince-nez came in wire-rimmed, horn-rimmed, and rimless glasses. They could serve as a vehicle for the jeweler's art or an expression of the chilly, metallic aesthetic of industrialism. They served clerks, adventurers, and revolutionaries alike. And though "never fashionable" (according to accessory historian Richard Corson), they were widely embraced by women. Fashion magazines even advised picking up the pince-nez when invisibility of eyewear was the goal.

The goal of women who wore the pince-nez wasn't necessarily invisibility. The style was embraced by women who felt newly entitled to a place in the working world, in fact. Women in the pince-nez assumed the long tradition of eyeglasses as indicators of knowledge and power, which is likely why cabinet cards of nineteenth-century suffragettes often featured the pince-nez. The establishment of eyeglasses as a fashionable accessory for men over the course of the nineteenth century made that accessory ripe for appropriation by women who were politically motivated to adopt elements of men's wardrobe and cultivate an appearance that signified their will to change their social status. The pince-nez could be combined with a boater hat, a four-in-hand tie, and a crisp white shirt as the uniform of the New Woman, the fashion icon of 1900.

THE YOUNG WOMAN HAS "ARRIVED".

93

< **THE NEW WOMAN,** that icon of dawning-twentieth-century modernity, surely needed a new way of seeing. As the embodiment of the end of the ideal of separate spheres for men and women, which had dominated the nineteenth century, the New Woman unapologetically appropriated multiple elements of the menswear wardrobe for herself. The radicalism of any given New Woman could be read in the degree of menswear she took into her ensemble. If it was as simple as a man's boater hat or a button-down white shirtwaist modeled after a man's shirt, she was likely merely on trend. But if she wore a plain homburg, an unfussy bow tie, a fitted vest, and white spats, she might well have the leanings of a suffragette or even a volunteer at a settlement house. In this *Vogue* illustration from 1896, the New Woman, here identified simply as the young woman, wears multiple menswear accessories, including the monocle. That very male-identified eyeglass is almost as confrontational as the cigarette in her mouth and the strong drink on her table. That *Vogue* would feature such a woman on the cover confirms that great change was afoot at the end of the nineteenth century. [(Previous page) *Vogue* cover. Thomas Mitchell Peirce, 1896.]

> **IN ITS RUDIMENTS,** the pince-nez, two lenses without temples or side pieces, secured to the bridge of the nose by a grip of wire, was not much changed from the rivet spectacles that began the history of eyeglasses. The pince-nez was far more refined and elegant due to the technical innovations in both fit and corrective power as well as the abundance of differing styles offered year-over-year, starting with their introduction around 1840 through World War I. The earliest version used a flexible, curved wire to clip the lenses onto the nose. By the end of the nineteenth century, springs, sliding bars, cork nose pads, and other innovations made the pince-nez comfortable to wear at all hours and on all days.

The pince-nez is most ubiquitous in men's photographic portraiture between 1890 and 1910. While it retains much of the "learned man" cred of eyeglasses featured in early photographs and fine-art portraiture highlighting spectacles, the pince-nez was worn by a wider range of people, defying easy definition. Fashion historian Richard Corson simply states in his definitive *Fashions in Eyeglasses* that it was "essentially a middle-class eyeglass."

Here it is worn by a scorching babe of a Swedish anarchist, otherwise remembered only by his arrest record. The photographer, Alphonse Bertillon, took the photograph as part of a system meant to identify repeat offenders in the Parisian criminal system. The photograph was but one of the statistical

measures taken of the person arrested. These were fundamentally the first standardized mug shots. The mug shot of Gustave Aguéli is among several of Bertillon's in which the pince-nez is worn, and it is worth noting that eyeglasses were by this time enough of an identifier that they would be included in a photograph of record. [*Aguéli, Gustave. 24 ans, né à Sala (Suède) le 24-5-69. Artiste-peintre. Anarchiste. 14-3-94* (Aguéli, Gustave. Twenty-four years old, born in Sala, Sweden, May 24, [18]69. Artist-painter. Anarchist. March 14, [18]94), photograph by Alphonse Bertillon, 1894.]

∧ **PRESIDENT THEODORE ROOSEVELT** was a man so deeply associated with his pince-nez that he was depicted wearing it sculpted in stone in his portrait on Mount Rushmore. Roosevelt's personal vigor and cowboyish self-styling meant that the pince-nez was a pair of glasses that finally escaped associations with the inbound and introverted scholars of the nineteenth century—they were glasses that could be looked through from the top of a horse rather than from behind a book. [*Teddy Roosevelt*. Photograph by Eugene Ashton Perry, 1901.]

∧ **A SKETCH** by Dutch artist Julie de Graag
captures both the pince-nez as one strong
graphic geometric element among several in
her sketch. The rectilinear effect of the bridge
of the eyeglasses is likely due to the use of a
sliding bridge, one of the 1890s innovations
that made the fit of the pince-nez so precise.
[*Portrait of Koos*. Julie de Graag, ca. 1892.]

< > **PROSCRIPTIVE FASHION** editorials of the late nineteenth century persistently advised against wearing glasses, though the editorials might allow some choices "for the middle aged," such as plain, blue-steel frames for the nearsighted because "the dazzle of gold frames is trying and injurious." Magazines also advised that eyeglasses might be acceptable for daywear, but in 1900, *Vogue* advised in its coverage of recent medical news that "spectacles or eyeglasses out of doors were invariably disfiguring." Despite this, portraits and even the occasional fashion image show the wearing of the pince-nez, testifying to its ubiquity. And fashionable department stores in this period featured optical departments that could fill prescriptions for corrective lenses, disfiguring potential notwithstanding.

This print by James Tissot captures the most elegant iteration of the pince-nez as worn by a young woman reading outdoors. Tissot was the son of a textile merchant father and a milliner mother and had a keen eye for fashion, observing its details carefully in his work. The pince-nez in his print is shown paired with the fur coat and fur hat, and was one that could easily be taken on and off. This was one of the charms of the pince-nez for the fashionable woman: it could be removed or added with a flourish similar to the lorgnette, which was more affirmatively fashionable at the end of the nineteenth century. The pince-nez as worn by both men and women was often secured by a black silk cord that kept it easily at hand and prevented it from becoming lost.

The pince-nez was also worn by women unlikely to be threatened by the appellation *unfashionable*, such as the women of great political will who populated the suffrage movement in the late nineteenth and early twentieth centuries in America. The suffragist and temperance reformer Frances Willard consistently appeared in her pince-nez in formal portraits in the late nineteenth century. In one, she wears a simple wire-rimmed pair, but in another she wore a rimless version. Rimless, oval pince-nez were recommended by fashion magazines of the period as the most invisible type of eyeglasses available, and they were therefore highly recommended (though they were considered the most easily breakable eyeglasses on the market). [(Previous page) *Woman reading a newspaper.* James Tissot, 1883. (Right) *Frances E. Willard.* Photograph by Veeder Photographic Studio, Albany, ca. 1875.]

Frances E. Willard

THE

SUBVER

SIVE

EYE

·7·

The Lesbian Chic of the Monocle
in the 1910s and 1920s

The monocle had even more radical implications than the pince-nez as it crossed the gender divide at the turn of the twentieth century. A descendant of the unapologetically pretentious quizzing glass of the eighteenth century, the monocle was a well-established accessory of the rich and royal man or anyone who wanted to ape him. It was a consistent stage accessory when a character needed to convey foppishness or a certain constipated Britishness. Opticians loathed the monocle, rightly noting that seeing well through only one eye was not a long-term solution to any true vision problem. This assessment argues for the monocle as the first eyewear worn as pure accessory. With origins in Britain and later Germany, the monocle gained prominence in the United States around 1880 and gained *Vogue*'s imprimatur in 1893, when the magazine noted that the young duke of Orléans was a wearer, though his "eyesight is excellent, and [he] merely uses the glass for the sake of pose."

By 1903, women of fashion had taken up the monocle with enthusiasm and full awareness of the subversive impact of hijacking this already-exaggerated form. The *New York Herald* noted "it takes a daring woman to use it," mainly because the scrunching eye muscle required was "a detriment rather than an aid to beauty." It is worth noting that that may have been the intent. Women persisted in wearing monocles into the 1920s, and fashion writers looked askance at them all the while. At the very least, the monocle on women drew light mockery as a useless pretense. Other writers clucked at the masculine nature of the accessory and its "severity" on women. In 1920, coverage of the races at Auteuil by *Women's Wear Daily* (*WWD*) claimed 80 percent of the Parisian women "wore eyeglasses stuck in the right eye, had on tailor-made suits cut in severe masculine line, low heeled shoes, and carried walking sticks," and then sniffed that the "masculine effect of the new spring fashions was generally criticized." In so many words, the fashion reporters' lack of enthusiasm for the monocle was also an acknowledgment of its lesbian chic in the era of *la garçonne*, the French iteration of the rebellious flapper, named for a scandalous novel by Victor Magueritte published that same year. This transgression of gendered eyewear and appropriation of an archaic style with newly subversive intent would persist in the twentieth century. Retro-hipsters would herald shifts in eyewear by digging through past forms with wicked intent again and again.

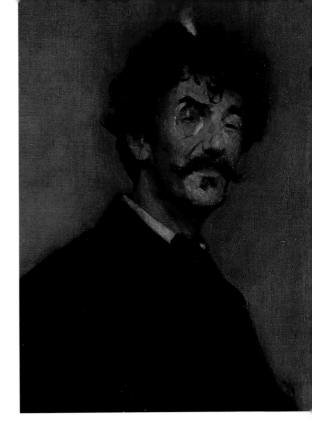

> **AS OF THE LATE NINETEENTH CENTURY,** the monocle was both an atavistic assault on the opticians' centuries of work in the improvement of vision and the perfect expression of eyewear as pure fashion accessory. Its form, a simple, single round lens either with or without a frame, could be traced back to the thirteenth century, when such a lens was used for reading before the invention of rivet glasses. Though the earliest invention date of the monocle is given as 1806, the eyeglass was an evolution of the quizzing glass, which makes a confirmed date difficult. And some of the earliest "monocles" had handles, which made them not monocles at all. The single eyeglass is mentioned in literature as early as 1820 and was associated with foppish and callow young men, but the word *monocle* didn't come into widespread use until around 1858. It is on the stage in the 1870s, with characters that were a cliché version of the British aristocrat, that a certain personality coalesces around the lens of the monocle.

That personality was that of a man or woman who would wear an eyeglass not for utility, but solely and unrepentantly for dramatic effect. Since the monocle required the user to contract the muscles of the eye around the lens, it brought observable intensity to any act of observation. This may have been its attraction for an artist like James Abbott McNeill Whistler, who was one of the great icons of monocle wear in the late nineteenth century. In this portrait of Whistler by William Merritt Chase, the monocle casts a slightly unearthly glow around the somewhat somnolent eye of Whistler. The painting was created when Chase and Whistler decided to do portraits of one another, but Whistler was offended by Chase's portrayal of him and called this work a "monstrous lampoon." [*James Abbott McNeill Whistler.* William Merritt Chase, 1885.]

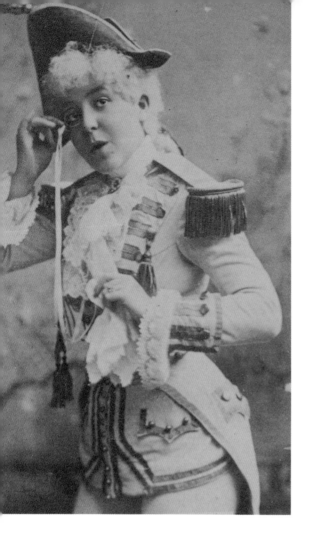

∧ > **DUE TO ITS ASSOCIATION** with the much-satirized quizzing glasses and scissors glasses of the eighteenth century, the monocle came preloaded with a bit of lampoon. That is why it lent itself so easily to the stage. Like eighteenth-century handheld eyewear, the monocle was associated with a flourish. It was a natural-born prop. In this cigarette card from around 1888, a performer named Laura Burt is dressed in a stagey military costume with an improbably nipped waist and naughtily exposed legs, outing her as a burlesque performer. Burlesque was a stage performance in the nineteenth century in which women performed men's roles to comedic effect and with prurient appeal. Miss Burt was the pornographic-fantasy version of the New Woman who would emerge a few years later, also using menswear for attractive appeal.

In a cabinet card of theatrical performer Lillian Russell from a decade later, the monocle also shows its relationship to the lady's eyeglass that was worn as jewelry in the nineteenth century. It is an expression of luxury and femininity with only a hint of the subversive appropriation of menswear, though that would have been part of the image's appeal as well. By 1903, the fad for monocles for young ladies was pronounced in the United States. By 1911, *Vogue* touted lush finishes of Dresden enamel as the trend, noting prices for monocles at a low of $4 and a high of $300. [(Above) Laura Burt, from the *Actors and Actresses* series (N45, Type 6) for Virginia Brights Cigarettes. Allen & Ginter, Publisher, ca. 1888. (Right) *Lillian Russell*. Photograph by J. Schloss, ca. 1898.]

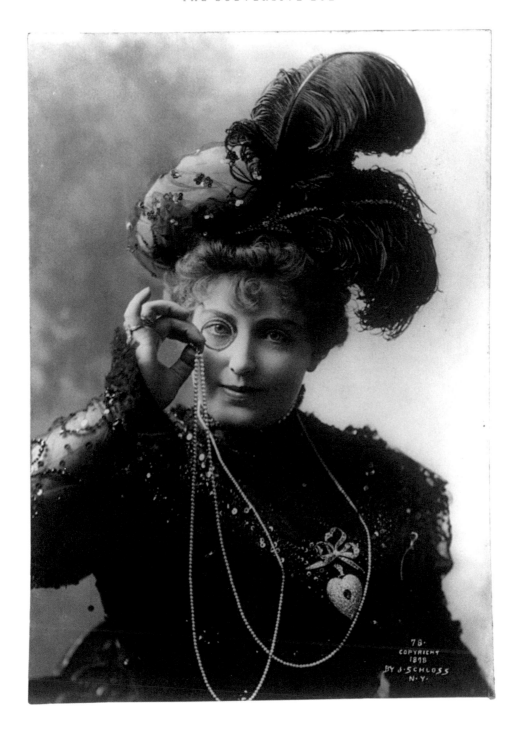

to the difficult artistic persona. Monocles and modernism both had an in-built resistance to prettiness, and fashion writers consistently remarked on the displeasing look of the monocle on women. In 1903, a writer for the *New York Herald* noted that the monocle "is a detriment rather than an aid to beauty" and "the New York Society belle may look interesting when she gazes at you through her Monocle, but she doesn't look any of the lovelier because she has this odd little glass fixed in her eye." By the 1920s, that was undoubtedly part of the point in women wearing monocles. It was the striking and unusual appearance of Sylvia von Harden in her monocle that inspired painter Otto Dix to ask her to sit for a portrait. As an artist, Dix was known for his portrayals and portraits of the ugly side of life in post–World War I Germany. As von Harden tells the tale, Dix approached her insisting that he must make her portrait because she was "representative of an entire epoch," embodying as she did the *Neue Frau* (which was the German take on the New Woman in the 1920s). While Dix's portrait emphasizes an awkward angularity and harshness in von Harden's appearance, she was in fact at the height of Bohemian chic with her bobbed hair and her rolled stockings. The daring of her monocle turns a glaring eye on the more mundane mainstream fashion of the 1920s. [(Left) *Portrait of the Journalist Sylvia von Harden.* Otto Dix, 1927. (Above) *Portrait of Whistler.* Carlo Pellegrini, 1881.]

< ∧ **THE MONOCLE** as a shorthand symbol of modernist tendencies might be traced back to the innovative painting and combative public persona of James Abbott McNeill Whistler. The nineteenth-century artist sported a monocle as a component of his theatrical and dandified persona, and it was easily integrated into caricatures and portraits of him. Thus, the monocle became attached

∨ > THIS ILLUSTRATION OF A ROWER in a monocle was published in a French newspaper in the same year that *Vogue* was assuring its readers that men of quality and royalty did indeed wear the eyeglass, some for utility and some for fashion. It cannot have been easy to keep the monocle secure during vigorous exercise, so this man's commitment to a look is to be respected. The monocle was again "one of the fads of the hour" in 1910, however it was considered strictly a masculine accessory and was especially associated with England and the Continent rather than seen as an American phenomenon. A 1911 *Vogue* article gives the origins of the monocle as an implement "designed for cavalry officers in England whose horsemanship engaged the hand." That particularly fanciful notion is unconfirmed by any other research and seems pretty dubious, but the 1893 illustration provides a portrait of such an idealized sportsman's use of the monocle. His eyeglass and unflinching gaze complete the studly look begun by his knotty muscles and competitively clenched jaw.

It is with the butch and aristocratic associations of the monocle well in mind that Una, Lady Troubridge, wore the monocle in her portrait by Romaine Brooks in 1924. Her bobbed hair and menswear appropriations associate her with the highly fashionable, if mildly controversial, figure of *la garçonne*, but the monocle specifically had clear associations with the visible lesbian culture of the 1920s. Considering the existence of the Parisian nightclub Le Monocle, which was well-known for its lesbian clientele in the 1920s and 1930s and the entrance to which was in the shape of a monocle, Lady Troubridge's wearing of the eyeglass could be read as an announcement of her proclivities. Her iconic pose in the radically fashionable monocle of the 1920s cements the narrative and associations that it retains today as well as mapping a path for other eyeglasses from visual tool to purely fashionable expression. [(Left) *Rowing Race in France*. Illustration by Luque, 1893. (Right) *Una, Lady Troubridge*. Romaine Brooks, 1924.]

MEN SELDOM

MAKE

PASS

ES?

·8·

Eyewear (or Not) in the 1920s

The fashion for subversion, unfortunately, would not arrive in mass-market women's magazines until the 1960s. In the interim, the fashion press lagged behind on approving of any style of eyewear in the 1920s. Glasses were very nearly invisible in the pages of *Vogue* and *Harper's Bazaar*. Dorothy Parker's truism may have explained this, but it was more likely the youthquake of the 1920s, which excluded the older woman in favor of bright young things. Eyewear retained its association with the older woman in the eyes of fashion illustrators and photographers of the day. A 1927 *Vogue* article explains, "We can't put eye-glasses or spectacles upon our languid lady fashion-plates (any more than we can shorten and broaden their slender figures and yet have them show clothes to advantage)." The assessment was that spectacles were "invariably disfiguring." They were strictly forbidden with evening wear (where the lorgnette was recommended). A little eye trouble could be charming as long

as a woman might say her optician was Cartier and carry a jeweled lorgnette, but spectacles were rarely acknowledged. *WWD* noted, "Eyeglasses are one of those things, like insurance or a doctor's services, that require infinitely greater skill to persuade people to buy than something like a new dress or new suit. Particularly is this so with women, many of whom, believing glasses disfiguring, would sooner hire a guide than wear 'spectacles.'"

Spectacles came into increased prominence in the 1920s as Hollywood exploited their narrative potential. Early comedic film star Harold Lloyd was hugely influential on young men performing as a daredevil in glasses. (His director Hal Roach had said Lloyd was too handsome to do comedy without a disguise.) Lloyd's "Glass" character influenced the vogue for heavier, owlish, horn-rimmed glasses, known as library frames. Fashion editors inveighed against the trend, which was most prominent on college campuses.

Despite the proscriptive words of fashion editors, glasses were continuing their evolution into a fashionable object for all. This was due to a conscious and concerted effort on the part of eyewear manufacturers. Speaking to *WWD* in 1927, an economics professor from Northwestern University noted, "There has been an introduction of the style element in eye-glasses. We are urged to wear one pair in the morning, another in the afternoon, another in the evening, and still another

when we go on a vacation. These are illustrations of an endeavor on the part of manufacturers to obtain a larger share of the increasing purchasing power which we have in this country." The endeavor would prove extremely successful. At the very moment eyewear was pushing into style, the trade associations of opticians, optometrists, and ophthalmologists were advocating for control of the sales and manufacturing of corrective eyewear, effectively muscling the more fashionable department store and the jewelry counter to the fringes of the eyewear business (unless they were willing to employ an optician, which some were). In 1928, New York State passed a law requiring a licensed optometrist to be in attendance wherever eyeglasses were sold.

The competing interests of those in the optical trade and those in the fashion-accessory business, which were in tension in the 1920s, would be key to the financial success of eyewear as a going concern. Eyewear that was medicalized was eyewear that could be priced at a premium. At the same time, the optical tradespeople could be a reactionary force against design innovation. With the necessities of corrective eyewear prioritized, opticians typically rejected more fanciful styling notions. This control would be challenged, however, by the introduction of a protective lens that would allow for more exuberant expression in eyewear.

∨ > **AS** the twentieth century dawned and fashion magazines continued not to see much use for spectacles, there was an exception, and it ideally involved diamonds. The interchangeability of lorgnettes, certain styles of monocles, and single eyeglasses worn on chains with high-priced jewelry meant that the more a pair of spectacles could evoke a tiara, the more likely they were to be chic. A *Vogue* editorial in 1911 acknowledges this to be the case saying, "Fashions often have a pretty way of transforming a utility into an ornament…The long, ornamental chains worn with the lorgnons are in themselves finishing touches to pretty costumes." The truth of this was borne out by the fact that by 1913 Cartier had established an eyewear department in its Paris store.

Illustrator Erté took a pass at designing eyewear in the pages of *Harper's Bazaar* in 1922. His elegant Art Deco eyeglasses were noted in the caption to "bear a little resemblance to the 'eye-glasses' of pedantry and pedagogy." This assertion was borne out in a pince-nez that held together two rimless lenses with an arc of jeweled platinum. His square-lensed temple spectacles featured jewels running down the side pieces as well as on the underside of the lenses, which one suspects were more pretty than optically correct. Another pair of eyeglasses were spectacles and a hair comb combined; the lenses could be folded back when not in use, making them more diadem than spectacles. The magazine commented, "Erté is kind to the ladies

who are beautiful though myopic. He designs the eye-glasses that appear to be charming whim rather than a necessity." Erté's concluding offering in the article, a pair of lenses built into an evening fan, would suggest that the artist was familiar with the excesses of eighteenth-century eyewear. More crucially for the evolution of eyewear in the twentieth century, Erté understood that eyewear must evolve as a fashion accessory to be appealing as a visual corrective. [Eyeglasses designs. Erté, 1922.]

∨ **BY PUTTING ON A PAIR OF GLASSES,** comedic actor Harold Lloyd found a character that would carry him through a significant career in the silent films of the 1920s as well as establish a market for heavier tortoiseshell frames to replace the wire-rims that had dominated for decades. In the 1917 film *Over the Fence*, Lloyd introduced his stock character, the "Glasses" character, a determined and capable but, in his glasses, unprepossessing young man who could also perform impressive physical feats of sport and slapstick. Lloyd didn't need glasses, and he didn't wear lenses in the tortoiseshell frames, since they would have caused a glare under the lights of filming. The glasses that Lloyd and numerous young college men of the 1920s wore featured heavy, round tortoiseshell frames with temples and a pronounced bridge over the nose. Tortoiseshell had been in use for eyeglasses for many years, but effective imitations were also becoming popular in the eyewear market. Celluloid imitations of ivory, horn, and tortoiseshell were in use for eyewear by the late nineteenth century. Using these early plastics, the "block method" was developed to cut eyeglass frames out of a sheet of material, and it remains in use today. [*Harold Lloyd.* Photograph by Gene Kornman, ca. 1924.]

> **SPECTACLES CONTINUED** to be effectively verboten in fashion plates of the 1920s. Though this stylized brunette is dressed in an afternoon dress, which would have allowed for the wearing of spectacles, according to fashion writers, she carries a lorgnette, which seems like a lot of look for daytime. Then again, so is yellow taffeta with monkey-fur trim. This level of formality would not disappear from fashion in the twentieth century, but it would begin to recede a bit, making room for sportswear and other more casual yet still fashionable styles with which spectacles would be a logical accessory. The slow demise of the lorgnette had been and would continue to be driven by lifestyle changes emerging at the turn of the twentieth century with the New Woman and accelerating in the 1920s. Women would need spectacles to see the wider possibilities of life available to them in the twentieth century. [*Le Goût du Jour,* fashion plate 16, possibly François Bernouard, 1920.]

> **AROUND 1916,** the term *library frames* began to be used to refer to any pair of spectacles with heavy, dark, round frames. It was a short walk from library frames to the easy cinematic costuming of the librarian character, who was the similarly underestimated female counterpart to Harold Lloyd's Glasses man in early film. This librarian and her owlish horn-rimmed spectacles would naturally find her way to the fashion runway. The tortoiseshell library frames used by designer Anna Sui in her fall/winter 2012 collection were worn with several ensembles, even including one navy-and-teal, book-themed conversation print dress. Sui captures the origin story of the frames best when they are paired with a dress whose pin tucks, Peter Pan collar, and tight, stylized floral print all evoke the fashions of the 1920s.

The library frames were first featured in *Vogue* on July 15, 1924, in an article entitled "Odds against Chic: Spectacles." The model Peggy Fish wore a pair along with an appropriately unfussy hat for the photographer Edward Steichen. Though the fashion advice in the article weighed against spectacles in many cases (or offered backhanded compliments, such as noting that eyeglasses might be worn appealingly with ruffles so as to look "like a small, downy owl"), the article actually marked a turning point for eyewear in fashion's all-seeing eye. Simply put, the article recognized the narrative power of eyewear. While the bulk of the advice still

tended toward the preference for "invisible" white-gold frames and lorgnettes for evening, the magazine acknowledged, "Beautiful, distinguished, elegant—even exquisite, spiritual, and spirited, piquant, and pretty—all these adjectives may be used in connection with the eye-glassed or the spectacled

woman." The odds were against romanticism though, and the reader was cautioned "not be greedy of the poetic, picturesque, and vampish adjectives." Eyewear as a shorthand for character would inform its evolution as a high-fashion accessory going forward, and *Vogue* had begun to recognize the potential of the accessory in which "the smartness must differ a little from that of the ordinary-eyed — or, perhaps, nowadays, we should say the extraordinary-eyed." [(Left) Anna Sui runway, 2012. (Above) Peggy Fish wearing eyeglasses. Photograph by Edward Steichen, 1924.]

< **WHILE LIBRARY FRAMES** have a 1920s nostalgia built into them, they also reflect an affinity for the early modernist movements in art and design. Library frames were worn best by the young, and they asserted youth's disregard for the polite and reticent charms of wire-rims and diamonds in favor of a form-follows-function directness of design. They were typically and without apology made of early plastics and their assertive geometry aligned the frames with the confrontations of Cubism. This is why library frames can also carry a note of radicalism in certain contexts. In Luella Bartley and Katie Hillier's collection for Marc by Marc Jacobs, a trippy, translucent, candy ensemble of slick synthetic fabrics is complemented by purple-lensed sunglasses with dank-rose library frames. This is not a librarian but rather a science-fiction traveler. [Marc by Marc Jacobs runway, 2015.]

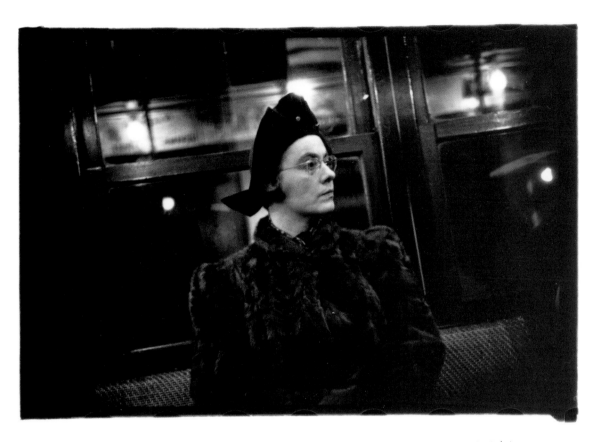

© Walker Evans Archive, The Metropolitan Museum of Art

∧ **IN 1931, AMERICAN OPTICAL** introduced the Ful-Vue frame and promised in their advertising "temples are high so that your eyes are fully revealed from the sides." This style helped to close the door on the 1920s iteration of library frames. The high-set temple, which held lenses in a downward tilt, was intended to be more elegant and more invisible for men and women wearers. In 1941, the style was captured on the subway in a surreptitiously taken photograph by Walker Evans. [*Woman Wearing Eyeglasses and Hat*. Photograph by Walker Evans, 1941.]

THE GLASS OF

FAS

HIO

N

Sunglasses and the 1930s

Tinted protective eyewear intended to shield the eyes from the rays of the sun was invented well before the twentieth century and even before the corrective-lens eyeglasses of the thirteenth century. There are records of lenses made of "tea stone" in China more than a millennium earlier. Eyeglasses lensed with colored crystal are documented in western Europe as early as 1600. In the eighteenth century, famed playwright Carlo Goldoni wore and popularized green-lensed protective eyeglasses. By that century's end, J. R. Richardson had patented a hinged pair of sunglasses to be attached to corrective lenses. Over the course of the nineteenth century, styles of the protective glasses multiplied and came in blue, green, and amber, and even with mica lenses. As offered in the nineteenth century, sunglasses held a different place from other eyewear — they were for outdoor adventures, for the young and vigorous. But they were not then the force they would become.

Around 1920, the photographer and optical-store owner Giuseppe Ratti developed a yellow-brown lens made from silica that was highly effective in blocking solar rays. For the company that would become Persol, Ratti made protective glasses for race-car drivers and air pilots. His innovative lenses became the state of the art and cultivated an association of sunglasses with daredevil heroism. By 1923, the established eyewear brand Bausch + Lomb had developed Crookes glass lenses for their own sunglasses, and by 1929, Bachmann Bros. had Solarex sunglasses. By 1932, Edwin H. Land had perfected the light-filtering plastic sheet known as Polaroid. This ferment of technical innovation was aimed unequivocally at the military and sporting markets, as early makers of sunglasses trumpeted their product's hypermasculine associations and technical innovations.

This is likely why the sudden boom in sunglasses as worn by movie stars took manufacturers entirely by surprise. The sudden popularity of sunglasses made space in the optical market for more democratic, drugstore brands, which sold sunglasses on merchandise carousels and offered more color and style than military excellence. The exponential growth of sunglasses that took place in the 1930s was very much star-driven. It also aligned well with the vogue for a well-heeled beach or resort vacation.

Since sunglasses could be free of some of the demands of the optical trade, styling became a key element of sales. American Optical created sunglasses to match Asbury Mills swimsuits in 1934 and in 1936 introduced Polaroid Day Glasses. By 1937, Bausch + Lomb introduced Ray-Ban sunglasses, with lenses

manufactured by Polaroid. With style at the forefront and confirmed health-care elements in place via the true blocking power of the Polaroid lens, sunglasses as a form were at the perfect nexus of want and need for a glamorous young audience (or an audience that wanted to see itself as a glamorous young audience). By 1939, one million Polaroid-lensed glasses had sold.

Fashion magazines embraced the trend enthusiastically, and sunglasses were featured in fashion editorials. American Optical was advertising for more fashion attention in *WWD*. They touted their ad campaign to the trade, hyping their launch of AO Cool-Ray Sun Glasses and AO Polaroid Day Glasses. American Optical recommended placement of its products on the department store's main floor, in beach and camp departments, in sporting goods, and in automotive accessories. At the relative low cost made possible by the increasingly muscular American fashion-manufacturing system, sunglasses were certain to be high-yield accessories. "AO Displays take up little space — pay for it many times over in the *extra* profits they make," the ad announced.

Sunglasses broke the last barriers to eyewear for fashionable women. They were protean and inescapable in the resort-collection fashion-magazine photo editorial from the late 1940s onward. Sunglasses accommodated every eyewear shape and every whim of styling. While further innovation would be required to draw fashion to corrective spectacles, sunglasses were secure in their place as a high-style accessory by the end of the 1940s. They offered youth and beauty, they offered mystery, and they offered a range of personalities from the dream machine of Hollywood films.

> **THIS ILLUSTRATION** by Georges Lepape, first published in a July 1, 1932, issue of *Vogue* next to an article entitled "The Gospels of Beauty: XIII: The Burning Question," captures the elegant woman's adoption of sunglasses. Driving or flying or other derring-do paled next to the serious business of tanning, which was newly supposed to be an expression of leisure and status rather than a harsh sign of a body's work and wear, as of the 1920s. A bottle of suntan oil at her side and a bottle of blond on her head, Lepape's beach girl is an escapee from the silver screen gone crispy sienna. The article's focus is the need for oils and creams for the enthusiastic tanner rather than the type of sunglasses to wear (simply solarized library frames in this case). The tinted lenses and the need for them at the beach began being sold to women when the innovations in protective coatings came to the market in the 1920s. Sunglasses went full supernova when Edwin Land's polarized plastic sheeting was adapted for the lenses and went into mass production via multiple brands in the late 1930s. The lens material was

> **THE KEY** to the emerging vogue for tanning, swimsuits, and sunglasses in the 1920s was the new significance of the younger American customer at French fashion houses. She was active, athletic, and affluent, and she drove the mode for sportswear. Then, as now, brief, snug swimsuits and hours under the sun were not commonly appealing to the middle-aged. There would have been no sun bathing or sunglasses in the 1920s without the youthquake.

A similar demographic shift was under way in the early 1990s, and it supported the extreme brevity of tweed and knit in Karl Lagerfeld's spring/summer 1994 collection for the House of Chanel. Among the pastel microminis was a black string bikini accessorized with Chanel-themed beach towels and a pair of pearl-studded sunglasses. Invoking Coco Chanel, the early adopter of suntanning chic as well as costume pearls, the House of Chanel created an exaggerated pair of sunglasses spectacles that are still iconic and among the most highly valued on the resale market today. [House of Chanel runway. Photograph by Guy Marineau, 1994.]

< **SUNGLASSES DIDN'T** necessarily have to answer to the discipline of opticians, who had by the end of the 1920s successfully corralled the corrective-eyewear business, taking it away from jewelers and department stores. That meant there was great freedom in their design. Making colors and more exotic shapes to match an ensemble was easy and limited only by the imagination. The 1930s sunglasses were plastics in an array of toylike colors and were sold at the corner drugstore. This meant they could be bought in multiples on a whim far more cheaply than any other accessory. For his spring/summer 1991 collection, Christian Lacroix included a perfectly matched pair of red-framed sunglasses for the naive-stripe-print swimsuit and the red stripe around the oversized beach hat. The purple lenses, though charming, were acknowledged in magazines to be pure fashion lenses with little protective ability. [Christian Lacroix runway. Photograph by Guy Marineau, 1991.]

> **IN KEEPING WITH THE SURREALISM** of trompe l'oeil pearls on bathing suits, Karl Lagerfeld's sunglasses for this swimsuit from the spring/summer collection for the House of Chanel are seemingly turned upside down and inside out. It is unlikely that these frames would aptly hold a prescription lens, but they repeat the "pearls" on the swimsuit quite nicely. [House of Chanel runway. Photograph by Guy Marineau, 1997.]

< **IN HIS SPRING/SUMMER 1995** collection, the designer Franck Sorbier offered a superflat version of white library frames to echo white-button trim on a black swimsuit. [Franck Sorbier runway. Photograph by Guy Marineau, 1995.]

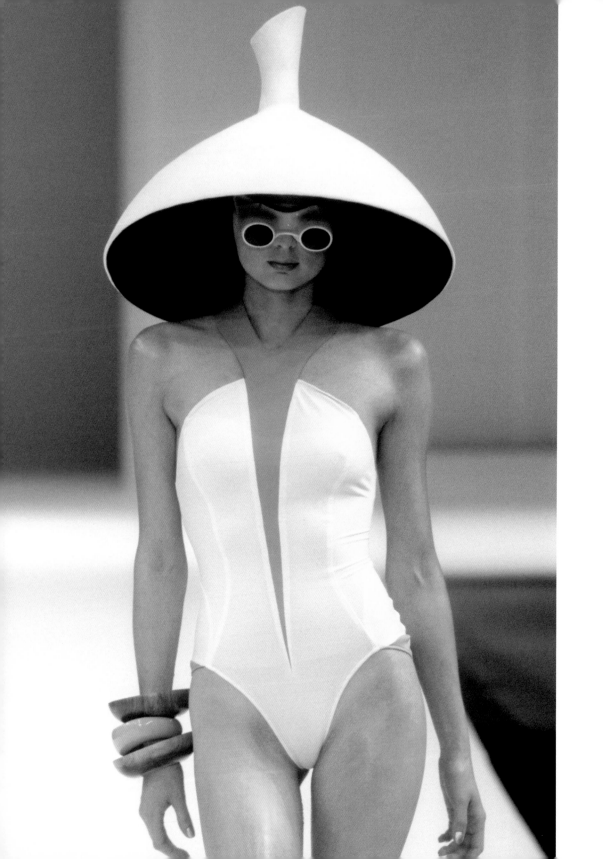

< **THE DESIGNER THIERRY MUGLER** consistently used exaggerated eyewear designs to render his runway models as couture graphic-novella heroines. While his offerings could run to full alien insect goddess, his spring/summer 1999 collection featured a relatively subtle pair of white sunglasses with built-in visor in keeping with the streamlined, industrial aesthetic that guided eyewear design in the 1930s. Over a white swimsuit and paired with bangle bracelets and an oversized, stemmed hat, Mugler's sunglasses summon a sci-fi fantasia version of the 1930s resort-wear context in which fashionable sunglasses emerged. [Thierry Mugler runway. Photograph by Guy Marineau, 1999.]

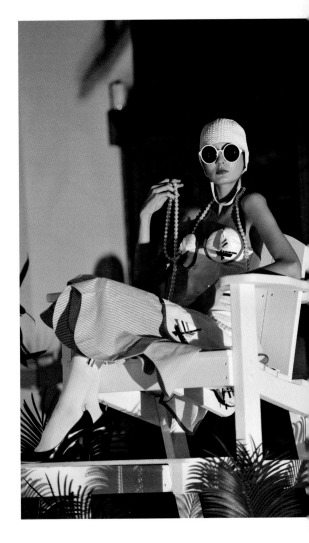

> **FOR HIS SPRING/SUMMER 2012** collection, designer Thom Browne created a tableaux of a 1920s pool party, accessorizing the models with library frames that were a size or two up from the Harold Lloyd originals. The exaggerated size aptly echoed the extreme silhouettes of the collection, making for a surreal re-examination through the contemporary designer's eye of the socialites of Toni Frissell's earliest *Vogue* photography, who first popularized sunglasses alongside the Hollywood blondes. [Thom Browne runway, 2012.]

THE
HERO
IC
EYE

·IO·

Aviators in the 1940s

While glam sunglasses took over the hearts and minds of women of fashion, an adventure storyline developed by Persol and Bausch + Lomb would birth a more heroic iteration in eyeglasses, the aviator. The earliest eyewear for the pilots of open-cockpit airplanes were goggles, a highly functional style, which was refined for a number of industrial uses in the nineteenth century. Along with their working-class associations, goggles were used as protective eyewear for those who traveled by coach in the nineteenth century. In 1867, goggles for polar expeditions were developed. In 1869, goggles featuring viridian lenses and wire-mesh cups were introduced for transcontinental rail conducting. By 1900, a rubber seal fit goggles to the face. In 1917, Giuseppe Ratti marshaled all this innovation into a rubber-framed pair of eyeglasses with an elastic headband, called Protectors, which were worn

by World War I fighter pilots. From the turned-teardrop shape of the Protector goggle lenses, the aviator frame was born.

The idealized form of the aviator frame crystallized as eyewear makers competed to design frames to be worn by military servicemen during World War II, with multiple manufacturers claiming credit for the invention of the aviator frame. As the U.S. Army issued an aviator-style frame to its air corps pilots, the heroic image associated with the frame, if not ownership of the design, was secure. The aviator was at first a primarily masculine style (though there were certainly women aviators); if an aviator shape was offered to women, it was under a generic name, such as *day glasses*. The macho associations of the lenses intensified when, in 1953, Marlon Brando wore the frame in the iconic biker movie *The Wild One*, combining antihero and hero cachet with already-proven, movie star marketing appeal. It was as a hypermasculine frame that fashionable aviators for women finally emerged in the magazines in the 1970s. Already established in the wardrobe of the feminist icon Gloria Steinem (who was, no doubt, aware of the pioneering feminist work of famed aviatrix Amelia Earhart), aviators were used in the fashion editorial to create the narrative of the boundary-breaking, liberated, and sexually aggressive woman.

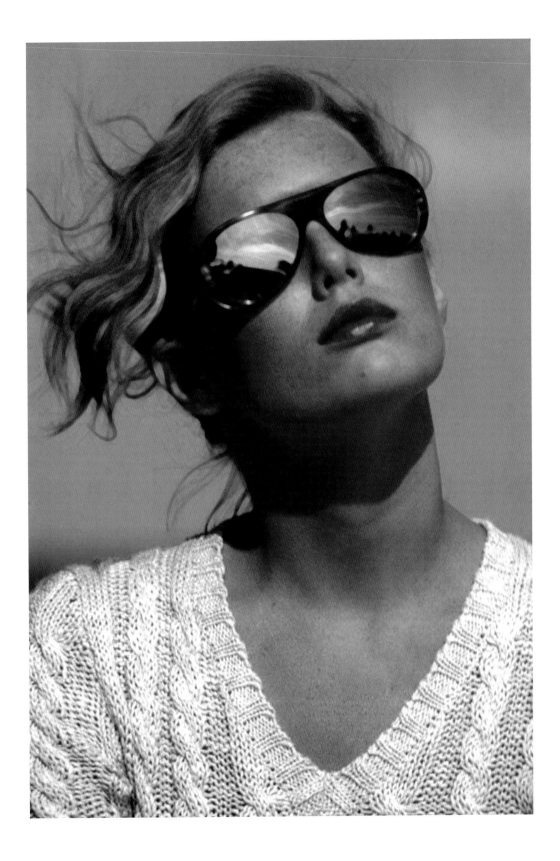

< **DESPITE THEIR UNDENIABLE** military and masculine associations, aviator glasses were embraced by fashionable women from the earliest days of airplane flight. And since aviation could be women's work, *Vogue* was already addressing the fashion issues by 1909, in an article titled "Women of Fashion Are Enthusiastic Aviators — A New Costume Must Be Evolved for Air Travel." While the article mainly addressed balloon travel and concerns over whether the situation warranted divided skirts, the opportunity for women's airplane flight (and what they would wear for it) was on the horizon. Through the 1910s, aviation was enthusiastically covered in the pages of *Vogue*, both as an exciting new pastime and as a heroic endeavor during World War I. Articles included first-person accounts of flight by aviatrixes, celebrity profiles of women

and men aviators, French women's enthusiasm for flight, and the Vanderbilts' investment in aviation. Aviation was even featured on *Vogue*'s "Society Calendar of Autumn Sports." Simultaneously, designers began to offer aviation dress, which overlapped with motoring dress and ski wear in the fashion pages. A June 1, 1913, article in *Vogue* noted, "Shopping in the airless zones of feminine fashion one met the 'lady aviator,' clad in knitted wear, complete up to her aviation cap, and intent on ascending in nothing more dangerous than a bargain-sale lift." The women's dream of flight established at the beginning of the century persists through Arthur Elgort's image of Patti Hansen, windblown and looking skyward in mirrored, tortoiseshell aviators in 1976. [(Previous page) Patti Hansen in mirrored aviators. Photograph by Arthur Elgort, 1976.]

> **CIRCULAR-LENSED GOGGLES** predated the teardrop-shaped aviator frames for real-life aviators, especially if they flew in an open-cockpit plane. They were simply the most functional design until Giuseppe Ratti's version, which combined the coverage of shield glasses with rubber-gasketed goggles. For flying, driving, and motorcycling at the beginning of the twentieth century, goggles were the most practical design. And with safety concerns paramount for early fliers, there was no compunction about raiding the menswear wardrobe for the goggles. A September 1, 1911, article

from *Vogue* profiling a Miss Quimby, cited as the first licensed American aviatrix, noted that she had "dismissed the difficulties of dressing for the sport by adopting the comfortable costume of men aviators," including "aviation goggles."

The designer Kansai Yamamoto used the goggle-style frame in his spring/summer 1991 collection to cultivate an air of maximalist industrial-design aestheticism. The goggle-style stands out as a highly functional iteration of the designer's often playful and absurdist vision in eyewear, which included many frames that at least marginally obstructed vision. The dramatic design impact of those less ophthalmologically correct offerings was also possible with the goggle style, which was iconic of the working-class heroism of the 1930s. A late 1930s Works Progress Administration (WPA) poster reveals the origins of Yamamoto's goggles in a vision of the eyewear that is equal parts Constructivism and comic book heroism. [(Left) Kansai Yamamoto runway. Photograph by Guy Marineau, 1991. (Right) Poster for WPA Illinois Safety Division promoting safety and use of proper eye protection, 1937.]

∧ **THE AVIATRIX** is a subgenre of 1920s and 1930s fashion, both as marked by fashion journalists in the early twentieth century and as revived and hybridized by contemporary designers. Female fliers were promoting Cutex Liquid Polish in the ad pages in *Vogue* in the 1920s while the magazine's reporters noted that a Long Island aviation club was looking for lady members. As for the flying wardrobe, fashion magazines were keen to advise, and a January 1, 1933, profile on Amelia Earhart in *Vogue* cautioned, "Don't mix your sports clothes. Flying has its own chic, distinct from that of any other sport, and the wrong costume brands you as an amateur." An October 1930 *Harper's Bazaar* article opened with the question "When Eve takes to flying, does she need special garments for the purpose?" and Paris fashion correspondents effectively answered yes, as French couturiers designed for the lionized women aviators. Meanwhile, an August 1932 article in *Harper's Bazaar* noted that the ensembles weren't solely for flying and that "many European women wear goggles and aviator's caps for motoring." Even the ubiquitous close-fitting cloche cap that was iconic of the era was consistently referred to as an aviator cap. [The aviatrix Ruth Elder, ca. 1929.]

∧ **THE CHIC AVIATRIX** has been persistently revisited by contemporary designers, usually with other mixed and reconfigured elements of the 1920s and 1930s sportswear wardrobe. In Consuelo Castiglioni's spring/summer 2011 collection for Marni, the designer combines small prints and rayon acid-bright colors influenced by the innovative synthetic textiles of early twentieth-century American mass-produced fashion with a leather aviator's helmet and a pair of ombre brown-to-yellow frames with brown lenses. The lens color in the early goggles and aviator glasses was a crucial distinction, as yellow-to-brown lenses were associated with the most glare reduction. In her fall/winter 2011 collection, Miuccia Prada took the hallmarks of the early twentieth-century aviatrix and exaggerated all the elements. The blown-up schoolgirl collar, the huge silver buttons at the edge of the thick-fabric helmet cap, and the outsized shield-style frames in red all cued up the fashionable flier of the 1920s. [(Left) Marni runway, 2011. (Right) Prada runway, 2011.]

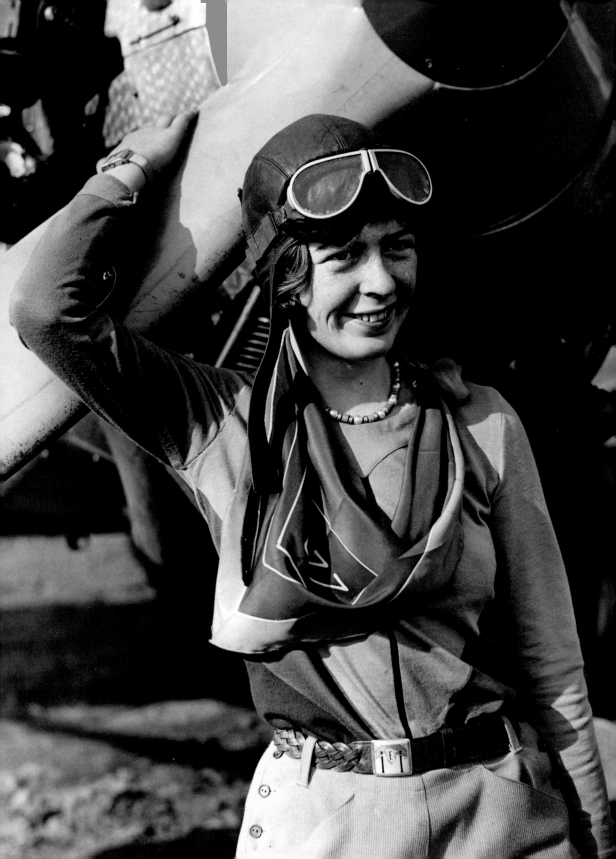

< **THE IDEA OF "AVIATION GOGGLES"** covered a broad range of shapes through the 1930s, and they were generously shared outside the strict confines of the airfield. A search for the styles in the fashion magazines suggests that while the idea of functionality was a selling point, the ideal of functionality was optional. An August 1933 *Harper's Bazaar* article promoted glasses that weren't even the proper lens color, for the sake of fashion, noting, "Dark glasses are sky-blue this summer. Meyrowitz has produced what they call their Anifra glasses, which are aviation goggles, exactly like those that they furnish government pilots, made according to government specifications. They cut down seventy-five per cent of the glare and none of the light, so that you can read a book without strain and see a fascinating little situation at the other end of the beach without any trouble at all." Blue-lensed protective glasses had a history going back centuries but were not ever considered ideal against glare, but still the report noted, "They come in the most divine shade of blue in the most divine ultra-modern mechanical age shapes…These little points have probably never even been noticed by the government aviators."

Aviatrix Elinor Smith, who flew to fame starting in the late 1920s as the "flying flapper," represented the pre–World War II vision of the fashionable woman pilot, but stunt-flying frivolities were to be abandoned as World War II came on the horizon. The aviatrix heroine very nearly disappeared from the pages of *Vogue* in the 1940s and was replaced by the military hero, husband or beau. Still, a 1940 *Vogue* article noted that there were 902 women pilots in the United States (out of 35,000 civilian pilots total). These women would serve the war effort as flight teachers or war-pilot auxiliary forces. *Harper's Bazaar* acknowledged the more serious work of the woman flier in an article profiling Barbara Kibbee, the only woman flight instructor at Troy Airport. In a June 1941 article: "The bored debutante seeking a new diversion, the adventuress flying for thrills have passed with the 30's. A new company of airwomen has taken over, to whom flying is a sober, serious business." At the same time, the army-issued aviator frames, dark-lensed and teardrop-shaped in a wire rim, became the prototype of the style going forward. [The aviatrix Elinor Smith. Photograph by George Rinhart, ca. 1929.]

< **THIS CLASSIC** aviator frame and the ballsy sense of heroism that should go with it were evident in Gareth Pugh's fall/winter 2016 collection, which featured a whole passel of 1940s hairstyles and several models clad in the type of butter-soft shearling-and-leather flight jackets and coats that chic aviatrixes had favored since the 1920s. If women could have flown for the air force, and not been limited to the auxiliary, this is what they would have worn. [Gareth Pugh runway, 2016.]

> **THROUGH THE 1950S** and much of the 1960s, aviator frames seemed to disappear from the fashion editorial, likely as much due to the shifts in eyewear fashion for women as to the military and masculine associations with the frames established during World War II. Aviator frames came blazing back in the 1970s, with the narrative of militant independence firmly intact. The ascendance of the women's rights movement in the 1970s was accompanied by an iconization of that movement in fashion photography. In order to make women read as independent in the fashion editorial, the chic of the aviatrix's narrative of the 1920s and 1930s, in which the women were first covered in the fashion magazines as society figures or entrepreneurs, was rediscovered. The aviator frames were the simplest shorthand stylist's tool to relay the association with the inherently feminist narrative. Whether the fashion magazine was leading or following with the aviator frame, an August 1972 *Harper's Bazaar* beauty column reporter confirmed the resurgence of the wire-rimmed aviator as a bestseller. By May 1978, *Harper's Bazaar*'s Eye Sense column covering the frames recommended them particularly for sports, since "wire-framed aviators tend to be best because they give you a wide field of gaze with the least amount of peripheral interference."

The rediscovery of aviator frames in the 1970s as a part of women's eyewear wardrobe coincided with a revival of 1930s and

1940s styles. In Kourken Pakchanian's image for *Vogue* in 1972, the hairstyles, short, bulky fur coats, and femme trousers all reflect the 1940s revival, as complemented by the aviator frames on the model on the right. Their slightly confrontational expressions as they look at the photographer capture the abandonment of docility in the fashion images of the decade. From the 1970s on, the aviator frame was never out of fashion, and variations on the prototypical frame would become huge merchandising successes for the major fashion houses.

In Stella McCartney's spring/summer 1999 collection for Chloe, the house launched their Diamante sunglasses, a glam variation on the aviator, which were hugely popular. One of the ensembles that feature the Diamante sunglasses included a baseball T-shirt with a bold, bald eagle emblazoned across the chest, evoking the hybrid and cross-gendered history of the look. [(Left) Two models walking in front of the Seagram Building in New York City. Photograph by Kourken Pakchanian, 1972. (Right) Chloe runway. Photograph by Guy Marineau, 1999.]

HAR
LEQ
UIN

GLASS

·II·

Cat Eyes in the 1950s

While sunglasses had glamorized tinted lenses, corrective eyewear for women was still struggling for appeal in the mid-twentieth century. Even though the 1930s through the 1950s were boom times for the mass manufacture of eyewear generally, the subtle squares, rectangles, and round lenses in muted acetate rims were the kind of thing the stylish ingenue removed, if she wanted any hope of a happy ending. *WWD* assured its fashion-industry readers that "eyeglasses are surely on the road to becoming, if they have not already become, a costume accessory with a definite style appeal." But in the same article, the reporter pointed to trends for "inconspicuous glasses" of white gold.

The introduction of the explicitly feminine style of what would be called the cat eye lens changed everything at the end of the 1930s. In the book *Eyewear: A Visual History 1491–Today*, eyewear historian Moss Lipow traces the origins

of the upswept cat eye frame to American Optical's Ful-Vue frame of 1931. The Ful-Vue placed the hinges on the upper part of the eyeglass frame and its ad copy promised, "Temples are high so that your eyes are fully revealed from the sides." It was an exciting step away from the owlish library frames of the 1920s (whose hinges were at the dead center of the eye), but it was not a completely striking departure. That would come in the 1930s, when then window dresser Altina Schinasi looked at a display of optical frames in a store window and found them profoundly unappealing.

Schinasi was a woman of many trades and the daughter of a tobacco magnate. She took her idea for a new fashionable frame to a number of manufacturers but was rejected by all until she convinced the high-style optical boutique Lugene to create her Harlequin frame. It was based on the mask of the stock character from Italian commedia dell'arte, and it was extremely on trend in the 1930s, when there was a Harlequin collection at Schiaparelli, as well as harlequin dish sets, textiles, and even a black-and-white Harlequin Great Dane advertised on the dog pages in *Vogue*. Eyeglasses credited to Lugene were already a feature in fashion-editorial images, and Schinasi's creation was further promoted when Clare Boothe Luce, who had been a caption writer at *Vogue* before writing the smash hit play *The Women*, bought one of the first pairs.

By 1940, Schinasi had accepted a $1,000 design award from Lord & Taylor and her frames had broken the last line of resistance to women's optical frames. The Harlequin frame came in an array of colors (to match every ensemble). It called for its own set of accessory rules (it was not to be worn with turbans or dark lipstick). It was "optically correct" and covered by insurance. An article in *Harper's Bazaar* marveled at the changed world Schinasi had wrought: "In the old days, we obliterated our big and beautiful eyes in a nasty, narrow squint; we cut our best friends dead; we reached for the ketchup and came back with the tabasco; we jeopardized our good names by smiling at strange men; and we missed a lot of fun, all because we were afraid, embarrassed, and just too vain to wear our specs in public. But today glasses are out on the town."

Schinasi left the brand in the mid-1940s, but Harlequin frames defined the style in 1950s fashion eyewear. Numerous eyewear manufacturers made their own versions, which were carefully referred to as "harlequin-style" and later "cat eye frames" or simply "cat eyes." The success of the style with women in the 1950s proved eyeglasses' standing as a designer accessory. When the era-defining American designer Claire McCardell introduced her own branded frame in 1952 (distributed by American Optical), it was unmistakably a cat eye. It was the first time a fashion designer had created an eyewear line.

> **THE RHINESTONE-STUDDED** cat eye sunglasses in Arthur Elgort's photograph of Kirsty Hume are decoratively used to corral a backcombed mass of cotton candy, blond hair that would have been aptly worn by a starlet of the early 1960s. The elfin frames first dubbed Harlequins by inventor Altina Schinasi were unquestionably the final element that made eyeglasses' transformation into a fashion accessory possible. The explicitly feminine frame was designed with optical needs well in mind, unlike the waves of glamour-puss sunglasses that had been racking up sales in department stores and five-and-dimes. This simple fact, a product of Schinasi's collaboration with the state-certified and fashionably well-connected opticians at Lugene, meant that her frames would be the first novelty in corrective lenses since American Optical's Ful-Vue frames in 1931. It also meant that the frames would be covered by health insurance, which made them a favorite among the well-covered and heavily unionized fashion workers of New York City. Lugene's early and entirely reasonable pricing of the frames at only $8 (about $140 in today's dollars), less than one-third the cost of an American designer dress at the time, allowed wide adoption of the frames. [Kirsty Hume. Photograph by Arthur Elgort, 1995.]

< **THE SHAPE** that would dominate women's eyewear (and be entirely disregarded in men's eyewear) was described by *WWD* as "slightly lifted at the outer upper corners, yet wide and rather squared off at the lower outer corners, to give lift to the face yet provide wide vision." Though pointed corners were iconic for the Schinasi Harlequin frame, any lifted and attenuated corner in the lens would be considered a cat eye. In a photograph by Horst from the January 1, 1954, issue of *Vogue*, the plastic edges of a cat eye frame from the optician E. B. Meyrowitz are rounded, but still distinctly upswept. The cat eye frames' dominance was such that every optician and manufacturer had a version of them. In 1941, only a few years after their introduction, *WWD* was asking that "Dorothy Parker Revise — Please" and reporting in 1942 that "every variety of harlequin glass is now wanted as this upward tilted frame is quoted exceeding all expectations for popularity." The same article also reported that "sometimes women buy a number of them, all with different color frames." This, then, was the turning point for eyeglasses as a fashion accessory. Buying multiple glasses for multiple moods bridged the divide between need and want. [Model holding a Josef carryall. Photograph by Horst P. Horst, 1954.]

< ∧ **THE CAT EYE** has always given free reign to any fashion fancy. In the 1950s, sculpted and carved acetate patterns that had previously been reserved for Spanish hair combs settled atop cat eye frames. The style reasserted the ideal of eyewear as a vehicle for the jeweler's, or at least the costume jeweler's, art. In more recent designs, surreal shapes and aggressively bedazzled designs found a vehicle on cat eye frames. In spring/summer 1998, Jean-Charles de Castelbajac drew the cat eyes into stylized angel wings on a pair of mirrored glasses. Anna Sui offered a vivid fluorescent cat eye frame with rhinestones as luxe kitsch, a beach-trip souvenir in her spring/summer 2016 collection. And for her fall/winter 2016 Miu Miu line, designer Miuccia Prada styled a denim-and-velvet coat with cat eyes made by building rhinestones to a point on a translucent blue oversized frame, making hers a cartoon character cat. [(Far Left) Jean-Charles de Castelbajac. Photo by Guy Marineau, 1998. (Above Left) Anna Sui runway, 2016. (Above Right) Miu Miu runway, 2016.]

> **THOUGH HARLEQUIN-FRAME** designer Altina Schinasi left the brand in the mid-1940s, the Harlequin Corporation would go on to decades of success with the style. In 1944, it placed ads in *Vogue* and *Harper's Bazaar* with copy that exhorted customers to "BE GLAD YOU WEAR GLASSES." By 1955, the company's ads were offering "the new Harlequin Style Selector Kit" for home try-on and asserted that the "shapes of the new Harlequin frames are cleverly designed to caress your eyes with a daring new boldness…subtly accent your cheekbones…make your mouth seem more provocative." Harlequin directed customers to the company's authorized optician-dealers, referred to as "Harlequin Salons." A set of *Harper's Bazaar* fashion-editorial images by the photographer Frances Pellegrini presented in the December 1955 issue captured the high-end work by the brand. Its "diamante spectacles" were described as having rhinestones "spilling over at the corners" and "leafing up at the sides to clasp the hair in icy sprays and tendrils." In her spring/summer 2020 collection for Miu Miu, the designer Miuccia Prada offered a pair of cat eyes that similarly provided the basis for a sprinkle of sparkle, albeit on frames with a decidedly more industrial edge. [(Near Right) Miu Miu runway, 2020. (Center Right, Far Right) Harlequin-brand eyewear. Photographs by Frances Pellegrini, 1955.]

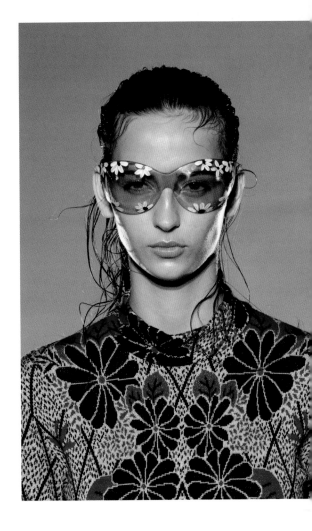

< > **WHILE AMERICAN-MADE,** simple acetate harlequin glasses were affordable, yet not everyone purchased them in multiples. The preferred trend on college campuses in the late 1940s was to modify an existing pair with nail polish for a refresh, as documented by photographer Nina Leen for *Life* magazine in 1947. Maison Margiela frames, though not cat eyes, offered a similar do-it-yourself effect with white daisies that echoed textile motives of the spring/summer 2015 collection. [(Left) Teenage girl having nail polish touches applied. Photograph by Nina Leen, 1947. (Right) Maison Margiela runway, 2015.]

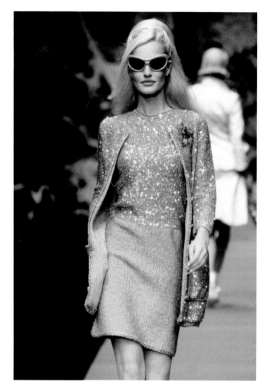

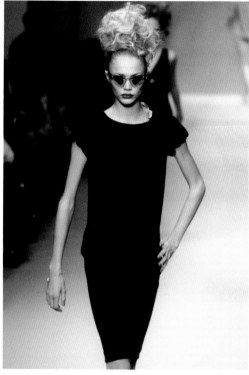

∧ ＞ **CAT EYES** have persistently framed nostalgia on the runway, often to complete or comment on fashion revivals of the 1950s and early 1960s. This was due in part to the fact that the frames went out of style in the late 1960s as hard as they had come in, in the 1940s.

An exceptionally bitchy column by Peter S. Prescott from *WWD* on February 17, 1967, that purported to cover the goings-on at the annual Westminster Kennel Club dog show but was really an extended exercise in high camp, noted the waning fashionability of harlequin frames as worn by "lady breeders,"

saying, "They are fat, unkempt and dizzy for dogs. They wear half-harlequin glasses that make them alternately resemble Altoona dentists or old maids who sell Bells of Sarna in seashore gift shops." It wasn't until the late 1970s that harlequin frames were rediscovered as cat eyes, when the 1970s styles that had supplanted harlequins were just as ruthlessly purged.

Christian Lacroix's work as a designer engaged with a lacquered and impossible luxe style of glamour for the traditional couture customer from the launch of his house in the late 1980s. As *WWD* noted in its

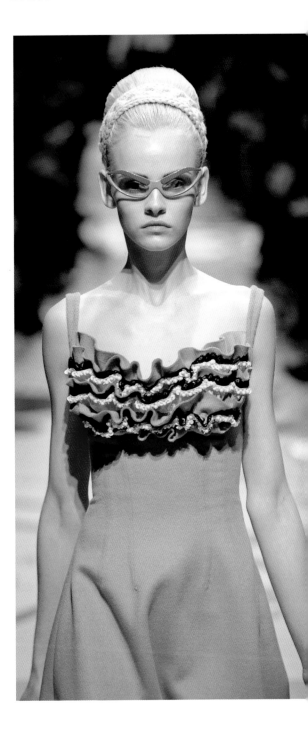

review of his spring/summer 1996 collection on October 16, 1995, "There are millions of women out there who couldn't care less about low-slung satin pants or industrial nylon, and they're just the women Lacroix targets." The collection featured a pair of gold cat eye frames perfectly matched to their ensemble, a supple, body-skimming French couture take on the type of sequined knit dress and jacket that would have been snapped up by a mob wife at a Long Island department store around 1962. In the same season, Karl Lagerfeld abstracted the cat eye and turned it inside out beneath a similarly deconstructed hairdo, less beehive and more rat's nest, all above a concerningly lean version of a 1960s sack-back-dress silhouette. Miuccia Prada returned to the 1960s for her fall/winter 2010 collection, which featured exaggerated cat eye frames in thick taupe with an exclamatory, arched browline in red. [(Far Left) Christian Lacroix runway. Photograph by Guy Marineau, 1996. (Center Left) Karl Lagerfeld runway. Photograph by Guy Marineau, 1996. (Right) Prada runway, 2010.]

∧ > **HEART-SHAPED SUNGLASSES** are considered a subgenre of the cat eye frame due to the upward swoop provided by the twin hearts' outer lobes. They were around as novelty eyewear from the 1950s but not acknowledged in the magazines as fashion eyewear, since they were more for the children's market. They were dubbed Lolita glasses after the fashion photographer Bert Stern used them in a photo for the movie poster that promoted Stanley Kubrick's 1962 film adaptation of the novel by Vladimir Nabokov. Since 1962, the frame and its acquired subversive impact have been used repeatedly on the fashion runway.

When Stella McCartney took the helm at Chloe in 1997, she was only twenty-five. Youth was one of her selling points to the established house, and there was a nod to that in the Lolita frames with blue ombre lenses that were featured with one ensemble in her first collection, for spring/summer 1998, which was marked overall by slip dresses, softly waved hair, and pink lipstick. For his spring/summer 2015 collection for the House of Moschino, designer Jeremy Scott featured candy-pink Lolita shades to match a candy-pink vinyl dress among the collection's array of Barbie-themed outfits. He had offered

a darker take on the frames years earlier in his own spring/summer 2012 collection, showing a pair of ominous black-on-black Lolitas to complement a plastic-patchwork, goth, country schoolgirl look. A half century into their design, Lolitas are a perennial frame, with versions from many vendors. In early 2020, the global department store 10 Corso Como offered its version in multiple tints. [(Far Left) Jeremy Scott runway, 2012. (Center Left) Moschino runway, 2015. (Right) Chloe runway. Photograph by Guy Marineau, 1998. (Below) 10 Corso Como heart-shaped sunglasses, 2020.]

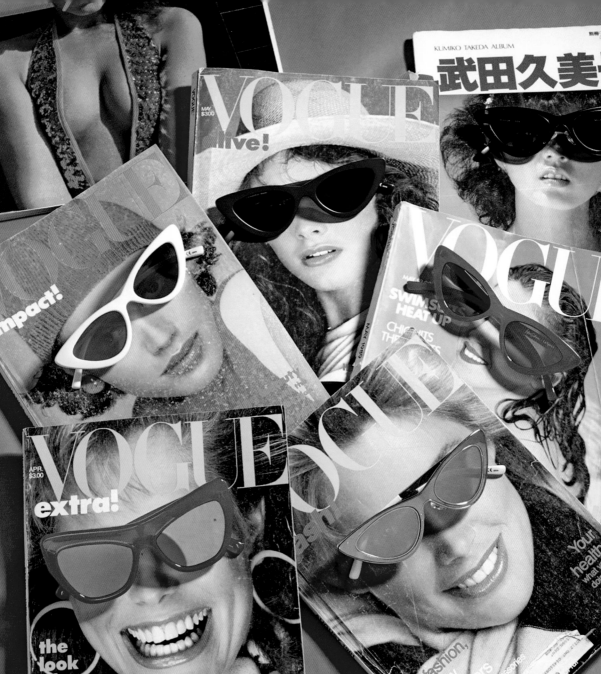

THE DESIGNER

ADAM SELMAN

The iconic sunglass frame of the late 2010s was unquestionably the Last Lolita. Released in 2016, the frames were born of a collaboration between Le Specs and American fashion designer Adam Selman. After starting his career costuming pop stars and codesigning a clothing line with Rihanna, Selman launched his eponymous collection in 2013. Not long after, he was approached by Le Specs to design the frames that would slowly gain critical mass, especially as embraced by Instagram fans like Lady Gaga and Gigi Hadid. Through successive drops that sold out over and over again, the Last Lolitas were a hit. Selman took some time out to discuss the making-of story.

JESSICA GLASSCOCK: How did you come to design the Last Lolita frames for Le Specs? How did it start?

ADAM SELMAN: Le Specs and I met through their PR agent, who's a dear friend of mine. I was just like, "I want to make sunglasses." We met and we just got along. It was never really like a name. I was a very, very small designer at the time. It was even before the Rihanna CFDA [Council of Fashion Designers of America] dress. We met and we just sort of vibed.

Whenever I was designing…I got to design two sunglasses, and the Last Lolita was the one that we focused on the most. I really studied the eyewear market and sort of decided that I wanted to make something that was really sharp and cunning that I felt was sort of missing from the market, and I just wanted something that was unique. That was the only thing that they wanted for me. They were like, "Just don't even worry about the market. Really just do something that you want to do, something that's truly unique and out there."

And so I wanted to flatten the idea of a cat eye. I wanted to bring it in, so it was sharp and small on the face, but not too small (because there's all these sort of regulations at the same time). So it was like, "How small can we make it without going too small?"

I went through a lot of sketches first and then I sort of figured out this process of doing CADs [computer-aided designs], and then I would cut the CADs out and tape them onto a pair of clear goggles, like safety goggles, so I could take pictures and look at it. And that was really my process, to sort of see how small I could make it so that it really transformed an entire look. You really can be wearing sweats or the dingiest outfit, but you put them on and it would just snap into an attitude. I wanted somehow to translate the design into a specific attitude, and it seemed to work.

JG: That graphic element is what I love about them. There's almost a comic book element to them, which is so striking and so effective.

AS: Definitely. My whole process has always been about connecting the past to the future, and I use a lot of past references. Even if I just tweak it a little bit. The cat eye is obviously synonymous with sunglasses and it's nothing new, but I wanted to take it and just sort of make it more for our time. I'm actually a huge comic book nerd, so it's funny that you say that they did sort of have a comic feel to them, because that's always been a huge inspiration for me.

JG: Sunglasses are a little like putting on the mask, right? I love hearing this idea of putting them on the goggles. In terms of the sort of health-care specifics, did Le Specs just say like, "Here you have to have this much space." Did they just give you a list of guidelines?

AS: They sent a grid to me that had little eyeballs on it. And they're like, "You have to keep

this much space around the circle and then we're cool." They kind of gave me some guidelines and they were really good about educating and there were lots of trials and errors through the process, too.

JG: Were the frames an immediate success for you and Le Specs?

AS: It took three years to really take off, actually... We made them and I showed them in 2015, I think. It really took a few years for people to really catch on. Even after multiple celebrities wore it and stuff, it didn't really have a spike for a few years. I think I was just sort of on the right path from the beginning,

JG: When you met the PR person at Le Specs and you said you had this connection and wanted to work together, how much was it a part of the process that in a sense they wanted it to become an influencer pair of glasses? Was that something you talked about or was that more organic?

AS: It was super organic. I wish that I could say that I had some master plan in place and that it worked, but it really was just a genuine... We really just liked each other, and they were, "You have creative control. We'll just help you make your vision happen." That's really how it went.

We started in 2014 like the development, 2013, 2014. That was sort of on the early side of what an influencer was today. We still hadn't

quite developed language around that. Celebrity culture, of course, was a big thing, but it hadn't translated through Instagram quite yet. Even if you kind of scroll back to those early days on Instagram, we were still figuring out a language around that and how to sell products. Really, even selfies weren't quite a huge, huge thing yet.

I think we were just sort of right ahead of that curve. And then as social media and society kind of wrapped our heads around it, the Last Lolita was just sort of there to help facilitate it at the same time. I think that it just sort of went hand in hand. But whenever we were doing it, we weren't thinking like, "Oh, this is going to be a huge influencer thing."

I think that Joe Chang, the PR director who connected us, who's a friend of mine — he was really brilliant at connecting the dots through those moments. I think that there was just sort of a pyramid of successes that people were able to connect the dots and give it to the consumer, and I just sort of lucked out in the process, I think.

JG: And had a vision. I love the idea that there was something that wasn't there, and you just wanted it to be there. I love that that's a driving part of the process.

AS: Exactly. And it was also just genuine. I wanted that sharp look to kind of offset the sweet gingham and sexiness of the clothes. I wanted to give it an edge. To me, it was more about completing the Adam Selman look. And that really helped it.

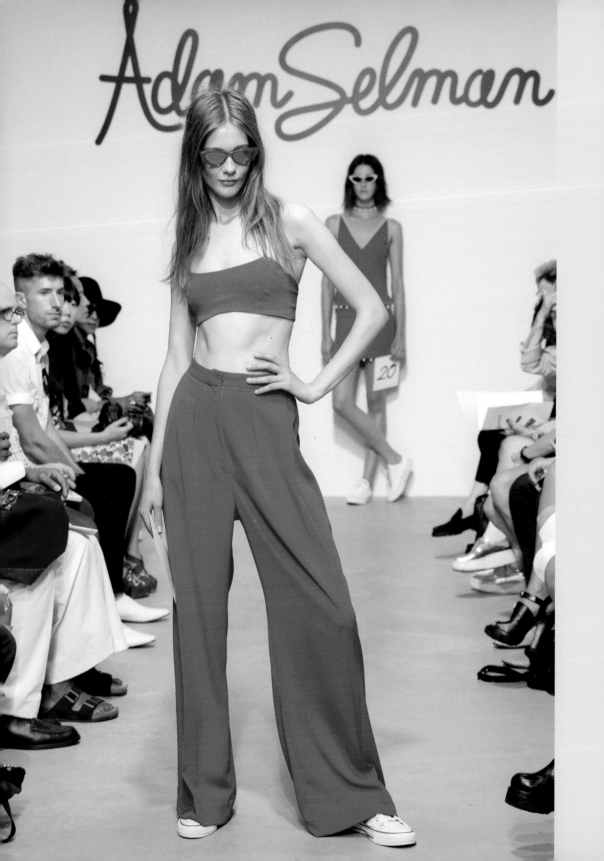

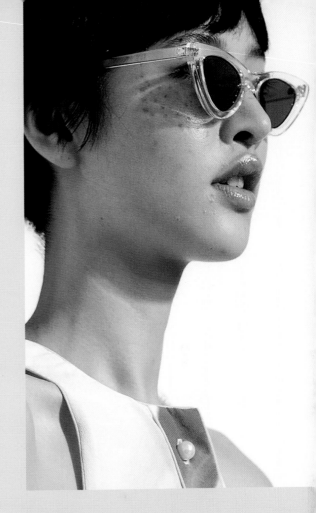

Even if you look at our first runway show with the glasses, it really helped offset the sweetness of what I was trying to do with the clothes. And that's how I wanted to sell it. It was just this instant attitude, this sort of instant fun, poppy sensation that you get whenever you wear a pair of sunglasses.

That was the reason why I paired with Le Specs, too. They were affordable. We sold them for $119. I wanted it to be poppy and catchy. They were a brand from the eighties, which I'm also so inspired by, and this Australian brand bought Le Specs. It was like this French brand. Everything about it just made sense for me and my world and the perfect collaboration. And I got so much imagery out of it.

I don't come from a luxury place. My idea of American fashion is something that is maybe more accessible than the rest of luxury fashion. I wanted it to be something that is not for the masses, but at least to be able to go in, you can get it, you can complete your look. If you can't buy an entire Adam Selman outfit, you could at least buy this Adam Selman piece and you would sort of have a sense of that look. I think that that's what individual style really is. Those glasses really helped put that cherry on top.

JG: You bring up the tension between luxury and accessibility, which is all over the history of eyewear. There are moments where the eyeglasses business is able to kind of push into fashion, but then fashion pushes back.

AS: Yeah. It's interesting. Even the Last Lolita really helped transform the Le Specs business. Celine ended up doing their own Last Lolita version. We were super in the middle and then the Celines of the world came out with their version and then Canal Street came out with their version. I guess that was what you call success.

JG: It's a blessing and a curse, but that's how you know like, "These are the glasses. There it is." Because it's a knockoff on Canal.

AS: And it makes me want to pull my hair out. And then also, I'm just like, "Well, I broke through," which is amazing. And I've been really fortunate in that regard.

I was able to break through. I was an independent, really small designer. Le Specs was a really small company, and it does prove that we're able to break through the system as well, because sometimes it feels like we're not able to gain that traction. But I think if it's authentic and it's a unique product, we really can break through on certain things. I was just hitting the market at the right time. At the end of the day, that's what it's about.

JG: It's almost like the luxury is always a little late to some things because they don't have that fluidity and that flexibility. They only have muscle.

AS: That's the interesting part about fashion right now is we are kind of coming to this point that you can't just say fashion. I think a lot of people are starting to use the words like *luxury* and how we sort of define what we're doing within the industry, because it does make a difference on who you reach out to from your platform.

JG: I know there's some additional shades you've done for Le Specs, the Luxe, the Flex. What were you thinking with those? How did you go on to do more ideas?

AS: The next big hit was this one called the Flex. It's like a wraparound. They had a side shield to it. No one was really doing that side shield whenever we had started that. I really just took a piece of paper, and literally it was just cutting out shapes and kind of making them almost like the 3D glasses that you wear in the movie theater. I was like, "Okay. We're on to something. How do you make it more interesting?"

My thing with the sunglasses is I want to make them cinematic. I took each sunglass and I looked at a point in movie history, so: the Last Lolita. Obviously, [it] goes without saying what that's inspired by. And then I had one called the Hunger, and I looked at Catherine Deneuve in *The Hunger* and looked at her glasses. It was like a cat eye as well. And then the Flex, which was based on a music video. I was just looking at different moments in history.

Everything kind of comes from a referential point of view that is cinematic in one way or the other. I went there and then we did the Luxe, which I was transitioning everything into sport. My own line into Adam Selman Sport. I wanted to go sportier.

I was looking at Elizabeth Taylor and the glasses that she used to wear, and really doing a lot of research around her and her sunglasses. And there's a movie where she's driving in a car and she has big shield sunglasses on, so I wanted it to be a mix of grandma blue blockers meets Elizabeth Taylor meets early 2005. It was this mashup of different references.

Elizabeth Taylor is actually a really fascinating sunglass icon. She really was adventurous with what she wore. She's an interesting case study in her own right for sunglasses.

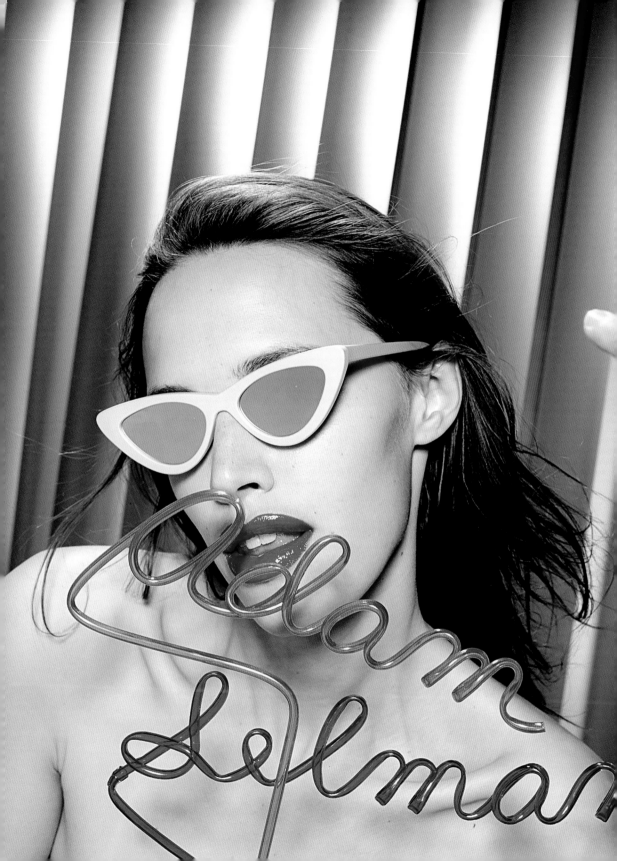

JG: A perfect inspiration! Will there be any more Le Specs?

AS: We have one more by collaboration coming out in the end of June. What's really fun is they've never given me restrictions or said like, "Oh, this is doing well, so do this." The most I'll ever say is like, "Maybe we should make an all-black pair." The black pair we launched in, I think, 2016. It was funny, because it took off. We just didn't even know to do black, since it took us two years or something to sell through the other ones.

JG: Any final thoughts or words you want to share?

AS: This is actually one of my first real interviews about the Last Lolita, which I'm thrilled will be a part of sunglass history. The Last Lolita really meant a lot to me, so it's interesting to actually finally talk to someone about the whole thing. I've done a few interviews, but not one of weight.

JG: I hope I have weight.

AS: It is cool, because eyeglasses are easily dismissed. Even though they're so present, they're easily dismissed and people forget, like, it's a real object. You really have to think about it differently than you do fashion because it's a well-engineered thing.

JUST

ONE

WOR

D:

·I2·

Plastics (1960s)

In 1960, Dorothy L. Wallis wrote in *WWD*, "What the eyeglass industry has achieved over a period of years has been nothing less than sensational." It was no exaggeration. The trade organization the Better Vision Institute estimated that more than seventy million Americans wore glasses by 1960. And options were ever increasing as eyewear manufacturers of the 1950s began to explore the possibilities for ostentatiousness. Eyewear became bejeweled and exaggerated. American manufacturers introduced modular systems, such as snap-on jewelry clips or interchangeable aluminum top rims to match every outfit. The designer Schiaparelli brought her Surrealist impulses to a line of eyewear licensed to American Optical, which meant frames decorated with oversized feather lashes. Fashion-oriented optical concerns like Viennaline established themselves with a view to the high-style customer, while the French

eyewear designer Pierre Marly became one of the early-known names in eyewear design as he cultivated celebrity clientele for his over-the-top creations, some of which were fabricated for the pure spectacle of it all.

The 1960s would be even more booming than the 1950s as eyeglasses exemplified the protean possibilities of the decade of plastic. In the fast fashion ethos of the era, tastemakers strongly advised that glasses should be consistently updated and collected in multiples. Diana Vreeland's *Vogue* cautioned against the dangers of sticking with a single, all-purpose pair of spectacles: "Unlike the perfect country house and the lifetime love, spectacles are hardly meant to be forever. And it strikes us that where spectacles do a poor job of everything except the improvement of vision, it's because they've been chosen with some vague hope for eternity—like copper pipes or a herringbone-brick terrace." The connection with high fashion strengthened in the mid-1960s. Shades of color were connected to designers, such as "Pucci–sky blue," while runways started to offer novel shapes, such as the curved slit glasses shown by André Courrèges. In 1966, Dior became the first French fashion house to license its name to eyewear manufacturer Tura. And for those interested in the even more luxe options available at the jewelry counter, fashion editors at *Vogue* touted "frames carved by jewelers out of coral, jade, or lapis lazuli," though they quickly noted, for the younger customer, that the same were made "by non-jewellers out of plastics." All these innovations were shared at newly established annual optical trade shows.

High-fashion frames of the 1960s were big and colorful. A cat eye framemaker advertised coordinating shades with an eye shadow manufacturer, with makeup and plastic frames both available in turquoise, frosted brown, frosted silver, crystal mint, cocoa frost, blue ice, snow beige, and frosted

violet. *Vogue* editors assigned fanciful color identities to tinted lenses offered in "Mouse. Grey-green. Sheer blue. Vaguely pink." The same *Vogue* feature articulates the advantages of the light tints and oversized frames, "Spectacles can provide a sneaky way to hide tired lines, re-contour a face, divert attention from the undereye department, or slink around wrinkles — and be amusing about it meanwhile… Why go to a plastic surgeon when tortoise is quicker…The more Onassis the glasses, the better."

At the exact same moment, fashion journalists at the *New York Times* and *WWD* noted the trend for decidedly retro, nineteenth-century frames in younger circles around the city and around the fashion industry. Marylin Bender for the *Times* reported that round, steel-rimmed frames for one Seventh Avenue show had been borrowed from "mature" fashion editors and buyers, but she placed the true origin of the trend at the coffeehouse Serendipity. The hipster hangout had acquired a collection of dead-stock frames from an optician who was going out of business around 1953 and "resold them, slowly and quietly, to visionary customers." These nineteenth-century frames, in a broad range of silhouettes, were the other icons of the decade, though more to the youthquake customer than Dior's. They were called granny glasses, Ben Franklin eyeglasses, teashades, and, finally, John Lennon glasses, after the Beatles band member with whom they became the most closely identified.

That supersized sunglasses à la Jackie O. could coexist, fashionably speaking, with tiny, lightly yellowed Lennon specs speaks to the comprehensive nature of the eyeglass wardrobe by the end of the 1960s. And Jackie to John doesn't even cover the breadth of what was available. Browline frames, held over from the 1950s, served a minimal butch severity to the more conservative

market, especially political figures. Sporting frames that refined the styling of the shields, goggle, and aviator frames of the 1930s and 1940s continued to be marketed as high-performance frames, such as those of Persol for driving or Vuarnet for skiing or Ray-Bans for surfing. In eyewear, as in fashion, the 1960s was the decade when everything happened. The final step toward fashion's full immersion into eyewear was taken when Dior moved its license from Tura to Optyl, a Wilhelm Anger–founded company based around the innovative plastic Optyl, which he had patented in 1964. Capable of being molded, rather than cut from rigid cellulose acetate, as most eyeglasses were, Optyl made all imaginable shapes of eyewear available to fashion designers in a light, jewel-tone pallet. The designer decade would follow.

∨ **IT IS IMPOSSIBLE** to nail down the silhouette of 1960s eyewear, because the decade is defined by a surfeit of styles. Once harlequin frames had provided proof of concept that glasses could be marketed as fashion accessories, especially if they fulfilled their corrective function as well, the invention of novel frames exploded. In a decade where plastic was a miracle material made from petroleum products that it seemed the earth would never run out of, and mending and saving was for boring old people, fashion in eyewear and in every other aspect was marked by acceleration of novelty and embrace of disposability. The progress of eyewear was noted in Dorothy L. Wallis's regular d.l.w. column for *WWD* in 1960 as she said, "We've learned to make distinctions between eyeglasses for different times of day, different types of costume… Eyeglasses may be a nuisance to plenty of us who need to use them. But there's no stigma attached. Quite the reverse. We make a feature of them."

In an effort to further feature eyewear, the Fashion Eyewear Group of America was formed in November 1964 with David M. Craig of Pittsburgh Plate Glass Co. as president and John A. Mulligan of Celanese Plastics as vice president. Their goal was "to enlarge the market for ophthalmic materials by stressing fashion in frames and promoting glasses for special cosmetic purposes." Their push for more production and marketing for eyewear was reflected in advertising and expert remarks in the fashion press. At the same time,

eyewear designers were being called out by name in credit lines of fashion editorials; captions recognized and acknowledged the eyewear designers Oliver Goldsmith, Pierre Marly, Wilhelm Anger, and Bernard Kayman. Phillip Oliver Goldsmith had been an early adopter of plastics in eyewear, beginning in the early twentieth century, when he purchased color plastic from a button factory to make his frames. [Model wearing sunglasses by Oliver Goldsmith. Photograph by Franco Rubartelli, 1966.]

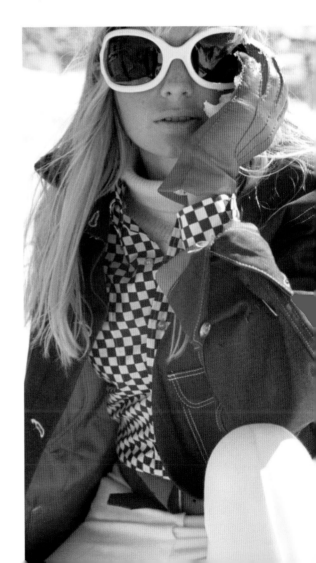

∧ > **WHILE DESIGNERS** like Schiaparelli had dabbled in wild and frankly nonfunctional eyewear ideas in the 1950s, it wasn't until the 1960s that some designers were blithely willing to prioritize aesthetics over sight in order to draw attention in the fast-moving market. The sense of play in 1960s fashion reflected the exuberant optimism of the era, though it was tempered with an equally abundant cold war anxiety. The new ideas that emerged from fashion designers could be read as evidence

of either. Were the oversized-side glasses presented in André Courrèges's winter 1969 collection playful or a mask of terror? Were the slit shield frames that had a moment in the mid-1960s driven solely by a desire to create something that had never been done or were they answering a desire for an almost armor-like level of protection?

The designer Kansai Yamamoto had no fear of sunglasses that might or might not obstruct clear vision, as long as they

augmented his outré aesthetic. In his spring/
summer 1992 collection, he included sev-
eral pairs of frosted slit frames that clearly
reference André Courrèges slit glasses from
1964, among other frames that had opaque
elements directly in front of the pupils. For
spring/summer 1994, Thierry Mugler created
slit frames that echoed the graphically cut
collar and cuffs of a short-skirted black-and-

white suit. Both designers took the permis-
sion given by the 1960s fashion designers
who had designed their own eyewear: glass-
es designed purely for visual impact. [(Left)
André Courrèges eyeglasses. Photograph by
Manuel Kansai. (Center) Yamamoto runway.
Photograph by Guy Marineau, 1992. (Right)
Thierry Mugler runway. Photograph by Guy
Marineau, 1994.]

∧ > ALL THE PLASTIC IN THE 1960S can be mourned as a fast fashion on which the earth is currently choking, but in the moment, plastic was perceived as a utopian material. It made it possible for all people to have all things immediately. It was a democratizing force. This ideal is articulated perfectly in Maurice Hogenboom's family portrait of the fashion designer Emmanuelle Khanh with her husband, Nguyen Manh Khanh, and their two children, Atlantique and Othello, all seated inside a "soft crystal" house made of plastic. Emmanuelle wore sunglasses indoors because she required prescription lenses, and she would go on to design her first eyewear line in 1972. Her husband was the designer of the vinyl furniture and "house" for his company Quasar Khanh Inflatables.

Designers engaged with supermodern themes retained the 1960s affection for plastics. For a spring/summer 1991 collection by Thierry Mugler, vinyl was a theme in the collection overall and a visual reference, in album form, on an ensemble with matching sunglasses, where both were a crazy-quilt take on Paco Rabanne's plastic armor freed from the 1960s designer's rigid grid. [(Above) "Soft crystal," transparent pavilion house. Photograph by Maurice Hogenbloom, 1970. (Right) Thierry Mugler runway. Photograph by Guy Marineau, 1991.]

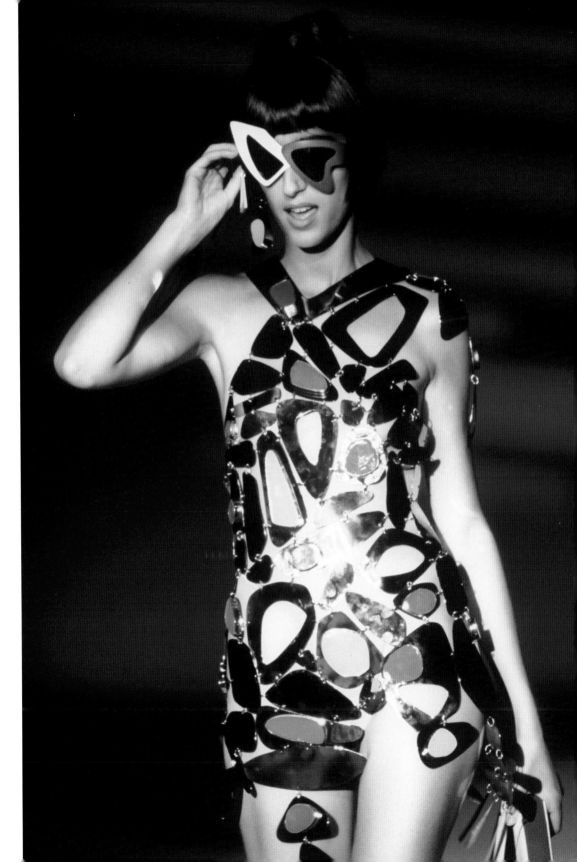

> **DR. MARGARET DOWALIBY** was an optometric practitioner from California who understood the interplay between eyewear and the fashion industry well before the 1960s, and she organized the first-ever eyewear fashion show for optometrists, in the Beverly Hills Hotel in 1950. In 1961, she published *Modern Eyewear: Fashion and Cosmetic Dispensing*, which guided opticians in their consideration of the business of fashion, which was bringing in customers who increasingly saw glasses as a potential form of eye makeup. Dr. Dowaliby advised on matching frames to faces while 1960s fashion editors advised on matching makeup to frame. In its October 20, 1969, issue, *WWD* even gave notice that a trade organization called Vision Group, Inc., would be offering a fashion experience in eyeglass shopping, "with specialists picking eyeglass frames to suit the customer's face, and a cosmetician suggesting tie-in makeup while the glasses are made up." The designer Karl Lagerfeld fully explored the aesthetic potential of eye makeup and eyewear interplay in his spring/summer 2012 collection for Fendi. Every model on the runway wore rimless, shield-style glasses in varying tints with gold or silver leaf eye makeup visible behind them and plastered up to the models' eyebrows. [Fendi runway, 2012.]

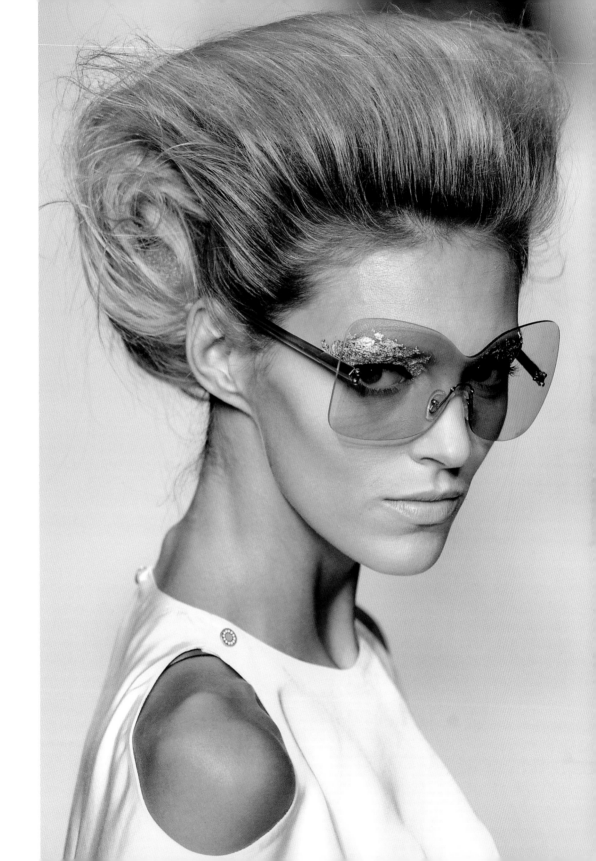

LOGO

MANI
AC
s

The Designer and Oversized
Eyewear of the 1970s

Optyl began distribution of its Dior frames in 1969, and other fashion houses thronged into the eyewear business soon thereafter. While fashion designers had dabbled with glasses manufacturers before, the 1970s marked the full embrace of the licensing model in fashion eyewear. In 1971, Mila Schön, who had already had frames on the runway in the mid-1960s, launched a licensing deal with Piave. In 1973, Pierre Cardin, who had already done extensive licensing, introduced his first eyewear collection. Mary Quant was the first British designer to design her own line of eyewear, in the early 1970s, working with the manufacturer Algha, which had previously made eyeglasses for Britain's National Health Service. Yves Saint Laurent was licensing frames specifically for the Japanese market by 1973. Givenchy had its own version of Optyl glasses by 1974. And so on. Designer eyewear in the 1970s, highly styled and assertively branded, was a stunning success. As *WWD* noted in 1975, "The license-franchise route is leading to untapped gold mines."

American designers were equally engaged with this new opportunity. By 1976, most of the major American designers had deals with eyewear concerns. Bill Blass eyewear was licensed to Titmus Optical. Halston was designing frames in his name for Bausch + Lomb. Ralph Lauren, Calvin Klein, and Diane von Furstenberg were all working with Optique Du Monde. Anne Klein was at Riviera, and Geoffrey Beene at Victory Optical. The gold rush was significant enough in the United States that a network of licensing agents sprang up to help designers profit from their names on eyewear or anything else that could be licensed. Covering a shop of agents in 1977, *WWD* pointed out that "fashion designers have become eminently salable commodities, spawning and supporting an army of brokers bent on protecting, promoting and licensing their names to manufacturers of everything from T-shirts to tennis courts." And for that license, a designer could expect an average 6 percent royalty on the wholesale price of their sunglasses.

For the consumer of designer eyewear in the 1970s, the many frames available offered not only high style but also a way into any given designer's total look. For American design fans, to have the Halston frames to go with the Halston dress (and the Halston towels and the Halston sheets) assured the buyer that they were perfectly correct. In the case of eyewear design by the European

houses, sunglasses might be the only piece of the look available to the buyer. Designer eyewear was an entry-level purchase — a way into the fantasy of the fashion editorial that was relatively accessible, as compared to the full couture ensemble.

Strictly fashion eyewear by no means defined the looks in shades and prescription lenses in the 1970s. In a decade where high-style eyewear was increasingly accessible, celebrities sought custom options from more exclusive retailers like Optique Boutique in Beverly Hills, which supplied bespoke eyewear to Elton John and Elvis Presley, among others. Widely available drugstore suppliers were still a significant part of the market as well, and they kept low-cost versions of classic frames in circulation. In particular, the aviator frame had a strong resurgence. Thus the eyewear editorial in the 1970s, especially in the hands of "porno-chic" photographers like Helmut Newton and Chris von Wangenheim, ranged from bourgeois hippie exotic chic gone to seed, to girl from the slutty beach house next door, to straight-up fur-wearing rich bitch, to the feminist in aviators, who could be any of the previous three if she damn well pleased. And for men, who could engage with high-fashion styles or the classics, the look was louche and virile, with maybe too much suntan oil glistening under aviators, or a squared-off, oversized frame lined with a square jaw.

> **HIGH-FASHION SUNGLASSES** of the 1970s might be best described with the overly broad but still-apt term *oversized*. The more-fanciful fashion-editorial caption writer might call some of them "butterfly" shades, a term that had appeared in *WWD* in 1943 describing a variation on the harlequin frame. The term took hold around 1970 when eyewear makers Anglo American worked with a toy producer to create an oversized, sculptural frame in 1970 that sold surprisingly well for a one-off idea.

The outsized, biomorphic frames and their oversized lenses, which dominated high-fashion eyewear designs in the 1970s, had already been a source of tension between the opticians that typically carried and sold designer prescription eyewear and the fashion designers behind the extreme proportions. While the styles worked well as sunglasses, some prescriptions for corrective lenses could not be properly filled on the excessive scale. In the early 1970s, Mary Quant became the first British fashion designer to put her name on glasses, produced in collaboration with Algha, which had previously worked mainly as a provider of National Health Service frames by the millions. Quant entirely designed the range, but the fit on her designs was poor. A second range was produced in 1974 with more input from traditional opticians and less fashion-over-function impetus.

The frames by Quant and the other big-name designers were aggressively marketed despite this, due in no small part to the competition from contact lens makers. Contact lenses had existed, at least in theory, since Sir John Herschel proposed the idea in 1845. The term *contact lens* was coined by Dr. A. Eugen Fick, who had been experimenting with them first in rabbits' eyes and then in his own. Contact lenses were first manufactured in 1892 but were not widely accepted until the 1950s and 1960s. Lower costs and wider availability led to a boom in contacts in the 1970s. The allies of contact lenses were predicting a dire future for eyewear, with Dr. Robert Morrison of Morrison Laboratories telling *WWD* on April 23, 1971, "In 15 years, I predict eyeglasses will virtually disappear; about the only place you will see them will be in old movies. One day we will laugh about glasses the way we do about other outmoded accessories to living."

So, suddenly fashion designers and opticians were in it together. The House of Dior was the first to secure the designer/optician relationship through its founding of Christian Dior Eyewear, Inc., in the mid-1960s. Dior recruited a fleet of women sales representatives through an ad in *WWD* seeking women "with previous sales and travel experience (preferably cosmetics or fashion) — for heavy travel in territories throughout the United States (to) introduce Dior's newest product, eyewear (eyeglasses and sunglasses) to the optical profession." The work paid off in an avalanche of "CD" logos for decades to follow. [Model in Dior sunglasses. Photograph by Arthur Elgort, 1976.]

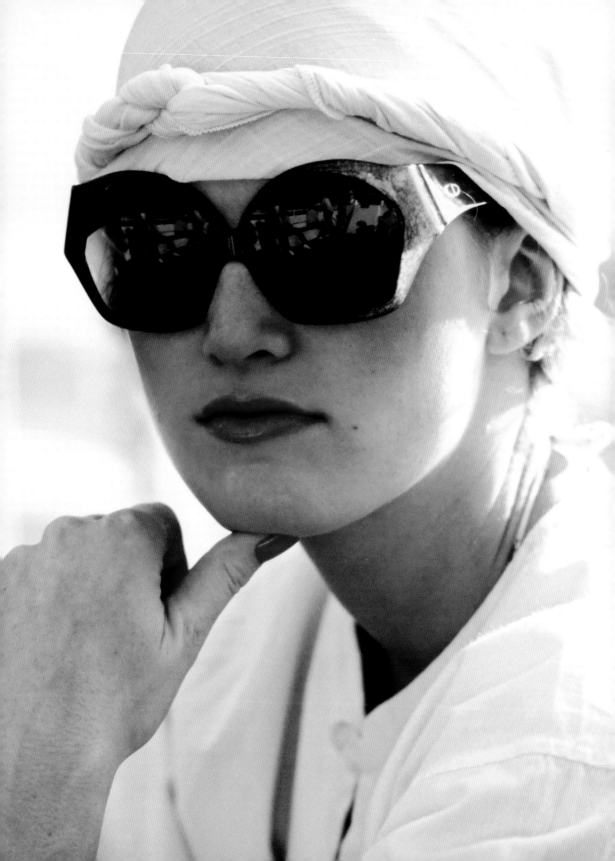

∧ > **WHILE THICK, SUBSTANTIVE** frames made an easy vehicle for the brand logos that were part of the 1970s designer eyewear DNA, other trends were embedded in that particular glasses silhouette. In Dior's enamel-insert over-sized sunglasses, the oversized round shape and straight temples are an imitation of Chinese spectacles of the late nineteenth and early twentieth centuries. The China of the nineteenth century and earlier was a fantasy location in the collective fashion mind of the 1970s, culminating in marketing campaigns at department stores like Bloomingdale's, exhibitions of Chinese dress at the Costume Institute, and a controversial collection and Opium perfume at the House of Yves Saint Laurent. The enamel decoration on both pairs of early designer Dior frames imitates the look of cloisonné, a material which evoked the aesthetic traditions of ancient Egypt, Ming Dynasty China, Meiji-era Japan, and czarist Russia, dovetailing well with the worldly exoticism cultivated by fashionable women in the early 1970s. The round, tinted lenses could also be read as an exaggeration of the hippie subculture's druggie teashades. The

House of Dior's reproduction of youth-culture, vintage styles at great expense is a fine example of the "hippie couture" moment of the early 1970s, in which the rebellious-youth affectation for secondhand or dead-stock glasses that were subversively allusive to early twentieth-century opium addicts was transformed into a high-status *object de luxe* for the *haute bourgeoise* hippie matron.

Bob Stone's photograph for *Vogue* in 1972 captured a relatively subtle tortoiseshell version of the Dior Optyl frames in less exotic circumstances. With the small print on the scarf, the color palette of mustard, rust, and brown, and the turn-brim hat, the Dior Optyl glasses revealed themselves as an oversized version of the 1920s library frames. The whole ensemble had seemingly traveled forward in time as a striking example of the revival of the 1920s in the 1970s. [(Above Left) Christian Dior enamel-insert oversized sunglasses, 1969. (Above Right) Christian Dior "Gipsy," blue enamel, oversized sunglasses, 1969. (Right) Model in an aisle at B. Wankel and Son hardware store. Photograph by Bob Stone, 1972.]

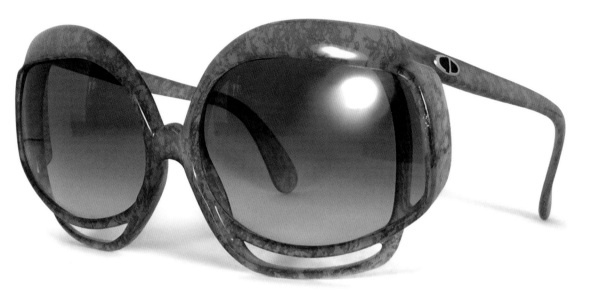

< ∧ **AS OPTYL LENSES** became the standard for designer eyewear, the reassertion of eyeglasses as jewelry was ascendant. That the carved stone is actually a thermosetting plastic did not detract from the narrative. If anything, Optyl eyewear extended the utopian values assigned to plastic from the 1960s. This highly accessible form of "jewelry" was particularly crucial to the recessionary fashion market of the early 1970s. While Bob Stone's image of the designer Halston's gray wrap skirt, gray wool-jersey cardigan jacket, ribbed black cashmere pullover, and ivory silk shirt was sure to stoke desire in the *Vogue* reader in 1972, the licensed sunglasses were likely to be the only element that was widely accessible. Even French designer glasses wholesaled around only $15 to $30, a far lower price than the clothing. [(Left) Model standing on the sidewalk styled with Halston's black round glasses. Photograph by Bob Stone, 1972. (Above) Christian Dior "Jade" Optyl sunglasses, 1970s.]

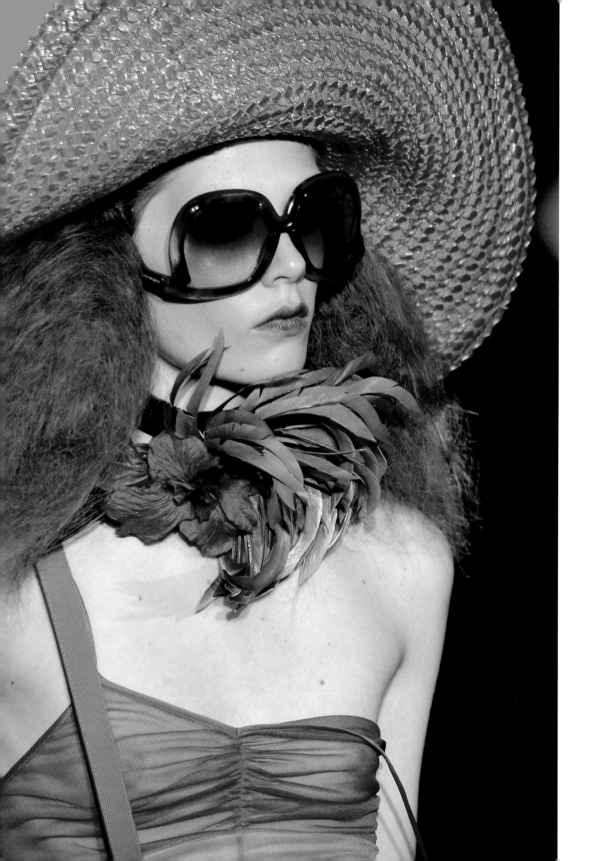

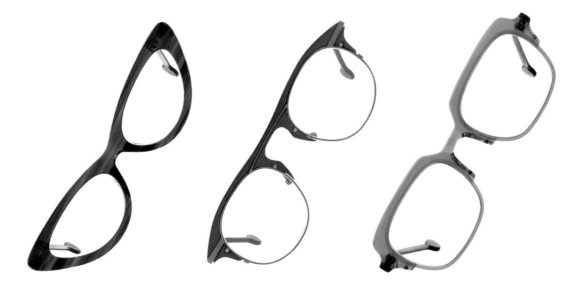

< ∧ **THE USE OF MASSIVE,** translucent eyeglass frames remains a clear cue that a contemporary designer is revisiting the 1970s, as was Marc Jacobs with his spring/summer 2011 collection. The trashy silhouette and sensibility of his model in an array of shocking pinks and purples seemed to allude to the actress Jodie Foster in the iconic 1976 film *Taxi Driver*. The pendulum-swing away from oversized frames would begin with *Vogue*'s proclaiming, "The—new!—Smaller, classic eyeglass frame...everyone's doing it" in the February 1, 1977, issue. The fashion magazines had inaugurated columns covering eyeglasses, sunglasses, contacts, eye health, and eye makeup to track the shift. In the September 1, 1978, issue of *WWD*, the cover feature showed an array of "one-of-a-kind authentic '40s catseyes made in France" and reported that a number of boutiques were now specializing in what the paper called RetroSpecs, by which it meant original glasses from the 1940s and 1950s. Of course, retro eyewear was hardly a new idea—it was a persistent force in the market for eyewear—but this framing of it as a retailing concept was new. In 1979, Barbara McReynolds and Gai Gherardi founded the optical boutique l.a.Eyeworks, initially as a reaction against the trend for oversized designer frames, which they saw as absurd. The classic and optically correct mainstream frames of 1950s and 1960s eyewear that informed the company's work and the gender-neutral values it embraced instead proved l.a.Eyeworks prescient in the coming decade. [(Left) Marc Jacobs runway, 2011. (Above Left) l.a.Eyeworks "Hickory" frame, 2020. (Above Center) l.a.Eyeworks "Diggs" frame, 2020. (Above Right) l.a.Eyeworks "The Mullet" frame, 2020.]

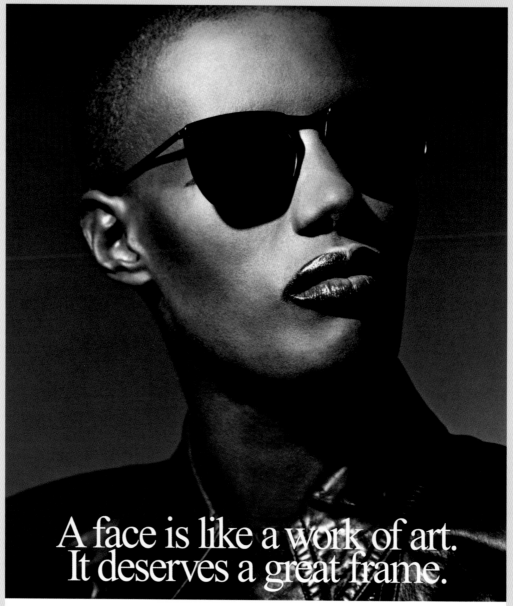

A face is like a work of art.
It deserves a great frame.

Designers of limited edition frames for sunglasses and prescription eyewear

l.a.Eyeworks®

Face: Grace Jones. Frame: Beato Lido. Photographer: Greg Gorman.
©1986, l.a.Eyeworks. www.laeyeworks.com

THE GAMECHANGERS

L.A.EYEWORKS

Established in 1979, l.a.Eyeworks started out with the proposition that eyewear
could be radical. Founders Gai Gherardi and Barbara McReynolds opened an
optical boutique in Los Angeles with a selection of frames designed to challenge
the strictly gendered vision of high-fashion eyewear in the 1970s. With an iconic ad
campaign drafting the likes of Andy Warhol, Ricki Lake, John Waters, Grace Jones,
and RuPaul, l.a.Eyeworks expanded the aesthetic narrative of high-style spectacles
to include outsiders and the avant-garde. The vast range of what constitutes
fashionable glasses would not have been possible without their decades of design.
Gai Gherardi took time to share the origin story of the brand.

JESSICA GLASSCOCK: My first question would be about when you started your business in 1979: give me the lay of the land of eyewear then and what made you start this business that has since been sustained for so long.

GAI GHERARDI: Really the beginnings were that Barbara and I needed a job, a summer job. We were working our way through school. We needed a summer job, because we wanted to hitchhike to New York. And we figured we needed two hundred bucks. That was going to do it, right? And so, summer job. And so $50 a week. Barbara got a job in an optical shop in Newport Beach, Lido Isle. And first day on the job, she called me and said, "This is—I've got the coolest gig, Gai. You've got to come and I think I could get you a job here."

I said, "Okay. This is great. We'll work together. We'll work our couple months and we'll book it." My first or second day, I had my first experience of taking a pair of glasses and putting them on someone, touching their head, looking them in the face, and there was this instant connection about what that was all about. And Barbara and I…we just couldn't believe this cool gig we got.

So it turned out this was a wonderful man, Ed Rose, who mentored us. He had two stores: one in Lido Isle, Newport Beach, and one at the University of [California–]Irvine. He trained Barbara and me from the very first day. Every morning he would teach us something. He taught us how to decenter lenses, how to

take measurements, how, how, how. All of it. Then he would go and play golf and leave us. So both of us have always been makers and do-ers and figure-outers and that was completely suited to both our personalities.

JG: Did you still go hitchhiking?

GG: We went on to work for Ed Rose for a long time, but we saved our money, had our summer job, went for our hitchhike. While we were gone, he wrote us a letter saying, "I don't know what you are doing, but when you get back, I know you're going to need a job." So when we did get back, we went back to the job. We also used the store at Irvine to hold draft resistance meetings after hours. We were figuring out how to make a lens to make someone 4F, to get them out of going to Vietnam.

JG: You were radical opticians from the very start!

GG: We were doing those kinds of things. That's the beginning of what this industry, what glasses, shaped for us, in terms of how we were going to express ourselves. They were a vehicle to us, for talking in a bigger way. And who knew it at the time, of course, but this is where we started.

And so we stayed with Mr. Rose, and he would say things to us like, "Look, I know you're not going to do this for the rest of your life, but why don't you get licensed." And, "Hey, I know

you're not..." So he would cart us off and make us get licensed or introduce us to an ophthalmologist who would tell us a great story of something about the medical aspect of the eye or that sort of thing.

JG: It was a stealth apprenticeship.

GG: Apparently. We left Mr. Rose and we wanted to do something hipper. We went to work for some other optical people at the time, a woman named Luanne Dick, who had a couple of beautiful stores. They were in the mode of the kind of what was the first of the real optical boutiques, for lack of better words. Barbara then ended up working at Optique Boutique, owned by Dennis Roberts, on Sunset Boulevard, where the whole Elvis posse and the Sammy Davis Jr. gang got their glasses. They made their mark in making something that was outside of what was going on.

For the next, I don't know, five, seven years, we worked in several places. Barbara was basically responsible for introducing the Varilux lenses into the United States when it was a French-owned company. She had a lot of technical knowledge about multifocal and progressive lenses. But we were all along just kind of saving our dough, thinking, "When can we do this?" So that's what happened; 1979 arrives and we were ready. And we got a space.

JG: Tell me about the original store.

GG: The lay of the land of Melrose was a great crosstown street. Basically, all that was on it was furniture refinishers, and there were a couple of stores that were just starting to... see it as the spot. On one side, there was a great gay-haven of goodness called Hardwear. And on the other side was a store called Industrial Revolution, who was kind of bringing around this whole idea of modern furniture. There was the beginning of a buzz, I would say. So we found a joint on Melrose. It was an old furniture-refinishing spot. It was found for us by a mentor of ours. And we knew right away this was it. This was our destination spot. We just loved it. We got a bank loan. We got a contractor (my father). We did the sanding, hammering, and nailing. And in our two great big windows, we had, "Coming soon — Changing the face," on big butcher paper, like butcher signs. That was it. And then, about two months later in the build-out, we said, "Facing the change." And then, the third one was "Changing the face — eyewear from the fifties, sixties, and eighties."

JG: What about the seventies?

GG: We had left out the seventies. And that was very important for us. We were in a massive phase of: glasses are feminine or glasses are masculine. Feminine glasses look like this and masculine glasses look like that. And if they're feminine, they're going to be ultrafeminine. Fashion designers were adding dropped temples and swooping them around and having

A face is like a work of art.
It deserves a great frame.

Designers of limited edition frames for sunglasses and prescription eyewear

l.a.Eyeworks®

Face: Jenny Shimizu. Frame: Monk. Hair: Marvin Lynch for Celestine, LA.
Make-Up: Bethany Karlyn for Trish McEvoy, NY.. Photographer: Greg Gorman. ©1996, l.a.Eyeworks. www.laeyeworks.com

something curve around, a big fat logo on it. That was something we had absolutely no affinity for in any way, shape, or form. In fact, we had dances that we would do to reenact what they looked like. I mean, we had these synchronized moves to say, "Oh, here comes somebody in a temple" that's going to go, well, into something I can indicate with a whole lot of jazz hands, which we did. We had the whole thing down.

JG: So you started designing right away to make eyeglasses that weren't that?

GG: There wasn't a lot to buy when we started, because that was the offering. But we started digging for the things we loved. We loved a frame called Speedway by Gaspari; we loved surf culture. We were raised in Huntington Beach, and the lifeguards had the good sunglasses. Or we were looking at military-issue glasses. We were looking at what the National Health glasses were in the UK. And we got our hands on those things, and we said, "Look, let's get that..." and so, because there wasn't a lot to buy, we went into looking for American, unused frames that hadn't been sold.

JG: Vintage frames!

GG: You would say vintage now, but they weren't. They were dead stock. They weren't even vintage then. We would find a tight 1960s frame you would think of now as Malcolm X glasses, for example. We found styles that had

fallen into disuse, like the Shuron Nusir. It came in a color called Moon Seed. And it was a beige-y, pinky, really vile color that we'd probably all love right now. But at the time, what it looked like to us was "Oh my God. We can dye this sucker any color possible." And so we found this dead stock of them, and we bought thousands of them, literally.

JG: An alternative eyewear. You were still a part of the resistance.

GG: We wanted to put these on women and men. We wanted to say, "Look, stop this." We really wanted to propose this kind of generic sensibility around glasses to show how sexy that was, how smart that was, how singular it was to explore your own personal style, rather than this being driven by what is for a guy, what is for a girl, especially around glasses. We were also influenced by some really cool glasses that our contemporaries were wearing in the rock scene, though they were made very cheaply. We were like, "Let's have a good one. Let's have a good quality one of those metal frames." We had an affinity for these archetypal shapes: the Ray-Ban Wayfarer, the Shuron Nusir, the aviator. And so we found them and we dyed them or we sandblasted them or we tricked them out with mirrored lenses. We took something that Aunt Ellie in Iowa would be wearing from her optometrist. And we put it in the context of young, beautiful L.A. people on Melrose.

JG: So you were part of the subculture of fashion that was living underneath the big eighties thing. It just sounds so much like that's your customer. And when you said beautiful people, I was like, "Oh, I think you mean cool people."

GG: Our appeal was definitely to writers, architects, artists, music industry. People who were in fashion…they absolutely had no eyes for l.a.Eyeworks whatsoever. But that wasn't who we wanted to talk to. We wanted to talk to this other person. And that was who came to us in droves in the beginning. And I mean, literally, we had to put a sign on the door that said, "I'm sorry. We're a bit overcrowded. Can you come back?" And it was, yeah, it was artists, architects, musicians, scientists. It was people who were

cool and thinking and were looking to identify in some way that was, I guess, outside of fashion.

JG: Whether fashion people were into you or not, *Women's Wear Daily* was covering you in the 1980s because of your success. What was the mission that guided your success? Were you tastemakers first? Opticians first? Designers?

GG: Well, we would have designed a frame the second we had a store, if we'd have known where to do it. We just didn't know where to do it. So we needed a little success to say, "Okay, we're asking questions, we're figuring it out, we're finding out." We were opticians first. And simultaneously just waiting to be designers. We didn't study design. I mean, I shaped surfboards

and Barbara was an incredible maker. I wish I could ask Barbara that question, if she sees herself as an optician or a designer first!

JG: I don't think you have to have a definitive answer.

GG: I was just thinking there were just ingredients along the way for us who were always makers, and we kept adding more tools and ingredients for the making of things. And that's just how we kind of have approached it all along. I mean, along the way we became restaurateurs, too.

JG: Or maybe curators. You use your store as a gallery, to a degree, right? As installation space.

GG: Totally. When we were building the stores and when we were designing the stores, we were fixated on taking away everything that had been there before — all of the houseplants, all of the tchotchkes. We just needed to clear the space and ask you to look at the objects we were presenting. We wanted you to see the negative space in them as much as we wanted you to see what the objects themselves were. We wanted the light to come in.

We brought in other things, like blow-up black-and-yellow-graphic road cones. And, oh my God, it just meant everything to see a black-and-yellow, blow-up road cone and a couple pair of glasses. It was just jarring. Or a bubble hat that you found at Pick 'n Save. And it was on a

glass head, and all of a sudden you just started to see the glasses differently. And that's what we were after. Our store was a gallery. We had openings every six weeks in the store with artists who became very, very notable. But it was all about the presentation of a perspective. That's really for us what it was. "Please look at it in this other way." If we've got Joe Boxer boxer shorts hanging down from the ceiling and sixteen of our new designs, there's some reason we want you to look at those boxer shorts and what we did here. There's a connection we want you to see.

JG: The idea that it was a gallery and that you were thinking in this way about the design, and the space, and installation, is so very obvious to kids now, because they go to Dover Street Market. And they're like, "Yeah, this is the way it's supposed to be. This is what a good store is. This is what makes it worth it to go into a store." And it's hard to explain, but in the eighties you got to go to the mall, and it was just this barrage of garbage and Orange Julius. And that's what you got.

GG: Hindsight tells you it's so much bigger and loftier than it really was. We were just flying by the seat of our pants, saying, "Oh, just look at it this way, it's so good." I mean, we would go to Echo Park, Silver Lake Park, and rent the little boat, because there were lotus blooming in that little lake. We'd never seen a lotus. And so we'd go out there in the boats, steal the lotus, and

then we'd make a display in the store with the lotus and a pair of glasses, because we'd never seen anything like that.

And I can remember saying all the time, "Doesn't everybody want to know where the cool music is? Just tell me where the radio station is, because that's where I want to go." Or, "Show me where the path is." Or, "If I find the path first, I'll tell you where it was." That's kind of how it evolved for us and what was exciting about it. And then the good thing was we had success. And the success, instead of binding us, gave us freedom to like, "Okay, well, let's try that." And, "Okay, we can do that." We just never thought about not doing it.

JG: It sounds like L.A. was the perfect environment for what you were doing, especially the optical community.

GG: L.A. was very supportive. The community was very supportive. When Barbara and I had a hard time getting answers, we said, "Gosh, as soon as we know stuff, we're going to tell everybody." At first we went through that thing of, unless you could frame the question absolutely perfectly, there wasn't an answer. So you could ask it, leaving out one thing, and you just wouldn't get the answer, with regard to manufacturing, what factories, those sorts of things. So that part was really, in the beginning, a little tight. But once we got it, which it didn't take that long, the established optical industry would go away scratching their heads. They

liked us. They really liked us, but they would go away, scratching their head, going, "Those girls are never going to make it."

One key connector was Michele Lamy. Michele had a store on Santa Monica in West Hollywood, called Too Soon to Know. She sold her own concept clothing and she sold glasses. She was tinting them like we were tinting them, in hairnets, in pots in the backroom, you know? She had two styles, and we bought them for our store and she would come and stand at the back door and deliver glasses. We said, "We want to go to a factory." And she said, "Oh, my father has an eyewear factory." And she gave us the address. So then we went to France and went to her factory and knocked on the door and presented a drawing. So that was a very supportive moment.

And our community was always really open to what we were doing. They just didn't know how to take us there. We even went to Bausch + Lomb and said, "Look, if you make the Wayfarer frame in this color palette, you'll sell so many!" And they said, "Ummm…" and they looked into it (at the time, the Wayfarer was made in Rochester). And came back to us saying, "Well, we made it in white. Do you want them?" They had a gazillion of them. And we said, "Yeah, we'll take all you have," because we could dye it. And that's what we did. We dyed it, we drilled it, we sandblasted it. We did it until they ran out. But in our own way, it turned out to be better, because, like I said, we had our drawings. We were going to make things. And

that's how it began. And it began at the factory of the father of Michele Lamy.

JG: So you have your curated collection of frames, you have your own designs — do you feel like fashion ever did come to what you were doing?

GG: Sure — there was a point where stylists started coming to look for what we were doing. We were a part of fashion shoots very early. I mean, the stylists would come. And our eyeglasses were transposed into illustration, if you can believe it. We would have stylists who would want l.a.Eyeworks glasses as part of an illustrative piece or something like that. That happened right away, actually, and by the time we had our first designs, that was just a given. It would be like, the stylist would come and the next thing, the Jacksons would all be in the Beat frame. But it was an L.A. vibe, not a New York thing. I mean, our glasses looked great on [Charles] Bukowski, you know? That's who they look great on.

JG: How would you situate l.a.Eyeworks in eyewear history? Besides looking good on Bukowski?

GG: We were making things that…I mean, we were so outside of the swoop of "eyewear history," because we were just making what we wanted to make. It sounds so arrogant. But we were making what we wanted to make,

believing what we wanted, believing in what we were doing, and lucky enough to have others who liked it. So how that sat, in the bigger picture, was just, you know, we were an ingredient in a time where people were doing all sorts of other things.

We were just kind of doing it, because it was our love to do it. And we would say, "God, it's just…wouldn't it be…we'll make this frame in twenty colors." We just had to, because there needed to be twenty colors, because that expressed something for us that we wanted to do and we could. And yeah, I think L.A.…back to saying it, it was always more interesting to us that a painter, or a maker, or someone like that, wore our glasses. That was always what we wanted. Like, I get chills right now when I say it. There's just nothing like that, because of the way they look at things. And so, the way that those other makers look at things. And that isn't to disregard fashion. It just wasn't our pot. I love fashion designers, but they just weren't the people we got that incredible feeling from.

JG: Still a part of the resistance.

GG: Just a little outside. I remember people saying to us sometimes, like they'd come in the store and be incredibly overtaken by everything in there and then look at us and say, "God, you know, you guys don't look as hip as we thought." We were just kind of regular…you know?

JG: "Your work is so cool, but you're, like, normal."

GG: Something like that, yeah. Because there was a big mystique, I think, about our designs. For us, they were always real and just doing what we loved and believed in. They didn't have to arrive in a black, tinted-out van with…paparazzi or something. And that's been the thing for us that is…that's the thing that, again, just the chills happen, it's like knowing somebody fell in love behind your glasses, walked along the Great Wall in your glasses, had a very…tremendous moment. All those things are happening with that. And that's what it's really been about for us, from the very second that we were able to make one.

JG: I love that. I love that. The full origin story right there. Marvel-worthy.

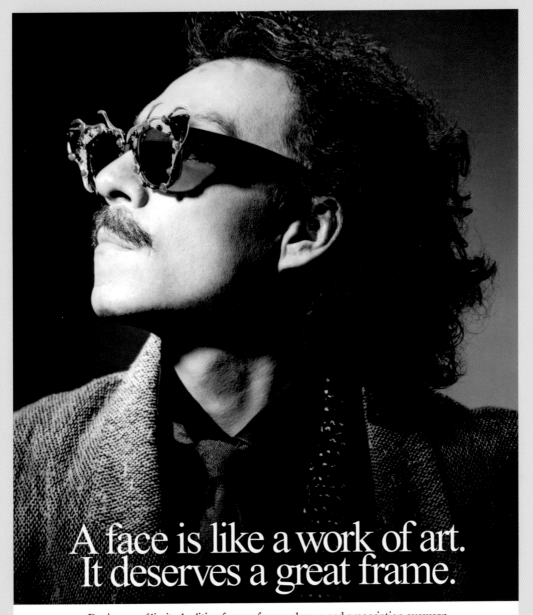

A face is like a work of art.
It deserves a great frame.

Designers of limited edition frames for sunglasses and prescription eyewear

l.a.Eyeworks®

Face: Antonio Lopez. Frame: Hillary Beane for l.a. Eyeworks. Grooming: Teddy Antolin.
Jacket: Susan Baraz. Photographer: Greg Gorman. ©1987, l.a.Eyeworks. www.laeyeworks.com

THE

ANDROG

YNOUS

EYE

·14·

Subversive Cool and
Retro Chic in the 1980s

By 1978, "eye" columns were established in the fashion magazines to give advice on eye health, eye makeup, and eyewear. The oversized Optyl styles had run their course, especially as health advisors featured in *Vogue*'s Eyes Only had to admit that the big-eye drama of oversized lenses did not effectively deliver the best prescription help. In their stead, the trend was for what *WWD* called RetroSpecs. A counter at Bendel's department store featured vintage cat eyes from France. The name Harlequin frame was lost, but the style was back, after having been purged or designated the eyewear of women who let themselves go, in the late 1960s. In the late 1970s and early 1980s, cat eyes were revived as the self-consciously antifashion choice of punk and New Wave girls.

In 1979, Gai Gherardi and Barbara McReynolds founded l.a.Eyeworks, a retail optical establishment devoted to upending the highly gendered designer frames

of the 1970s in favor of a harder-edged, unisex style. Starting with dead-stock browline frames that evoked Malcolm X, and Ray-Bans in white that they could hand-tint to a range of pop colors, l.a.Eyeworks led the way to the clean-edged graphic style of 1980s eyewear. The Go-Go's lead singer, Belinda Carlisle, wore the company's first design, the Beat, in advertisements. It marked a shift toward, or maybe a return to, Los Angeles–centered vision of Hollywood-star glasses, and it was only one of a number of revivals. The Ray-Ban Wayfarer made a comeback, as did mid-1960s wraparounds, tiny teashades, and metal frames.

Aviators survived from the 1970s as an indicator of 1930s/1940s retro glamour, as well as the established sport frame. Aviators were particularly successful when paired with a mirrored lens. Bausch + Lomb, multiple French eyewear companies, Foster Grant, and the Bloomingdale's Private Eyes counter all produced aviators. A 1980 article on the fashion scene in Los Angeles from *Harper's Bazaar* named aviators as part of the gay "clone" look in West Hollywood: "Short hair, small mustache, white vest and blue jeans or boxer shorts, optional extras include aviator glasses." By 1985, aviators were available in children's sizes. Sports-lens variations by Carrera and Vuarnet also shared in the aviators' success.

Oversized frames weren't completely gone, but the jewel-like Optyl frames for ladies wearing their resort-collection pieces were eclipsed by overlarge, high-status Cazal frames promoted by hip-hop performers. In 1984, *Vogue* summed all the trends up as "masculine" frames. *Unisex* might have been a more apt word. By 1986, sunglasses alone were a $1 billion dollar business. Sales were being

driven ever higher by movie stars in the perfect frames for the perfect moment. The fashion for eyewear had created more than just a wardrobe — a whole range of associations were secure in the popular imagination, and personas could be taken on or off at will.

By the end of the 1980s, fashion designers had begun to perceive an eyewear vernacular with the cinematic potential for a brand. Designer eyewear began to be less a monolithic style of oversized frames and more a nuanced expression of an individual designer's aesthetic. Fashion designers could pick and choose from the full sweep of eyewear history to find the pair of glasses that fit. Giorgio Armani's small round frames that evoked the 1920s and 1930s marked the beginning of this shift. His eyewear line of eighty-five styles for men and women was meant, according to an expensively produced advertising insert titled *Naming Names: Who's Who in Designer Eyewear*, to motivate "consumers to think of eyewear as a functional fashion statement to be collected, as much as the discerning consumer collects fine watches to punctuate a desired look." The Italian eyewear manufacturer Luxottica had the license and owned the Giorgio Armani Occhiali distribution entity while being, according to *Naming Names*, "carefully governed by Armani's direct input ideas, and philosophy." This somewhat-revised and more carefully managed fashion designer– manufacturer licensing arrangement, especially as practiced by Luxottica, would inaugurate another exponentially successful boom in designer frames over the next two decades.

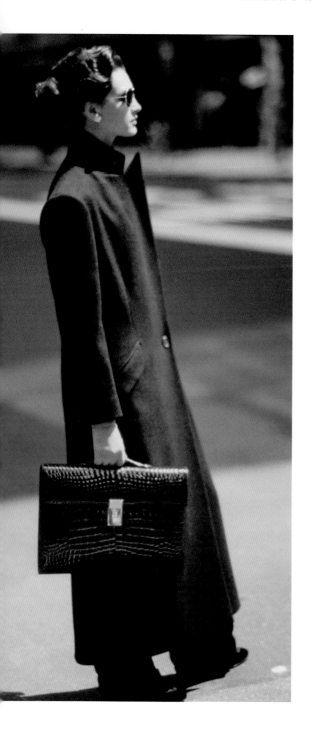

< **A CRISP-EDGED AESTHETIC** defines the style shift in fashion eyewear of the 1980s, likely as a resistant contrast to the syrupy appeal of the pretty Optyl frames of the 1970s. High-priced boho Art Nouveau lines of semi-transparent, jewel-tone plastic frames were replaced by assertive metal frames or stark New Wave asymmetrical shape combinations. Eyewear with an origin story in the military, police forces, and radical politics moved to the center of the high-fashion editorial, reflecting the high-dollar version of the independent woman, her overblown shoulder pads, and her rapacious commitment to capitalism. Fashion magazines were recommending an eyewear wardrobe of at least three frames for the older woman, who was the focal fashion customer of the decade: a daywear pair of "career" glasses, a sports-appropriate pair for the daily workout, and lightly tinted frames for evening.

Optical boutiques supported the trend of simplified shapes by encouraging the rediscovery of the highly functional frames made by American mass producers in the 1950s and 1960s among which Ray Bans were

particularly resurgent. Some shops offered vintage and dead-stock frames, and some fine-tuned elements of eyewear of that era into new designs that sharply contrasted with the less correctively functional shapes of the 1970s. While optical boutiques asserted themselves creatively on the fashion-eyewear market, the accessible drugstore eyewear brands were fading in the face of manufacturing competition from factories in Asia.

The phenomenon of the celebrity eyewear designer continued to be a force, especially through the work of Alain Mikli. Mikli founded his brand in 1978 and started offering frames under his own name as well as collaborative eyewear expressly for the high-fashion runway. In the 1980s alone, his work would be featured by and produced for Claude Montana, Chantal Thomass, and Jean Paul Gaultier. In 1984, Mikli was quoted in *WWD* on the eyewear industry generally and noted, "For me, the frame is not a medical device—it's an accessory that contributes to fashion…I think of my glasses as a jewelry line for the face."

In their February 1, 1986 issue, *Vogue* recognized the ongoing expansion of the fashion-eyewear market, with sales of more than $1 billion annually in the United States alone. The author Kathleen Beckett noted, "Today's sunglasses are in the same league as jewels—and shoes and makeup…But the tremendous popularity of sunglasses right now lies in their ability to do more than simply add the perfect finishing touch; it rests in their power, through summoning a whole range of associations, to provide a different persona for the wearer." While the magazine pointed to a few iconic frames of the season, especially Cartier's 22 karat gold-plated frames, Carrera Porsches with 14-karat-gold frames, and gold Cazals, the real story was about the expanding range of styles. With eyeglasses firmly in place as a storytelling tool in fashion, any eyewear silhouette could find a niche. As an accessory, spectacles could connote coolness; celebrity; jet-set, Jackie O. glamour; athleticism; the noir; or any other instance of retro. Gold aviators might reign, but Ray-Ban Wayfarers, white frames, cat eyes, and granny glasses could also still rule. [Daniela Ghione in sunglasses by Ray-Ban for Bausch & Lomb. Photograph by Arthur Elgort, 1984.]

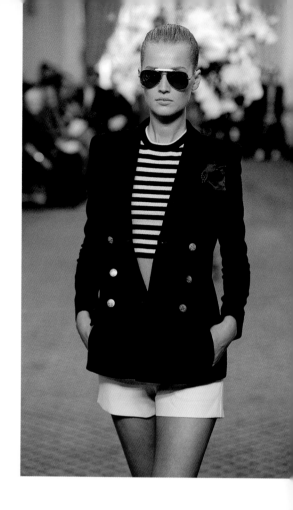

WHEN THE 1980S ARE REVIVED
by designers, the styling can tend toward
the up-to-something-nefarious-near-the-
Berlin-Wall look. Frida Giannini played with
this in her spring/summer 2011 collection
for Gucci, plopping weighty gold aviator
frames under androgynously shellacked
hairstyles. For the spring/summer 2012
Bill Blass collection, the designer Jeffrey

Monteiro gave gold-frame aviators to a bunch
of boathouse-bound preppies, also aggres-
sively coiffed into gender indeterminacy. The
idea that gender was a performance rather
than a fixed identity went into wide circu-
lation in the 1980s, and the fashion runway
has expressed it in various forms ever since.
[(Above) Bill Blass runway, 2012. (Right) Gucci
runway, 2011.]

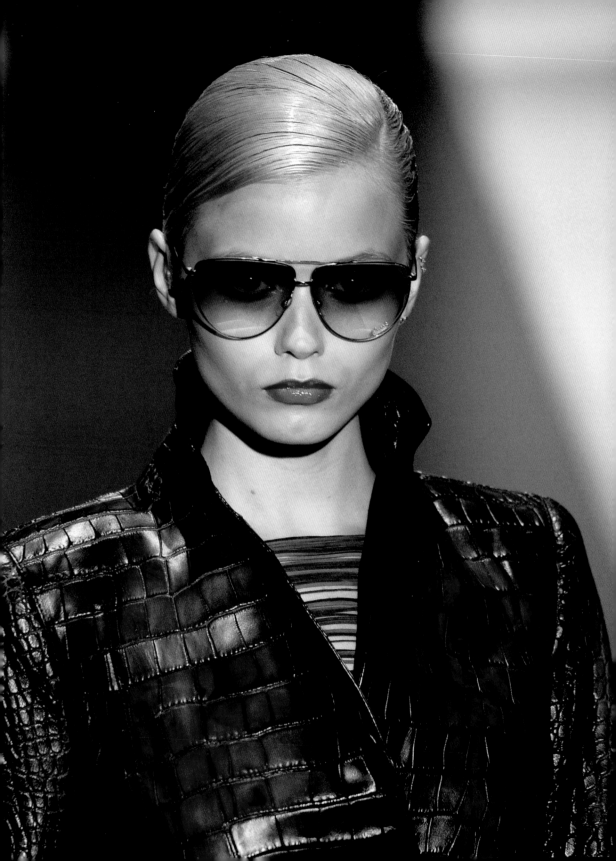

> **FRENCH DESIGNERS** promoted a retro-
grade hourglass silhouette during the 1980s,
which was in keeping with the decade's
1950s nostalgia for hothouse-flower women
in stiletto heels and Merry Widow corsets.
Meanwhile, the emerging Japanese design-
ers Rei Kawakubo, Yohji Yamamoto, and Issey
Miyake were reinventing and deconstruct-
ing that silhouette, creating alternative cuts
for alternative bodies. Issey Miyake would
be the first among the group to reinvent the
eyewear silhouette as well. In a photograph
of a total Miyake look by Arthur Elgort for
Vogue in January 1985, the model wore a rad-
ically reinvented pair of sunglasses. Miyake's
model IM-101 departed from the minimal-
ist functionality of retro frames, the pastel
honey flow of typical fashion-designer frames,
and the jewelry maker's shiny bag of tricks.
Miyake's frames were more architecture for
the face, or a piece of modernist sculpture,
and they invented a new category of eyewear
that would be embraced by fashion design-
ers with a bit of Bauhaus in their psychic
DNA. [Daniela Ghione in Issey Miyake Suit.
Photograph by Arthur Elgort, 1985.]

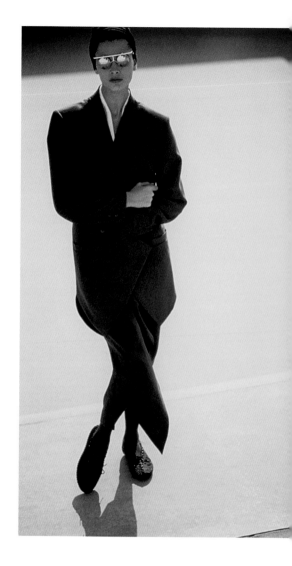

> **THE REJECTION OF GENDER** as a rigid, fixed point proposed in the conceptual and fashionable firmament of the 1980s was fully realized on the runways in the 2010s, especially through the work of Alessandro Michele for Gucci. In this ensemble from the spring/summer 2016 collection, Michele encoded multiple historic transgressions from genderfucks past. The suit's fabric is pure Carnaby Street, male peacock circa 1967. The briefcase, the heavy-brocade red tie, and the subtly upsized, lace button-down shirt all imply a theatrical performance of "business" via a psychedelic-color funhouse mirror. The glasses that top the look are similarly masculine just a hair oversized that undermines the fundamental conservatism of the frame shape. Michele produced an impressive amount of eyewear in his late 2010s collections, making use of the full palette of the eyewear wardrobe that was established in the 1980s. [Gucci runway, 2016.]

THE

HIT

FACT

ORY

The Triumph of Eyewear in
the Twenty-first Century

There were some clearly discernible trends in glasses from the 1990s. Thin, light, metal frames had a moment. Reporting from the 1995 Vision Expo, the word from *WWD* was "Be it stainless steel, copper, gold, silver, pewter or even brown, the leading trend in both sunglasses and ophthalmic frames is pure metal." High-tech sports shield frames had a moment as well, one that was kicked off at the beginning of the 1990s when Oakley patented a lens coating with a uniquely appealing icy gloss. The first shield style of eyewear, featuring an unbroken piece of optical glass stretched over both eyes, is credited to Austrian opticians around 1830. The shield style was, in the hands of sports enthusiasts like skiers and cyclists, a unisex frame. In 1891, the Lamb Eye Shield, which hinged the shield lens at the center, was patented. By the twentieth century, the shield style was adapted for driving

as well, and thus gained notice in a May 1913 issue of *Vogue* magazine, which pictured glasses "sent over from Europe['s] Paris motor exhibition." By the twenty-first century, the only question was: driving what? A sports car? A thousand-dollar bicycle? A Hummer H1 with a surf rack? The options were endless.

Oversized lenses for women returned in the twenty-first century as well, and were well matched with blond plastic hair extensions, exceedingly disciplined slenderness, and a purse-sized dog. The real story was the consolidation of power in the hands of Italian eyewear manufacturers who held most of the designer licenses, with Luxottica and Safilo at the lead. The demand for high-fashion lenses had already pushed into traditional optician's stores, transforming the site of conservative marketing and merchandising into a venue for the high-fashion ad campaigns that accompanied licensed eyewear. In 1996, the retail environment was further transformed when Luxottica purchased the retailer LensCrafters. By 1999, Luxottica's licensed and house-brand combined sales were at $1.89 billion.

The juggernaut of Italian-manufactured designer eyewear (and its less-remarked Chinese-manufactured imitations of similar frames, though without logos) thrived into the twenty-first century, though it did not secure total hegemony. As the vertical integration of Luxottica's marketing strategy drove fanciful novelty in design as well as the highest prices the market would bear, pockets of resistance emerged. Fashion-forward youth in American cities began

to gravitate toward the functional aesthetic of mid-century modern eyewear, especially heavy black frames. At the same time, Andrew Hunt, David Gilboa, and Jeffrey Raider founded the eyewear company Warby Parker with the express intent of disrupting the high-priced eyewear market. Launching with the seemingly radical idea of avoiding brand licensing fees altogether, Warby Parker initially bypassed brick-and-mortar retail and sold online. With styles that reasserted mid-century modern shapes already in circulation in hipster enclaves like north Brooklyn, the optometrically friendly eyewear was an immense success. While the company foregrounded values of sustainability and social consciousness, the fashionableness of the frame was crucial to Warby Parker's foothold in the twenty-first-century eyewear pantheon.

By the twenty-first century, a nearly perfect machine for making fashion eyewear had formed. Any perusal of runway images or fashion editorial from the 1990s onward shows that all the frames had a moment. The retrospective hybridity and fantasy of high style into the twenty-first century meant that all of fashion history was constantly on display. So cat eyes? They were still in play. Aviators? Never out of style. Library frames? Sure, why not? Tortoiseshell, horn-rimmed, wire-rimmed? Yes to all. The real story was the endless novelty, which encouraged customers to joyfully and infinitely replace them. The transformation of eyewear from function to fashion was complete.

> **FROM A SPRING/SUMMER 2011** collection that the designer called minimal baroque, Miuccia Prada's sunglasses with temples modeled after seventeenth-century interior design motives were the "it" sunglasses of the summer of 2011. The glasses sold out quickly and then became the ever-evolving Prada Minimal Baroque line of glasses, still on the market nearly ten years later. The eyewear edifice that began to be built in the late 1980s, when fashion-designer-licensed lines surged, had created the consumer's desire to constantly trade up to whatever was next in spectacles and sustained it into the twenty-first century. The licensing deals and design programs were no longer the 6 percent royalty licensing deals of the 1970s—they were joint ventures between the designers and manufacturers. As early as August of 1993, *Vogue* noted that "the latest designer sunglasses…now rival designer scents in number." The machine worked, according to a 1994 report in *WWD* from an eyewear-industry conference, "because of its unique combination of medicine and retailing, the eyewear business is one of the few areas where the majority of consumers 'haven't a clue' what brand or type of frame to buy." The reporter went on to note that it didn't hurt that "one large group of eyeglass wearers, aging baby boomers, places the same emphasis on design in frame selection that they do with many purchases. This group 'insist that frames be progressive looking

and make some sort of fashion or personal statement.'" The owners of optical boutiques at the conference said that "two-thirds of all the frames [they sold] represent second, third or fourth purchases, which convey a different look, level of seriousness, or are sports or activity-specific."

The boom expanded in the late 1990s and early 2000s. A 1998 *WWD* profile on Alain Mikli reported a $30 million wholesale business for the name eyewear designer, a combination of his own designs as well as the designs he manufactured under license for Jil Sander, Claude Montana, Philippe Starck, and Frederic Fekkai. In 1999, *WWD* stated that "nearly two-thirds of American women wear eyewear, and U.S. retail sales in 1998 tallied $15.8 billion." In 2005, the profits were such that top fashion designer Tom Ford made a personal appearance at SILMO (the French eyewear industry conference) to launch his signature eyewear collection: it was twenty-three different oversized frames in a licensing deal with Marcolin. In 2006, Ralph Lauren opened a dedicated eyewear retail store with nearly one hundred styles of frames available. His eyewear retailed from $130 to $310 (with a gold-plated frame inspired by Lauren's own glasses at $360). A consultant asked by *WWD* for comment on the venture said, "[Sunglasses] are an affordable luxury, with a great entry price point." The eyewear hits, especially the high-fashion oversized frames, showed no sign of stopping. In August

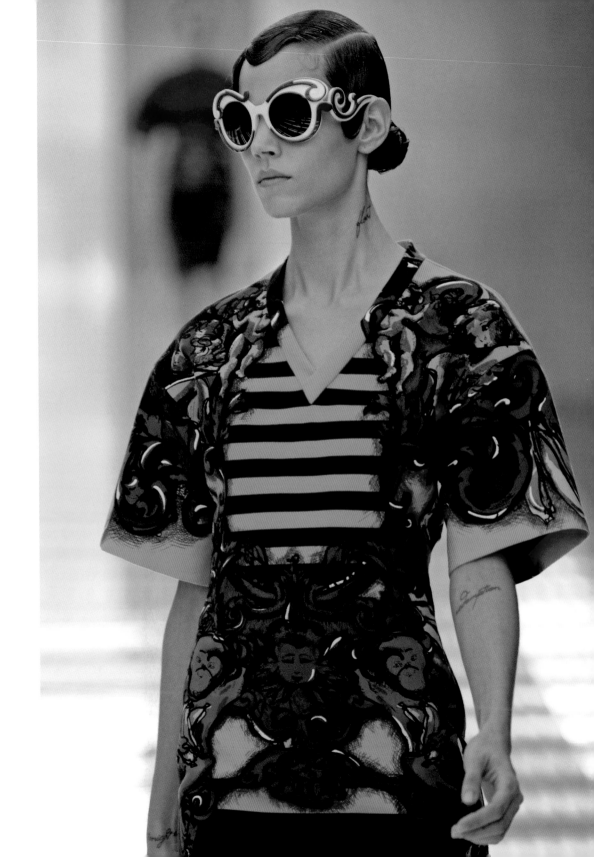

2007, fashion muse (continues on page 230)
Amanda Harlech commented to *Harper's Bazaar* that following the Chanel cruise show in Los Angeles, "practically every girl I saw there was wearing those disproportionately big dark glasses with skinny jeans and an enormous bag. I suppose it's a distillation of a particular look—the young Hollywood star...and it sends out the message, 'I'm a celebrity.'" [(Previous page) Prada runway, 2011.]

> **IN THE HANDS** of Karl Lagerfeld for the House of Chanel in the early 1990s, smart and vividly branded eyewear was part of a suite of accessories that would offer access to the Chanel brand and iconography. An eyeglasses wearer himself, Lagerfeld consistently featured spectacles on the runway as an integral part of the total look of the season, whatever that was. Chanel was working with Luxottica on eyewear for the spring/summer 1991 and 1993 collections, but Chanel's sunglasses line was pure fashion and unlimited by the need to modify vision in any way. In 1999, Chanel entered its first licensing arrangement with Luxottica that had the intention of "going beyond sunglasses to corrective eyewear." According to Chanel executive Bruno Pavlovsky in *WWD*, "a license was the only way to tap into Luxottica's production know-how and its distribution."

In a precise alignment of clothing and accessory, several of the prints of Stella McCartney's spring/summer 2012 collection were preserved in amber (or, rather more likely, acetate) for the eyewear collection. McCartney had licensed with Luxottica dating back to 2009 for "everyday aviator wayfarer styles mixed with statement pieces," which would be the apt category for the sunglasses that repeated the fashionable print. By 2013, McCartney would add an optical collection as well. What had started in the late 1980s as a more thoughtful alignment between eyewear manufacturers and the fashion houses had evolved by the 2010s into a granular, season-by-season series of collaborations, proving that the eyewear wardrobe was at its capacious ideal in the twenty-first century. [(Top Right) Chanel runway, photograph by Guy Marineau, 1991. (Bottom Right) Chanel runway. Photograph by Guy Marineau, 1993. (Far Right) Stella McCartney runway, 2012.]

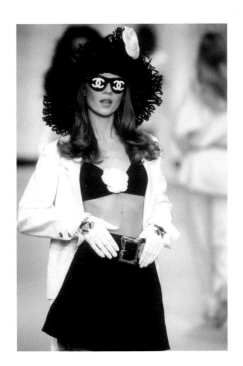

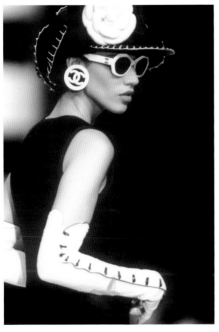

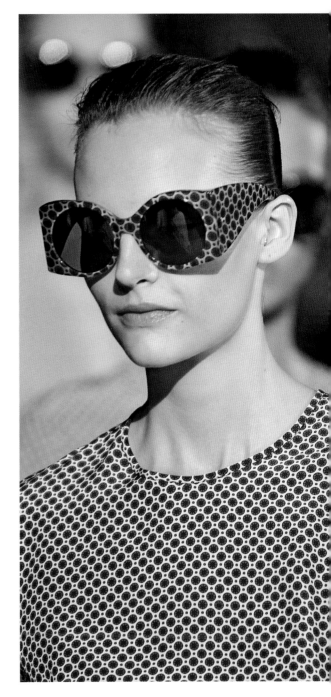

∧ > **FOR SPRING/SUMMER 1991,** the designer Azzedine Alaïa based his collection in part on the trademark pink-and-white Vichy check–print fabric of the popular French budget store Tati, one of the earliest examples of high-low collaboration in French fashion. Tati agreed on the promise that Alaïa would design some pieces expressly for the store. The resulting collection saw that check print scaled up and down all over the ensembles and accessories, with sunglasses completing the look. It would be years before Alaïa licensed eyewear though. This early iteration shows the fashion designer's completist compulsion. More recently, the eyes have been the window to the brand at Alaïa, with design elements that alternately deconstruct and recreate iconic design elements from Alaïa's fashions. The punched patterns echo foundational leatherwork by the designer, though executed in acetate instead. [(Above Left) Azzedine Alaïa runway. Photograph by Guy Marineau, 1991. (Above Right) Azzedine Alaïa runway. Photograph by Guy Marineau, 1991. (Opposite page, Top) Azzedine Alaïa runway. Photograph by Guy Marineau, 1991. (Opposite page, Bottom) Azzedine Alaïa frame, 2020.]

∧ **THE TWENTY-FIRST-CENTURY** history of eyewear in the House of Chloe features a number of hits, like 2014's Carlina frame and 2017's Poppy, which are both still in circulation. On the runway, there have been more avant-garde statement pieces, like the asymmetrical frame from the spring/summer 2001 Chloe collection designed by Stella McCartney. Archival notes on Chloe's eyewear reveal that the house dedicated advertising of its eyewear during the first designer boom of the 1970s and sustained advertising in the 1980s as well, but that the most aggressive production of its eyewear began in the late 1990s. As a part of the creative relationship with a range of licensing partners, Chloe produced the most iconic images of its house eyewear through integration in ad campaigns by photographers such as Craig McDean, Inez van Lamsweerde and Vinoodh Matadin, Glen Luchford, Charlotte Wales, Steven Meisel, and David Sims. Currently in a licensing agreement with Kering Eyewear, Chloe leads all the design and advertising. [(Left) Chloe sunglasses, 2020. (Right) Chloe runway. Photograph by Guy Marineau, 2001.]

> **AS A DESIGNER,** Rick Owens has often oscillated between utopian and dystopian visions of the future, and the same could be said of the shield-style frame, the most futuristic form of eyewear. Owens's spring/summer 2020 eyewear collection featured only shield frames. The style dates back to the 1830s, but it didn't break out of sportswear and into fashion until the 1960s, with a similarly ambivalent take on whether the shades were required by a future that was so bright or so terrifying. Only the orientation toward the future was certain.

Though eyewear with futuristic functionality, such as wearable computers, dated back to the 1970s, the idea of wearable technology as potentially fashionable wasn't acknowledged in the fashion press until the late 1990s. In 1997, *WWD* discussed eyeglasses with wearable computers as "Future Chic," but no designer versions were immediately forthcoming. Perhaps the trade magazine was only having a momentary surge of millennial anxiety. While the look of futurism persisted, especially when promoted through films featuring science fiction adventures and comic book heroes, proper wearable tech has yet to become anything more than a signifier of mildly concerning creepiness. [Rick Owens runway, 2020.]

< ∧ > **THE 1960S** is a point on the fashion-history time line to which Miuccia Prada returns again and again. Her fall/winter 2011 collection alluded to the 1960s' affection for fashions of the 1920s and offered an exaggerated vision of both periods with an exaggerated pair of yellow shield sunglasses to match. Meanwhile, an alternate interpretation of futurism from the 1980s has been handed down to designers, one that was picked up in Jonny Johansson's spring/summer 2016 collection for Acne, in which some ensembles were accompanied by asymmetrical wraparound shields that echoed the aesthetic of a synth-heavy pop-music video circa 1982. Thierry Mugler's sci-fi vision wrought bubbly mirror-lensed shields that finished his spring/summer 1996 fembot. [(Left) Prada runway, 2011. (Above) Acne runway, 2016. (Right) Thierry Mugler runway. Photograph by Guy Marineau, 1996.]

< > **THE SHIELD FRAMES** used during a chic ski vacation have always had a berth in the fashion magazine along with skiwear ensembles, which were consistently produced by French design houses in the 1920s, '30s and '40s. It is to this period's elegant iteration of the shield frame that Karl Lagerfeld looked back for a 2016 flight-themed collection for the House of Chanel. His rimless shield harkened back to the earliest form — a single piece of optical glass — albeit in a vivid purple version. [(Left) Toni Frissell, "Skier," 1947. (Right) Chanel runway, 2016.]

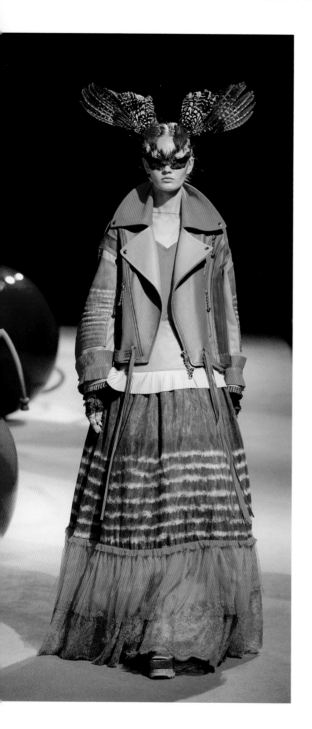

< **HIGH-FASHION EYEWEAR** has contin-
ued to take liberties with spectacles for the
sake of spectacle. For his spring/summer
2015 collection for the Undercover line, Jun
Takahashi went into full fantasy through a bird
headpiece that implies eyewear but actually
uses maquillage. It is the extreme end of the
narrative of eyewear, which is ultimately one
of wild abundance. The bottomless appetite
for this needful thing means that any and all
are served by the current range of designs.
One need only decide how to be seen.
[Undercover runway, 2015.]

Acknowledgments

I have so many people to thank for their help with this project, especially since so many extended their time and effort under the year 2020's extenuating circumstances. First and foremost, I would like to thank the eyewear makers who participated in this project via their wonderful interviews: Gai Gherardi, Kerin Rose Gold, and Adam Selman. Your creativity inspires me! I would also like to thank the photographer Guy Marineau, whose iconic runway images from the 1990s helped shape my thinking on fashion eyewear.

To my editor, Joe Davidson of Hachette Book Group, I thank you for your patience and good humor, which made our collaboration such a pleasure. To my literary agent, Dana Murphy of The Book Group, I thank you for your support and guidance. To Seung-min Kook, I thank you for serving as my quick and ready research assistant at terribly short notice. I would also like to thank my husband, Dennis Shealy, and my son, Malcolm Shealy, who had to listen to me talk an awful lot about eyeglasses.

I would be remiss if I did not mention that I stand on the shoulders of giants, namely my colleagues from The Costume Institute at The Metropolitan Museum of Art. Most specifically, I would like to thank Becky Perry and Anna Yanofsky, who offered the enthusiasm and encouragement I needed to take on this project; Julie Le, who hooked me up with all the right books and all the right friends; Marci Morimoto, who was always happy to serve as my nineteenth-century fashion guru; and curators Andrew Bolton, Karen Van Godtsenhoven, and Jessica Regan, who set the bar for fashion history scholarship I hope I have reached.

Finally, I would like to thank the museum and fashion archivists who assisted me with images and research even while off-site and at limited capacity. This includes Julie Zeftel and Jeri Wagner at The Metropolitan Museum of Art; Julie Le at The Costume Institute's Irene Lewisohn Costume Reference Library; Maria Smit at Rijksmuseum; Carla Sozzani at Fondation Azzedine Alaïa; Raya Daher at Richemont; Geraldine Julie Sommier and Catherine Lebrun at Chloé Archive Paris; Chrissie Miller, Bethany Freund, and Kate Boyle at Warby Parker; Marley Glassroth from Selman & A.S.S.ociates, Inc.; Brent Zerger at l.a.Eyeworks; Elvire de Rouge at Azzedine Alaïa SAS; Marco Castro Cosio, Gregory Bishop, and Cesar Imbert at Cartier North America and Cartier International SNC; Andrea Oreni and Vera Zennaro at FirstVIEW; Maureen Pellegrini; Ray Perman at Sevenarts Ltd.; Joyce Faust at Art Resource; and Hayley Blomquist at Artists Rights Society.

About the Author

JESSICA GLASSCOCK is a Lecturer in Fashion History at Parsons School of Design and worked as a researcher at The Metropolitan Museum of Art's Costume Institute for over a decade.

Selected Readings

A Spectacle of Spectacles. Germany: Edition Leipzig, 1988. [With essays by Claus Baumann, Joachim Töppler, and Gerard L'E. Turner. Produced by Carl-Zeiss-Stiftung Jena.]

Corson, Richard. *Fashions in Eyeglasses*. London: P. Owen, 1980.

Davidson, D. C. *Spectacles, Lorgnettes and Monocles*. London: Shire Publications Ltd., 1989.

Handley, Neil. *Cult Eyewear: The World's Enduring Classics*. London: Merrell, 2011.

Lipow, Moss. *Eyewear: A Visual History 1491-Today*. Cologne: Taschen, 2011.

Mazza, Samuele. *Spectacles*. San Francisco: Chronicle Books, 1996. [With essays by Luca Gafforio and Guilio Ceppi, Marco Meneguzzo, and Cristina Morozzi.]

Riccini, Raimonda. *Taking Eyeglasses Seriously: Art, History, Science and Technologies of the Vision*. Milan: Silvana Editoriale, 2002. [With essays by Alessandra Albarello, Ezio Alberione, Giovanni Anceschi, Paolo Brenni, Omar Calabrese, Alfredo Chiappa, Antonio Costa, Paolo Legrenzi, Giuseppe Longobardi, Patrizia Magli, Tomas Maldonado, Steve Man, Silvia Marinozzi, Leonardo Masotti, Marco Piccolino and Andrea Moriondo, Anna Poli, and Ugo Volli.]

With special thanks for the many sharp observations contained within:
Harper's Bazaar
Vogue
Women's Wear Daily

Image Credits